Survey of African American
Dance

Vikki Baltimore-Dale

second edition

Kendall Hunt
publishing company

Cover images © Shutterstock

Kendall Hunt
publishing company

www.kendallhunt.com
Send all inquiries to:
4050 Westmark Drive
Dubuque, IA 52004-1840

Published in the United States of America

Contents

To my loving mother,
Conswella Baltimore
who loved to read about
the dance.

And to my special family
and friends

I love you

1 Introduction

Fifteen years ago, I was awarded a grant by the University of Nevada Las Vegas to study *African American Dance in Worship*. The quest for academic material guided me from the Lincoln Center for the Performing Arts in lower Manhattan to the Schomburg Research Center for Black Culture in upper Manhattan, Harlem. Lincoln Center is the national leader in arts and education. Schomburg is one of the leading institutions focusing on the interpretation of the history and culture of African Americans and people of African descent.

Gathering research material in these two venues led me to a new academic focus-afrocentric study. The perspective was introduced to me by afrocentric scholars. They persuaded me to realign my approach to my research, which included findings that were revolutionary to my understanding. Fortunately, the internet has exposed information that would have been overlooked in the past. Today, written history can no longer obscure the existence of relevant truths.

I realized that my academic studies and media exposure desensitized my rational thoughts in certain areas of study. Upon acknowledging the void, it became my intent to take responsibility for supplementing my knowledge and embarking on my own investigations. The result of that research is shared as material in this textbook and will be fueled by further investigation of the reader.

Survey of African American Dance is a panorama of the contributions and influences of the African American aesthetic and movement qualities seen throughout the history of American Dance. The course can only address a limited number of recognized artists in each area, but by no means devalues the many personalities whose tremendous, groundbreaking contributions merit acknowledgement.

The knowledge shared in each subject area, within this text, is limited. The research content is so vast, each chapter could sustain its own course. For example, many university and college dance departments offer courses such as the History of Ballet.

The first half of the course will investigate the dance of the Ancient Egyptian culture, the influence of African dance, effects of the slave trade, dance on the plantation, and minstrel shows. The second will encompass concert forms of dance — tap, ballet, modern, jazz, and other forms of movement. Identifying categories of dance and body torso movement, as defined for this course, will give the student a simplistic visual of dance as a whole.

Course Description

A survey of the role of the African American in the development of dance in America. Special focus placed on artists, their philosophies, and contributions in the areas of ballet, jazz, modern, and tap.

Course Outcomes

1. Students will be able to identify the contributions made by various recognized African Americans in the area of dance.
2. Students will gain an understanding of the struggle of African Americans to produce their works.
3. Students will have a greater knowledge of the styles and techniques of various African American choreographers in the areas of tap, ballet, modern, and jazz.
4. Students will be able to understand and articulate an introductory view of the history of each of the above-mentioned dance forms.
5. Students will be able to recognize the influence of African dance on social dances, past and present.
6. Students will be introduced to a vibrant manifold culture and appreciate its artistic increase in the world of dance.

Categories of Dance

There is consensus across the dance world that dance, as a human movement system, can be grouped into two main categories of movement: ethnochoreological dance and concert dance.

Ethnochoreological Dance is the study of the human movement system, especially that of participation and social cultural exposure. It includes cultural folk dance and participatory dance activities such as taking a movement class, a yoga class, or engaging in social celebrations. Dance is performed with a specific, often personal agenda-the appreciation of which generally does not require an audience.

Concert Dance is the collective of human movement designed for an audience. The performance venue is markedly separated into two sections. Commonly an area is designated for the performers' movements distinctly separate from the audience. With the exception of the artist who is exploring physical artistic options, such as dancing amidst structures at a museum, it is obvious to the viewer where the audience space is located. The concert or theatrical area calls for production, lighting design artists, and personnel for stage crafting and operations. The performers are transformed into thematic representation calling for makeup, costumes, and possibly props. Choreographers craft the movement and polish the technically trained dancers. Other aspects are needed to advertise and create the production vision of the choreographer or director. The process for converting movement to concert readiness requires attention to detail and perfected artistry. For clarification, description, comparison, and contrast investigation, two categories of torso movements will be referred to intermittently throughout the course. These identifications are not devoid of exceptions but are useful for the understanding of the movement base of a dance idiom. The two categories are:

Single unit

1. The use of the torso appears restricted and compact.
2. The torso is predominately erect but moves forward, back, to the right, or left with simplistic variations of those basic movements.
3. Celtic dancing and ballet would be an example of the single-unit torso articulation.
4. This category is usually found among the folk dances in cold regions. The necessity for heavy or bulky clothing would hinder extensive movement in life as well as dance.

Multi-unit

1. The articulation of the torso is freer. Movement of the body is executed in an unrestricted fashion. Multiple body isolations are employed. The upper portion of the body may move separately or asymmetrically. Hips move freely and are unapologetically celebrated.
2. Warm and hot climates give birth to the multi-unit articulation. The free, uninhibited, and many times asymmetrical use of body isolations acknowledge the appreciation of natural physical expressions. Consequently, the hips are free in celebration of the body and earthbound to celebrate the richness of the land.
3. African and jazz dance would be examples of multi-unit torso articulation.

Terms

Certain words will be used frequently throughout the course and have specific meaning in regard to the study of the text. The definitions are my understanding of the way they relate to the research.

Abolitionist – those who fought against the institution of slavery.

Aesthetics – a principle recognizing the interpretation of artistic philosophy and taste.

African Diaspora – diaspora means dispersal. In the context of this course it relates to the African people removed from their geographic origin.

African Americans – the descendants of the African race abducted and forced to America by the dealers of the Mid-Atlantic Slave Trade. There will be references using the word colored, black, or Negro in some instances, depending on the era.

Afrocentric – pertaining to African American culture.

Ancestors – respected forefathers and elders who have transitioned from this world to an afterlife.

Artists – references to persons who create in the fine arts.

Asymmetrical – not evenly distributed in form or movement arrangement.

Authentic – original.

Barre – horizontal pole usually attached to the wall for support when warming up the body.

Body Isolation – one part of the body moves in opposition to another part of the body.

Challenge – friendly form of competition.

Choreography – art of designing dance movements with specific intent.

Costumier – one who creates costumes for theatrical productions.

Dance – movement forms consisting of selected sequences of human movement.

Dance Idioms – refers to different dance forms such as ballet, jazz, tap, and modern.

Dynasties – a sequence of hereditary rulers of a country.

Earthbound – movement focused into the ground.

Eclectic – utilizing choreographically a variety of dance forms as opposed to only using one dance idiom.

Ephebism – strong demonstration of the intensity, vitality, and energy of the African youth. Elders who execute movement in this manner are especially valued in the African cultural movement.

European Americans – name referring to the Europeans whose origin was from Europe just as African Americans' origin was Africa. Native Americans were the indigenous people of America. The word caucasian will be used interchangeably with European American.

Fraternities and Sororities – Greek organizations started by African Americans on college campuses whose focus was serving the community and promoting brotherhood and sisterhood in the institution.

Griot – a member of the community selected to sustain the oral traditional history of a tribe. The griot may use storytelling, music, and dance to convey ancestral information.

Improvisation – arranging movements without previous preparation. Spontaneous movement. Not choreographed.

Minimalistic – repetitious.

Negroid – characterized or belonging to a major ethnic division of the human species indigenous to central and southern peoples of Africa.

Pantomime – technique used to convey emotions, actions, feelings, etc., using only gestures without sound.

Participatory Dance – dance that exists for a primary common purpose, such as the social interaction among the participants rather than the enjoyment of an audience.

Pharaoh – Great House.

Pickanniny – derogatory stereotypical term for a child of African descent.

Polyrhythms – two or more rhythms demonstrated through the body at the same time.

Possession – in regard to dance, a state when an outside influence takes dominance over the movements of a performer.

Props – objects used to enhance a dance or production.

Repertoire – a company's library of dances.

Ritual – ceremony established with prescribed proceedings may be performed with few restraints.

Signature Piece – choreographic work for which the artist is best known.

Spectator Dance – dance that is designed for an audience.

Symmetrical – even on both sides in form or movement arrangement.

Syncopation – physically accenting weak beats in the music.

Tattooing – imprinting the skin with artwork or symbolism.

Traditional – well-established styles or techniques of dance.

Work – choreographic presentation that may range from one dance to a full concert.

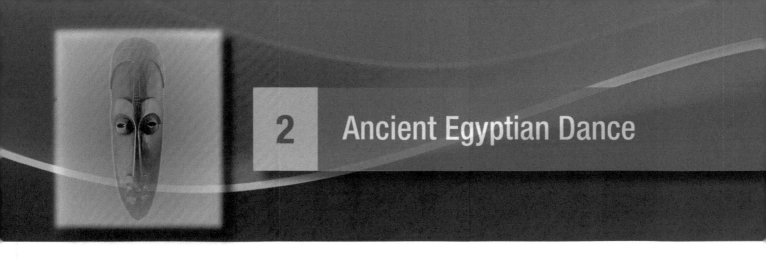

Ancient Egyptian Dance

©Charis Estelle/Shutterstock.com

Introduction

In this age of technological advances, research has uncovered hidden realities, challenged old concepts and revisited anthropological theories. These advances have created new possibilities in the area of ancient revelations. In this fresh awakening, Afrocentric scholars have addressed the presence of African ethnic influences on the evolution of the Ancient Egyptian culture.

Ancient Egypt was not an isolated civilization delivered to a continent from a different time and space. It was born on African soil, and to understand the evolution of African dance the Egyptian culture must be broached even if only at a surface level.

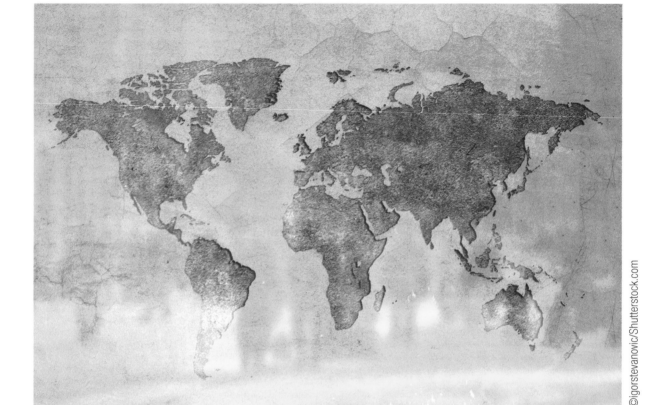

World Population Concept

Afrocentric scholars confirm the African influence in Ancient Egypt. In his book entitled *The African Origin of Civilization: Myth or Reality*, Cheikh Anta Diop, scholar, physicist, philosopher, and director of the radiocarbon laboratory at the University of Dakar, cites as follows:

> Ancient Egypt was a Negro civilization. The history of Africa will remain suspended in air and cannot be written correctly until African historians connect with the history of Egypt. (Diop, 1967, p. 1)

The title of Diop's first chapter poses a provocative question: "What were the Egyptians?" His own response:

> In contemporary descriptions of the Ancient Egyptians, this question is never raised. Eyewitnesses of that period formally affirm that the Egyptians were Black. (Diop, 1967, p. 1)

Since the first dynasty, black pharaohs ruled a flourishing African civilization on the Nile for 2,500 years. Racism did not exist at that time as we know it. Culturally, in the ancient Egyptian society skin tone was irrelevant (Draper, 2008).

Ancient Egyptians excelled in creativity, inventiveness, knowledge, construction, and theoretical explorations. The culture created innovative revelations in the artistic arena evidenced in wall drawings, sculptures, pottery, textiles, jewelry, and remains of other ornately crafted artifacts. The architectural framing of the pyramids have scientists puzzled by their extraordinary methods of construction. A prime example is the Great Pyramid of Gaza-one of the oldest, large-scale, and only remains of the seven wonders of the world (Browder, 1992).

The study of agriculture practiced by the Ancient Egyptians revealed the balance of relationship between plant growth and astrological positions of the stars. The wisdom of the Ancient Egyptians in the area of astronomy led to the creation of the original zodiac, solar, and lunar calendars.

Ancient Egyptians were master craftsman in shipbuilding, perfecting the art of constructing boats of all sizes as well as sailing boats (Erman, 1971). Advances were achieved by the Ancient Egyptians in the study of chemical contraceptives, the pulse, cardiovascular system, intestinal disorders, dentistry, obstetrics, and dermatology.

Ancient Egyptian Dance

Historical research has disclosed the importance of the arts in the Ancient Egyptian culture. The African influence on movement was uncovered in renderings and Ancient Egyptian artifacts. Dance was embedded in the culture; it was not often taken up for study due to its common, inherent, and functional use in the community. Celebrations consistently involved dance for the Egyptian who viewed movement as a natural expression of joy. Dance was considered indispensable as a representation of quality entertainment (Lexova, 2000).

Renderings of dancers from Ancient Egypt were consistently two-dimensional. Evidence on temple walls, tombs, and papyrus disclosed the movements prevalent in the culture. These corporeal representations were governed by the artistic precedence of Ancient Egyptian criterion, which did not allow for creative variations or three-dimensional illustrations (Spencer, 2003). As a result, draftsmen selected steps showing form or position rather than an exact replica. Artifacts of renderings do not show the precise duplication of the dancer or any expression of emotion, but simply present an interpretation of the moving form.

The Ancient Egyptian renderings of archaeological findings displayed at the Schomburg Museum in Harlem and Lincoln Center Library revealed an extensive dance vocabulary that included jumps with pointed feet, ballet arms, flexed foot movements much like modern dance, and a jazz dance layback. The technically skilled movements now taught as specific codified dance idioms such as ballet, modern, and jazz existed in the rich, advanced Ancient Egyptian culture thousands of years ago.

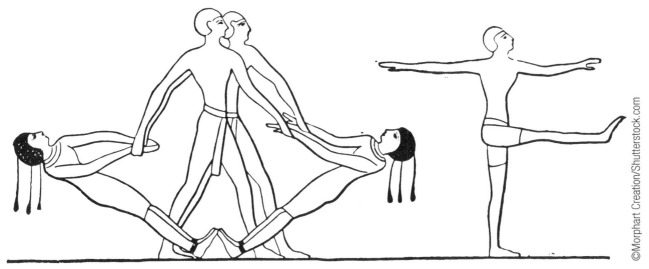

Acrobatic and traditional dance arm and leg extensions

Due to the limitation of archeological references to dance, only general categories can be discussed. Those cited below are not designated specifically to any time frame of the Ancient Egyptian experience of dance, but a summation of the functions and types of thematic dance forms found in the society as understood by the instructor.

General Categories of Ancient Egyptian Dance

1. Corps Dance
 Dancers moving in harmony as one unit.
2. Duo Dance
 Performed by two men or two women. Dancers must be of like gender.
3. Pure Motion Dance
 Movement executed by men or women for the sake of moving.
4. Acrobatic Dance
 Strenuous and contorted movement performed by men and/or women.

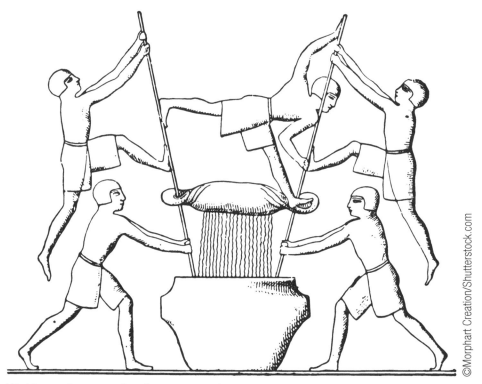

Working a wine press. Dancing as a part of labor is also an African tradition.

5. Burial Dance
 Dances performed at funerals for ritual, bereavement, or celebration of entry into the afterlife.
6. Sacred Dance
 Ancient Egyptians worshipped numerous gods. Sacred Dances were often performed to honor, revere, and appease the gods.

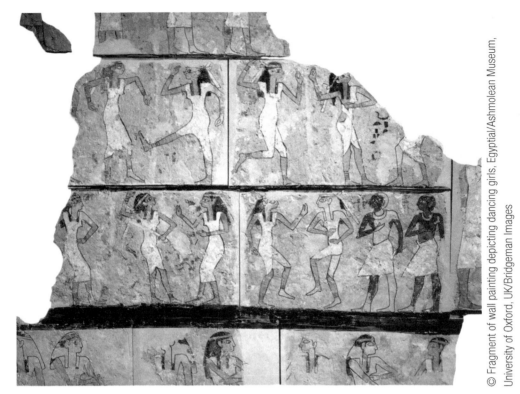

Group of performers

7. Mimick Dance
 Replication through creative movement-the physical essence of an animal or environmental expression of a natural phenomenon.
8. Battle Dance
 Rest, preparation, and victory celebration for troops.
9. Story Telling or Educational Dance
 Tells a story, usually of historical events.
10. Expressive Dance
 Smooth, free-flowing movements.

Accompaniment

Accompaniment for the dance was valuable and rhythmically driven. Any assimilation of a surface producing, percussive rhythm would suffice. The lack of musical notation greatly limits the ability to describe the essence of the accompaniment. However, percussive instruments were a strong element of choice (Spencer, 2003).

Examples of accompaniment are:

Drums
Clappers (similar to wooden castanets)
Clapping of hands
Snapping fingers

Rhythmical shouts
Singing
Chanting
Harps
Pipers
Tambourines
Lute
Lyre
Shakers

It has been established that dance was a common occurrence in Ancient Egyptian society. Investigating the movements of three vital kingdoms will provide insight into the temperament of the environment and the freedom or limitations of expression in each. Different studies identify different divisions and dates, but despite the discrepancy, scholars agree that three major kingdoms existed:

The earliest, The Old Kingdom (2830–2530 BC), Dynasty 4–6, The Middle Kingdom (2130–1930 BC), Dynasty 12–13, The New Kingdom (1530–1050 BC), Dynasty18–20 (Erman, 1971).

The Old Kingdom

Movements: The dancers and musicians are often shown in rows resembling a procession. These linear movements appear stylized using single unit torso articulation. Performers are barefoot and move identically. Accompanists also move identically not using elaborate instruments but with simplistic body percussion such as hand clapping and finger snapping. Under the Old Kingdom, movements appear measured. Dancers may be moving steadily and methodically to keep the constrained posturing. Movements seem restricted, repetitious, and monotone.

Attire: The performers usually wear some form of ribbon, caps, and garland in their hair. As a rule, when dancing, men and women wore a short skirt around the hips. Female dancers rarely wore long dresses. Necklets and ribbons were worn around the upper part of the body, with garlands of flowers, stars, and other ornate objects about the head (Erman, 1971).

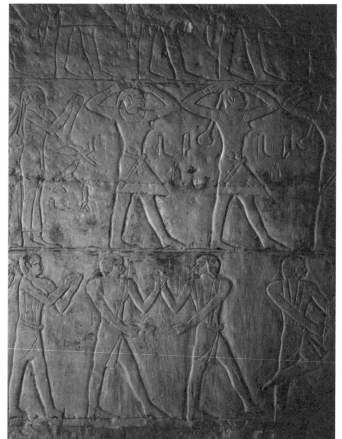

©DEA/G. Dagli Orti/De Agostini/Getty Images

Old Kingdom Dance with arms over head and clapping as accompaniment. Dancer in lower right hand corner with pointed foot.

The Middle Kingdom

Movement: Movement exploration refreshes the aesthetic of this kingdom. There appears to be a shift of creative thought with an explosion of acrobatic movement and use of elevation with jumping and leg raising. Most posturing of dancers maintain different arm positions, minimal repetition, or copying of the movements of others. Energetic and exuberant maneuvering seems purposefully displayed.

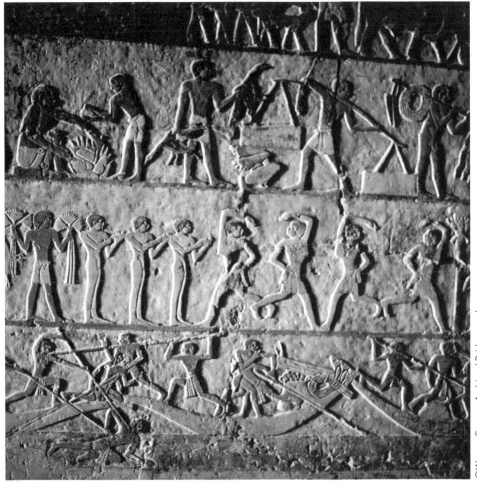

Three rows of pictorial. Second row exhibits exuberance using technical body movements of small leaps and dance runs similar to the natural movements of modern dance.

Establishment of technical training is most likely being developed. Body percussion visibly instituted with the use of finger snapping, hand clapping, and tambourines. There is a demonstration of freer and extremely flexible gymnastic movements to contrast the stiff dance positions of the Old Kingdom. No festive celebration was considered complete without dancing.

Attire: Tassels, caps, and the subtle semblance of jewelry around the neck are recognized in the Middle Kingdom. The clothing does not deviate much from the Old Kingdom.

The New Kingdom

Movement: Movement takes on a theatrical aesthetic with the use of props to enhance the dance or individual fundamental movements. The concert aura of the festive scene that is presented in the following image appears to thematically tell a story created with a moving set of props. There is also the presence of movement opposition and body isolation. This is pronounced when the two-dimensional torso is in one direction and the dancer's head focus is in another. Earth-bound movement within the performance begins to emerge, which is a strong African dance characteristic.

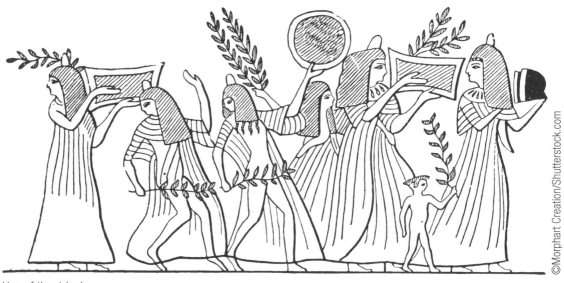

Use of theatrical props.

In the following image the addition of freer movements is indicated by the artists' depiction of strong intensity, which causes the wigs to swing. The dynamics of the head's thrusting movements denote tremendous jovial celebration.

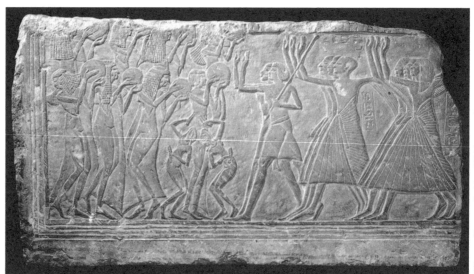

Group dancing with a theatrical concert aesthetic and use of oppositional movement.

The representation in the previous image would be an example of artistic theatrical choreographic abandon. Dancers are raising their arms and many are moving with their body alignment in different angles. Sections of dancers articulating completely different movement qualities and group placement are seen on the left side of the frame, yet the right side has a single unit posturing with strong forceful energy depicted by the articulation of the feet in travel. Thinking three-dimensionally, the group on the right side could be advancing across the floor and in front of the left group as evidenced by the position of the footing of the first two lead performers moving from the right to the left. Two figures, bent with focus to the ground in the center, portray the rounded forward earthbound multi-unit position again distinctive of African dance.

Attire and Accompaniment

The attire is dramatic, elaborate, and flamboyant, enhancing the variety of diverse choreographic creations. Instruments are constructed with stronger detail and artistic crafting. In the previous frame, the women are clothed in ankle-length transparent covering with tambourines, drums, or some form of castanets in their hands.

Women flaunted broad bejeweled necklaces and wig ornaments. Hoop earrings not seen in the Old or Middle Kingdoms were introduced and distinctively identified in the New Kingdom dance attire. Jewelry previously worn in simplicity appeared skillfully crafted with painstaking detail.

During the New Kingdom the dancer's head could be topped by a cone of scented beeswax. Eyes were heavily outlined with Kohl and the wigs were intricately braided and designed long and loose (Spencer, 2003). The tradition of braiding is seen throughout Africa and frequently in the African American community today.

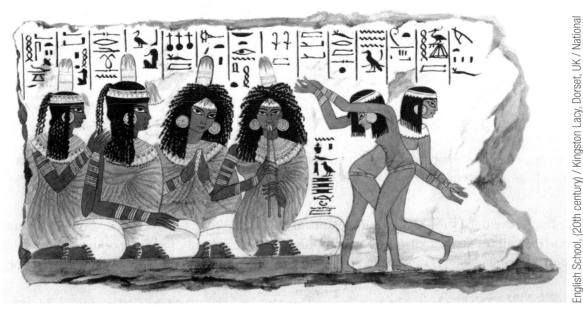

Musicians and Dancers

Two dancers on the right in the image below demonstrate the rounding of the back and more earthbound approach to movement. Sheer outerwear offers the African aesthetic in appreciation of the body. The exposure of the upper part of the body does not have the same connotation as the Western world's interpretation. The acceptance and celebration of the body encompasses the ideology and organic philosophy that permeates the African culture.

Elegantly crafted harps and other refined instruments, the addition of bejeweled apparel, the whimsical free theatrical aesthetic utilizing props, and experimentation of movement represented a graduation from the commonplace single unit of the Old Kingdom. The New Kingdom experimented artistically with the use of innovative risk taking and technical growth within the dance discipline used during the Middle Kingdom, reminiscent of circus performances with its acrobatic movements, juggling, and entertainment similar to the art of jesters. The pronounced productions of the New Kingdom, rich in details, indicate a wealthier and more artistically advanced empire.

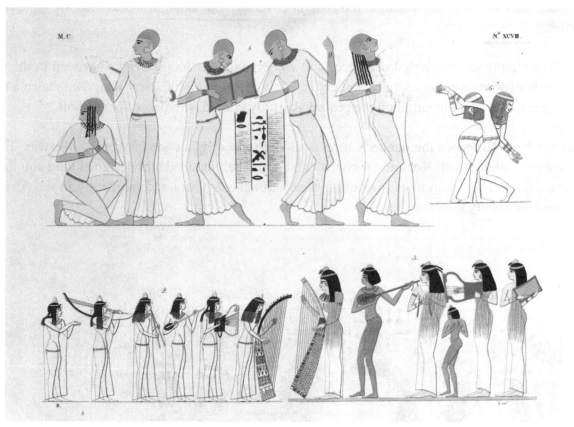

Accompanist using very elaborate stringed instruments. The third dancer from the left on the top row points the foot with the elegance witnessed in ballet today.

Movements reveal the subtle technical movements found in today's concert dance such as the raising up on to the balls of the feet known as a demi-point in ballet, meticulous lifting of the leg, the extended leg with arched back in jazz dance and the formation of abstract configurations in modern dance.

Art imitates life. The Old Kingdom with its restricted movements could speak to a more rigid authoritative reign. The Middle and New Kingdoms show a progression of expression ranging from extremely

celebratory to artistic and theatrical. In the evolution of movement throughout there are distinctive characteristics of African dance. The celebratory use of dance, percussive accompaniment, use of bare feet, body posture, the appreciation of the physical visual body through sheer attire are examples. As the society was able to surrender to movement impulses, we see a shift to lower earth-bound maneuvers. The rounded back or contraction has the same design as the African dance movement found in the use of a flexible back and bent over body articulation. Ancient Egypt had a rich movement vocabulary that was revolutionary in retrospect. The understanding of the rooted essence of African movements naturally interwoven in the dance will be discussed further in the next chapter.

World Map

©Rafal Kulik/Shutterstock.com

Introduction

The DNA of dance is ingrained in the veins of the indigenous peoples of the continent of Africa. From the onset of humankind, dance has been an integral part of the African culture. Its value is equivalent to breathing. To date, archaeological scholars agree that the oldest human bones have been unearthed in Africa. In 2009, the bones of a female, Ardi, were uncovered in Ethiopia. She stood 4 feet tall, weighed 110 pounds. Previously, the oldest bones were of Lucy found in the 1970s by paleontologist Donald C. Johanson in Hadar, Ethiopia (Shreeve, 2009). Both discoveries attest to the fact the African continent holds the keys to early civilization. It is recognized as being the "cradle of humankind."

Africa is a vast mainland, a continent considered by the Egyptians as the motherland. In fact, the name "Africa" originated from the Egyptian term "Afuika" meaning "Motherland." Africa is the home of

17

54 countries; it is the oldest populated and the second largest continent. Africa is a continent of one of the world's youngest populations with 50% under the age of 25. There are over 1500 languages and thousands of dialects (Boyes, 2013). African dance is an integral part of the African people and each region, language, and dialect has its variation of movement. It is clear that the expanse of movement renders a complete study of African dance impossible within this text. Consequently, there will be generalizations discussed and exceptions to different African movement traits.

African dance represents a moving canvas painted with a palette of multiform life experiences, spirituality, and rhythm. The dance culture is steeped in oral history and tradition. Its philosophies are deeply rooted in religious and polyrhythmic expressions of motion. Music and dance coexist and are a vital part of purpose. A generalized description of categorization and qualities found in African dance follows.

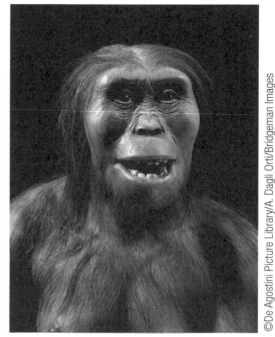

Reconstruction of Lucy

©De Agostini Picture Library/A. Dagli Orti/Bridgeman Images

Categories of African Dance

African dance facilitates multiple functions having principal and subsidiary purposes.

Birth

Ritual dance movements in worship that pay homage and thanksgiving to the Creator extending expressions of blessings for a new life.

Education

Dance is a teaching tool for children to learn standards of order, traditional community movements and discipline, in addition to strengthening physical motor skills.

Funerals

African communities participate in honoring the dead and in celebration of transition into a new realm.

Harvest and Labor

Dances of thanksgiving for bounty of food provided by the earth along with movement that may mimic acts of labor.

Purification Dances

Dancing may be used for water blessing rituals or land purification.

Sacred Dance

Religious dances used to honor diverse faiths frequently with unrestrained abandon, sometimes involving possession.

Rites of Passage

Dances used to escort the youth into adulthood with the blessings of family and community.

There are many rites of passage rituals depending on the individual tribe. A ritual for Maasai men coming of age is to use the physical strength of jumping in a manner that elevates, propels, and sustains the young men in the air competing for highest agility. Suspension in the air is executed without allowing heels to make contact with the ground.

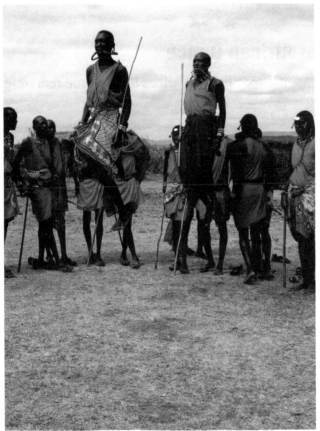

Masai Warriors Dancing

©Katie-May Griffiths/Shutterstock.com

War and Defense

Dances can be used in preparation for war, celebration of victory, and practicing of skills. The defense skills can be in the form of martial arts, which during slavery was disguised as dance.

An example is the creation of capoeira by African slaves in Brazil.

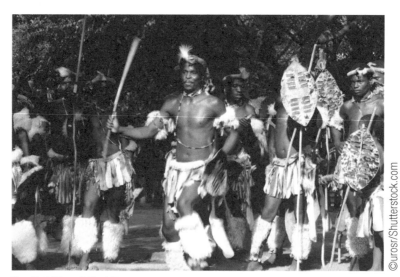

South African Tribal Dance

General Qualities of African Dance

The following generalities are not specific to all tribes but they are representative of many.

Community Focused

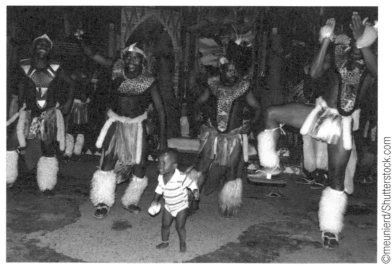

Zulu Dancers

In the African tradition the community is family centered. The often repeated "It takes a village to raise a child" is an African adage. African dance embraces all ages and abilities in the participation of community movement socialization. One of the endearing characteristics of African culture is its innate commitment to congeniality. A hearty welcome for a visitor takes precedent over all else and the host employs all manners of cordiality with utmost sincerity to make the visitor comfortable. Because of the honest, welcoming hearts of the African people, existence in the community has a forgiving letting-go kind of approach to life, especially during a festive time of celebration. Silence and stillness has no place in the performance arena. To be silent is to appear critical and stillness represents a show

of disdain or contempt for a performance. Africanist dance reflects the emphasis on the unit, the whole. Even solo dancers are affirmed and supported through singing, clapping, shouting, and movement expressions of encouragement such as jumping or twirling. Oddly enough, embracing the opposite sex in couple dancing is seldom seen in authentic traditional African dance.

Use of Body Isolation

Incorporating the multi-unit torso articulation called body isolation, where one part of the body moves separately from another, is common in many traditional African dances. The emphasis on the specific body parts used and rhythmic timing of the movement may vary in location and religious ideologies.

Orientation to the Earth

Kara, Togo

With the use of body isolations, the pelvic area bends forward, which enables freer movement of the arms, shoulders, hips, legs, and torso facilitating the execution not only of movement but of vocalizations that often accompany the dance. The upper torso is held forward while the legs maneuver with slightly bent relaxed knees. This posture lowers the body to honor the earth, a repository of life-sustaining elements and show reverence to African ancestors and elders who have transitioned from the present life.

Executed in Bare Feet

Dances are generally performed barefoot. The concept of being connected to the earth and not separated by soles of shoes is one philosophy for dancing with feet unrestricted or covered. Boots and shoes are used due to a region's tradition or history. Work may require men to cover the feet. This is true of mine workers who wear rubber boots as a necessity to protect the feet from the elements. In dark mines workers could only hear each other through slapping the side of their rubber boots. It evolved into a dance called the Gum Boot dance, which later influenced the demonstrations of fraternities and sororities.

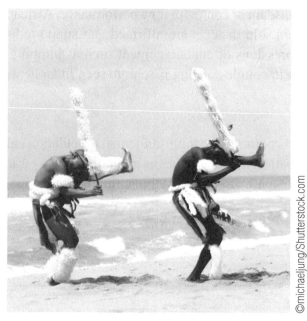

Two Drummers with Dancer African Zulu male dancers

Demonstrations of Ephebism

African people of all ages, engulfed in the percussive ambience of powerful drumming, get into a mental state of surrender and youthful energy called ephebism. (Thompson, 1974).

Ephebism or youthfulness demonstrated in an elder's robust approach to movement is valued in the African culture. This vigor can be seen in movements including shuffling, stomping, and hopping steps along with other percussive maneuvering demonstrations. In certain African regions, the legs strike into the dry earth sending the dust in the air, thereby enhancing the demonstration of the force and power of the movement ignited by energy and rhythm.

Use of Masks

Dances may reflect cultural history and sacred beliefs, which may evoke the spiritual realm. Masks are important in releasing and embodying otherworldly connections.

Positioning a mask in contact with the body necessitates a knowledge of the purpose or function of such a sacred act. An understanding of its purpose allows the dancer to set aside the human identity and portray a spirit messenger. The masked dancer becomes a conduit for an ancestor or deity to manifest and speak to the community through movement. This experience frequently results in the performer succumbing to a state of spiritual possession. This manifestation occurs as an entity initiates control and dominance over a surrendered performer.

Masks serve various functions such as providing protection, initiating communication with the people, dramatizing a story, revering deities, and assisting in diverse ceremonies. The artistic or sacred design,

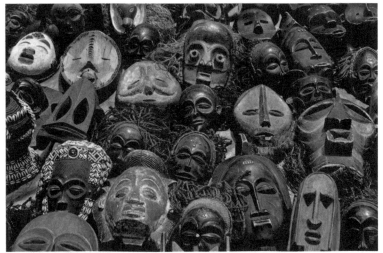

©Terry W Ryder/Shutterstock.com

African Masks

ornamentation, and size of the mask figure have significant meaning and provides specific services. There are three ways masks are worn: helmet or cap, which can extend as much as 3 feet up; face masks, and the full body masks, which encompasses the whole body.

Three types of masks:

1. Helmet or cap—covers the top portion of the head but can extend upward.

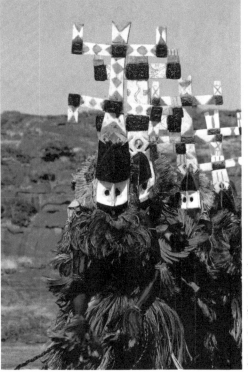

©Henk Paul/Shutterstock.com

Masked Dogon Dancers

2. Face mask—covers only the face.

Face Mask

3. Full body mask—covers the entire body.

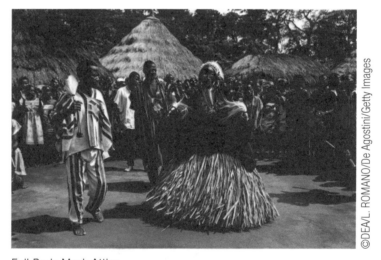

Full Body Mask Attire

Use of Rhythm and Polyrhthms

African music and dance are inseparable. Each gives energy fueling the other. In the African aesthetic, not only is the use of the drum important, but singing or chanting are also interwoven in expressions of dance. A favorite pattern is the call-and-response chant. Leaders sing out a phrase or one word and the audience is expected to answer with the same word or phrase. The method of call-and-response is exercised today in churches and social arenas. Rappers and contemporary performers use the call-and-response chants to energize, hype, and initiate inclusion into the synergy of the stage.

Wooden Bongos

Singing and chanting in conjunction with African dance provides an audible rhythmic thread throughout movement phrasing. The drums, however, represent the primal part of the performer. They are symbolic of the heartbeat, the propeller of all life. The drum is a telegraph that communicates spiritually in the African culture. Tribes with the use of the drums communicate with other tribes. There exists a drum language sometimes referred to as talking drums. Talking drums were used to call out gatherings, alert the community of danger, and were capable of transmitting drum language for miles. The skin covering the head of the drum was deemed a better communicator than the voice due to its ability to copy pitch patterns of language. Making different tones gave the language a special intonation and resonance, which at times appealed to Africans more than speech. The drums are the catalyst for African dance.

African music and dance include several rhythms at the same time known as the the polyrhythmic concept. Within the ritual dance protocol, the master drummer sets a central beat. Other drummers add varied rhythms to make an orchestra of polyrhythmic textures that are enhanced as dancers join the composition of percussion with the same principle of movement. One part of the anatomy moves rhythmically in sync with various isolations resulting in an orchestral use of the body where the upper and lower halves develop different harmonious rhythms.

The drummers initiate the beginning and ending of the dance experience. They are in complete control and the dancers focus visually and musically on the drum, which could be present in large numbers. The drum is revered and the drummers are respected. In a class of

Djembe Afri Drum

another dance form, dancers focus on their bodies and technical skills, giving little attention to the accompanist.

African performers face the drummers and focus on the music, not themselves. After an African dance class accompanied by live drummers, the class bows to the ground and participants use the floor as their personal drum to pay homage by pounding their applause respectfully honoring and thanking the drummers for their astounding display of rhythmic ritual.

Use of Imitation

African dances reflect the motions of life such as the rhythm of the wind, elements of nature, imitation of animal behavior, and reenactments of manual labor.

Use of Objects

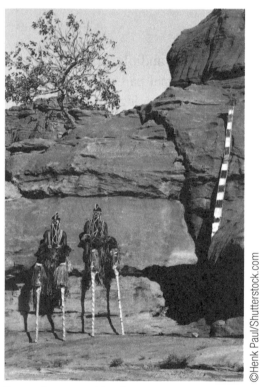

©Henk Paul/Shutterstock.com

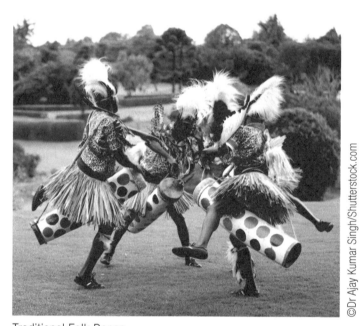

©Dr Ajay Kumar Singh/Shutterstock.com

Dogon Dancers with stilts Traditional Folk Dance

Dances often dramatize community history and religious beliefs. The griots of dance may utilize objects or props such as masks, decorative thematic costumes, stilts, staffs, cloth, spears, and shields. Stilts 5–10 feet are constructed in unique proportions seemingly incapable of holding the weight of adult performers. They may be covered with material matching the performer's upper costume projecting the illusion that the dancer has extremely long legs. Other times the stilts are shown in their raw state revealing the less than dense structures supporting the weight of the rhythmically active movements of trained performers. Defying gravity, stilt walkers perform athletic contortions along with daring uses of the upper torso. In some communities, walkers are recognized as gatekeepers due to the guardian illusion contributable to their height.

Use of Improvisation

Africans are a creative people. As long as spontaneous movement exploration remains within the rhythmic musical phrasing, improvisation is encouraged in the dance. The practice of improvisation is inherent in the African dance sensibility and open to organic promptings of spiritual awareness. African dance continuously changes and reshapes itself; the art of improvisation is practiced in a circular formation in celebration and during religious expressions of worship. It nurtures creativity and an inventive but challenging movement vocabulary. It keeps the mind open and stimulated. The innate ability and necessity to improvise has served African and African American dance through time, and ultimately influenced the African American performance of concert dance, especially tap.

Use of Formations

Circles and lines are commonly used in the dance; the circle is valued as a representation of life. The use of the circle may be influenced by cultural circular environmental dwellings. "The circle of life" is a familiar phrase popularized by the movie and musical *The Lion King*; the phrase has its origin in African philosophy. The circle as a rule moves counterclockwise representing freedom and release. Competitions are executed in a circular gathering. Within the circle a drummer may initiate a rhythmic challenge with a dancer. It is a unifying formation representing eternity, continuity or the unified whole. Innate in its structure, the circle nurtures closeness and is inclusive of spectators.

Use of Attire

Attire varies in each community, but must provide freedom for acrobatic movements, agility and flexibility for most African dance vocabulary. African clothing enhances the body nuances, meaning, purpose, and motivation of the occasion.

General attire includes natural materials and fibers such as grass skirts, anklets made of shells, and natural face paint made from elements in the earth. Facial paint is influenced by the purpose of the dance. Hunting, religious reasons, and camouflaging during battle would be a few examples. Decorating the face is a common practice across the continent. The wide range of patterns created exemplify the

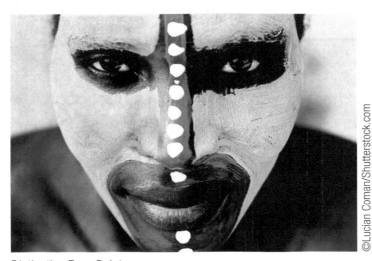

©Lucian Coman/Shutterstock.com

Distinctive Face Paint

emotions and significant meaning of cultural events. Traditionally, face paint, body paint, and tattooing are distinctive to the tribes who practice the historical traditional custom.

Other additions contributing to attire are vibrant colors, animal skins, beads and intricately designed jewelry, ankle bells, handkerchiefs, and cloth.

West African Dancing

Men and women can wear clothing displaying beaded jewelry and woven blankets and cloaks with elaborate motifs. African ware displays beautiful cloth, and textiles are detailed and intricate. Cotton cloth dyed with fermented mud is referred to as Mud cloth, sometimes known as bogolan. The Kente cloth interwoven with silk and cotton is the best known of the woven cloths. Originally worn by political authorities and high-ranking officials of the Ashanti people, the fabric displays saturated colors of gold, yellow, black, green, and red. Messages about historical and philosophical concepts, and moral values of society, are embedded in the construction of the Kente cloth. For the Ashanti people each color has a meaning, black represents Africa, red, blood of the ancestors, yellow represents gold, and green the forest.

African Kente Cloth

Black and White Cloth

Artists and Pioneers Representing African Dance Culture

Many artists have specialized in African dance aesthetics with a mission to insure the continuing appreciation, respect, knowledge, and preservation of the form. Unfortunately, this section will only identify a few of the national and international companies who continually breathe life into the preservation of dance movements that represent the African diaspora. The following artists are pioneers who were met with opposition. Their influences vary across eras but are recognized historically for their contributions in the deeply rooted arena of African and African American culture.

Asadata Dafora (1890–1965)

Dafora was born in Sierra Leone and studied to be an opera singer. He came to the United States in 1929. Finding minimal success as a concert singer, he was inspired to present African culture to unknowledgeable audiences. With the encouragement of an African organization, Native African Union, Dafora started training dancers, drummers, and singers. He began crafting his works by skillfully meshing African and European American aesthetics in performance traditions. Asadata Dafora was the first recognized African American to have presented a performance in America in concert form. His first company was a cast of all-male dancers, West African JABAWA. (Perpener III, 2001).

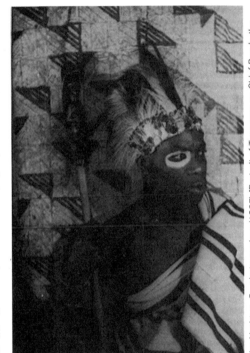

Asadata Dafora

In 1934, females were recruited to join the company before the production of his greatest work, *KYKUNKOR*. Relying on his African roots and artistic sensibility, he successfully created the African dance production resulting in a resounding success with both critics and audiences. The story begins with a curse being placed on a bridegroom played by Dafora. Each character portrayed an aspect of a tribal community. *Kykunkor* represented real human beings, not caricatures, and it told its story with the aid of African vocal and instrumental music. Asadata Dafora proved that Black dance is a theatrical force of artistic worth.

Katherine Dunham (1909–2006)

Katherine Dunham, anthropologist, company founder, choreographer, researcher, author, humanitarian, and civil rights activist, created a legacy for African American Dance for years to come. Her prolific artistic voice in many arenas of life is one of her most powerful contributions. She is a major pioneer of African American Dance, modern dance, and the "Mother of Jazz dance." Her spirit has encouraged countless of artists, humanists, and activists. Her scholarly research afforded her opportunities and invitations to lecture nationally. Dunham's choreographic expertise was showcased on Broadway and in movie successes such as the classic all African American movie *Stormy Weather* in addition to the works she lavished on her company.

In high school, Katherine Dunham excelled in athletics, particularly basketball and track and field. She began to teach dance lessons to earn her way through college with a major in anthropology. Dunham delved even deeper into anthropological field work as a part of her doctorial studies.

Melvin Herskovits, a noted anthropologist, recognizing her interest in dance and anthropology, suggested she explore the dance of the West Indies. She acted on his advice, and received a Rosenwald Travel Fellowship, which afforded her an opportunity to study there. (Perpener III, 2001). She traveled to Jamaica, Martinique, and Trinidad to research the influence of the existing African-derived dance culture. Upon her visit to Haiti in 1936, she fell in love with the Haitian culture where she focused her studies.

Dunham

The *Dances of Haiti* was her master's thesis subsequently published as a book. However, the information performed by her company, The Katherine Dunham Dance company, was the most valuable contribution of her studies. The company traveled nationally and internationally. She created most works in the repertoire of her company. Dunham's first full-length ballet, *L'Ag'Ya'*, based on Martinique fighting dances and produced with her husband, John Pratt, held special meaning for her even though Shango was her signature work. Katherine Dunham has made contributions in several different dance forms and will be referred to often throughout the textbook.

Pearl Primus (1919–1994)

Primus was born in Trinidad in 1919. She moved with her family to New York at an early age. Eventually, Primus majored in biology and pre-medicine graduating in 1940 from Hunter College. While in college she excelled in track and field competitions much like her counterpart, Katherine Dunham. The development of her strength and athletic prowess was heightened on stage. Primus was offered a scholarship with the New Dance group where she studied movement, concentrating on cultural dance forms of the continent of Africa. After extensive research she completed a solo entitled African Ceremonial. Most of Primus' early performances were solo works.

In 1948, Pearl received a Rosenwald grant, which enabled her to study in Africa. The nine months there endeared her to the African people who gave her the name Omawale, child who has returned home. Primus founded her company with the intent of preserving through movement her research of the elements of the African dance aesthetic. Pearl then opened her own School of Primal Dance in New York City.

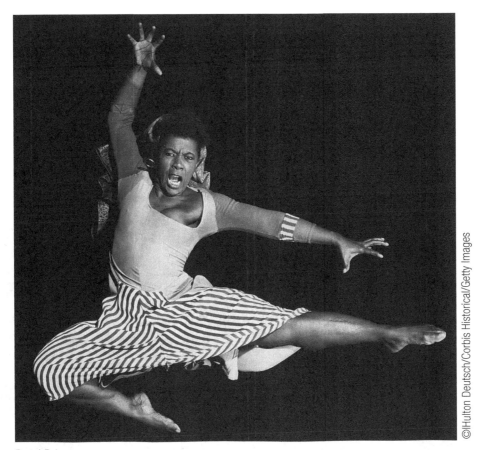

Pearl Primus

In 1961, Primus established the African Performing Arts Center in Monrovia, Liberia, the first arts center of its kind in Africa. Her full-length program work, *Dark Rhythms*, explained and demonstrated the cultures of the African Diaspora.

Charles Moore (1928–1986)

Born in Cleveland, Moore moved to New York to study with Asadata Dafora, Katherine Dunham, and Pearl Primus. Moore was a member of the Dunham company from 1952 to 1960. His discipleship afforded him specialization in the Dunham technique, which he extensively taught in the 1960s. Being a specialized instructor of the Dunham technique was equivalent to a certification. The technique was put in codified form, the closest record of a dance patent.

In 1972, he formed Dancers and Drummers of Africa and was awarded the opportunity to perform Asadata Dafora's solo signature work, *Ostrich* (1932). Moore received critical acclaim for his performance. His extensive performances of *Ostrich* became a staple in his concerts. The Charles Moore Dance Company, posthumously renamed by his wife, Ella Thompson, was the only repertory company of its kind to include Asadata Dafora's reconstructed works and folkloric idioms from the Carribean.

Olatunji (1927-2003)

Olatunji worked with Asadata Dafora before starting his own company, Olatunji's Drums of Passion. His music was used extensively in African dance classes. His classic recording, *Drums of Passion*, was his most popular. Olatunji also coauthored the book, *Musical Instruments of Africa* in 1965.

Chuck Davis (1937-2017)

Ensemble Performance

Chuck Davis grew up in Raleigh, North Carolina. Although Davis received a degree in dance, his focus was on performing. He worked with reputable artists such as Olatunji, Bernice Johnson, and Eleo Pomare. At 6´5˝ Davis was a formidable presence on stage and presented movement with African cultural, philosophical, and spiritual messages interwoven in the dance. Davis founded his company, the Chuck Davis Dance company, in 1968. His desire was not just to perform African dance but also to teach the form to all ethnic people believing dance could unite the world. Annually, Davis traveled with his company to different regions in Africa to learn authentic dances, which were presented nationally and internationally. It was the first African dance company to tour Europe with the support of the State Department. In 1977, he founded DanceAfrica, a festival presenting African Dance Companies throughout the nation.

Muntu Dance Theatre of Chicago (1972)

This Chicago-based company performs progressive works thematically, incorporating ancient African and African American dance, traditional lore, and music. The company seeks to uncover and express the motivation of movement and spiritual connection with its audiences. P. Amaniyea Payne brought a 30-year career with her as a performer, choreographer, and instructor before bringing her artistic

expertise to Muntu in 1987. As artistic director, Payne has taken the company to greater heights in its commitment to traditional African, African American, and Caribbean cultural dance.

http://www.muntu.com/

Ronald K. Brown

Ronald K. Brown founded his company, Evidence, in 1985. Community education is an important theme for the impetus of the works produced and performed by Evidence. A unique marriage of African dance vocabulary with the African American experience, Ronald K. Brown creates a palatable repertoire for all ages. The beauty of traditional African dance forms crafted with a contemporary flavor is highlighted in the performances of his company. Brown's unique combination of African dance with other dance elements is an all-encompassing work of art. He has set works on Alvin Ailey American Dance Theatre, Cleo Parker Robinson Dance, Dayton Contemporary Dance Co., Philadanco, and Muntu Dance Theatre of Chicago.

http://www.evidencedance.com

Nick Cave

Nick Cave is a contemporary performance artist, sculptor, dancer, costumier, and educator, working extensively with full-body fabric sculptures. He has created what he calls Soundsuits, which are inspired by the African cultural aesthetic. Soundsuits conceal parts of the body creating an artistic depiction of forms that have no race or gender, permitting the viewer to intellectually observe without judgement. The enigmatic soundsuits are wearable, vibrant, and whimsical, as the fabric emulates sound through natural or choreographed movement.

A former dancer, Cave trained with the critically acclaimed dance company Alvin Ailey American Dance Theatre. Nick's original Soundsuit was conceived after the beating of Rodney King. He has also created a Soundsuit in response to the Travon Martin tragedy. Cave's artwork has established itself as artistically, informationally, politically, and socially relevant. Profound as a reaction to societal tragedies, it speaks to the inconsistencies of life (Munro, 2015).

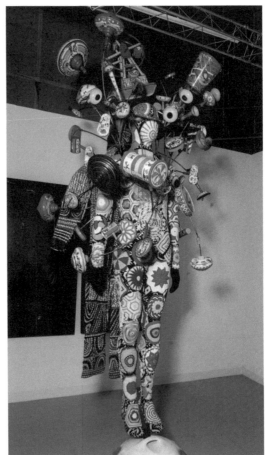

©lev radin/Shutterstock.com

Soundsuit

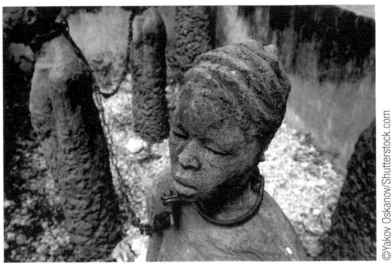

Slave Memorial

In the past, the mention of Africa evoked only images of jungles, wild animals, dust, poverty and danger. During the Transatlantic slave trade, the people of Africa were viewed as life forms devoid of heart, soul and intellect. Yet, a study of Nubian and Ancient Egyptian social and political systems prove the opposite. Africa established educational institutions, created an advanced legal system, cultivated grain, and constructed proficient irrigation methods. That knowledge would later be exploited on American soil.

Foreigners invaded Africa with an insatiable greed that blinded the consciousness of outsiders and brought chaos and turbulence to the continent. Unsuspecting Africans accommodated and openly welcomed visitors. Captors with that advantage would study the social structure of the people and use those observations for future attacks and kidnappings. Dance, music, and celebration provided outsiders access to the heart of a community assemblage. The focus of a celebratory dancing community as well as knowledge of entrances and exits allowed captors easy calculated opportunities to invade unsuspecting Africans.

Slavery would grow to be big business-it was the most massive forced migration in history. Slavers were not the only ones to assist in the collection of Africans. When ethnic rivalries in Africa led to

warfare, African leaders would sell or trade prisoners of tribal wars for cheap goods overlaid with deceptive coating. Africans at times were pitted against each other. The continent was under siege.

Slavery and slave trading were ancient phenomena that existed in all cultures for thousands of years. In West Africa, slave labor occured frequently; however, it was usually less oppressive than it became in the Americas and other global destinations (Hine, Hine, and Harrold, 2006).

On the African coast prisoners of war were sold to incoming ships or traded for cheap goods. At the beginning a small ratio of slaves left Africa. As the practice of the slave trade grew, the ships that came to the shores approached with the purpose of kidnapping Africans from their ancestral homes and in the process dehumanize, demoralize, and strip them of any sign of dignity or respect.

The rationalization of removing human beings from their families and ancestral homes required a separatist mindset that devalued the existence of the enslaved Africans. Viewing slaves as beasts legitimatized the inhumane treatment of the enslaved Africans. Animals are separated after a period of time from birth and sold. There is no consideration of the psychological effects of the transactions. The practice is commonplace. Similarly, traders looked upon their captives as beasts. A cultural disrespect and distortion of thought justified the disregard and abuse of a race of people. Because slavery was seen as an economic necessity, the thought pattern of mistreatment persisted.

The Machinery

Africans had been enslaved by Europeans before the sailing of Columbus. The slave trade had been started by the Portuguese in 1441 (Emery, 1988). Columbus' quest to reach the orient led to his discovering America accidentally in 1492. With the intention to conquer the world, Europeans immediately enslaved indigenous Native Americans as laborers in fields and mines. As a result of the combination of overwork and the outbreak of European diseases, Native Americans were limiting the European ambition of profits. Therefore, Native Americans were then considered inadequate candidates, which forced Europeans to look elsewhere for laborers. That demand for manual labor triggered the slave trade and brought tens of thousands of African slaves across the Atlantic to the Americas (Hine, Hine, and Harrold, 2006).

The Atlantic slave trade, or the Triangular Trade, lasted at least three centuries and grew to distressing proportions to meet the requirement of manual labor in Mexico, Peru's gold and silver mines, and Brazil's industrial sugar plantations. The Portuguese and merchants from other European countries began to specialize in an enterprise referred to as "Black Ivory" (Carter, 2003).

For the purpose of this study the activity of the Transatlantic Slave Trade is divided into four segments.

1. Seizure of slaves
2. Middle passage
3. Arrival at destination
4. Life on the plantation

Seizure of Slaves

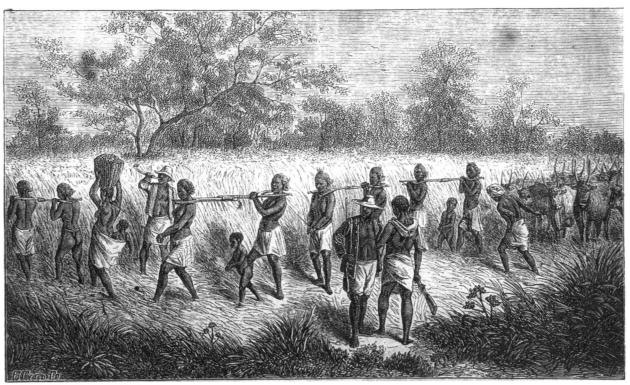

Group of Slaves

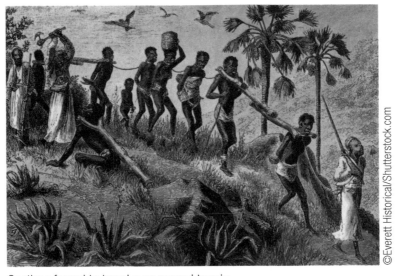

Captives forced to travel over rugged terrain

Slaves were obtained in different ways. Sellers bartered human beings for textiles, ironware, beads, and cheap goods rather than valuable commodities (Carter, 2003). Africans were trained in martial arts, as fighters, as warriors, and participated in rite of passage initiations, which required them to demonstrate their virility, fortitude, survival skills, and ability to use the spear as an instrument of defense as well as the hunt. The dedication and grueling process to establish warrior mentality was not abandoned when

confronted with the invasion of Europeans. Even with the Africans' generations of skill in hunting and combat, Europeans had the advantage of fire power, which made them a formidable force. Even so, Africans did not merely lay down and submit to their seeming fate without a fight.

The Europeans used netting for capture, whips for control, and shackles to ensure the slaves were secured. Chokers were clasped to the neck with coiled spikes to keep slaves from escaping through foliage. Raiders fastened captives with rope or affixed them with wooden yokes about their necks (Hine, Hine, and Harrold, 2006). Logs placed in between the limbs of the slaves reduced their ability to revolt as it made their physical maneuvering awkward and travel slow.

Psychological methods were used for the destruction of the family unit. The dignity of the slave was assaulted by the stripping of defense, relocation, dehumanization, lack of rations, raping of women and children, and removal of clothing. There was no consideration of the vulnerability of ages. Older men or women could be disposed of or left to fend for themselves, and toddlers or babies could also be left behind or taken.

Large number of slaves came from the perimeter of West Africa but as the demand for slaves flourished, pursuers ventured into the interior of the continent. Once captured, the journey back to the African shores where the slaves were sold to the buyers could take weeks. Africans who sustained wounds by resistance were not attended to while further skin aberrations came from the chaffing of the rusted shackles attached to feet and hands as slaves traveled through rugged terrain.

Many of the Africans captured in the interior of Africa had never seen men with light skin and believed them to be ghosts or spirits. The journey from inner Africa to the shores was an arduous one. Slaves did not know their fate. The travel with logs and shackles cleverly attached to the African captives did not guarantee a healthy slave once they arrived at the castles if they survived the trip at all. Some captives died of hunger due to poor rations and exhaustion, and some killed themselves (Hine, Hine, and Harrold, 2006).

It is estimated that 5 to 10 percent of Africans destined for the slave trade died before they were sold (Carter, 2003). Enslaved Africans still had hope while in their homeland as they traveled but capture took on an ominous course as slaves were met with the sight of large castles on the shores awaiting the arrival of slave ships. These European-built fortresses for Africans represented tortuous dungeons, holding tanks designed to break the human spirit. Some referred to these fortresses as factories, "Points of No Return," or "Doors of No Return." The castles were constructed from Senegal to Angola. The most infamous trading forts, Goree Island, loomed off the shore of Daakar, Senegal (Carter, 2003).

The castles were the headquarters of the traders where transactions were processed. Slaves were squeezed into unhealthy dungeons under the castles. Sometimes the men were separated from the women and children with no place for the slaves to relieve themselves. Families and those of same languages and ethnic groups were divided to avert any planning for resistance (Hine, Hine, and Harrold, 2006).

Once inspected physically including teeth, ears, hair, and personal areas of the body, slaves were sold to the highest bidder. At this point, if a family was fortunate enough to stay together, that union

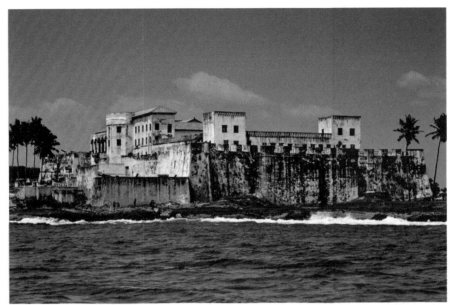

©Max Milligan/Getty Images

Slave Castle - Point of No Return

could again be tested. The slaves were branded like cattle, stripped nude in some cases, heads shaven and put into small boats to be taken to the slave ships. This was the last opportunity to escape: slaves attempted to jump overboard to drown themselves knowing that once on the ships they had no control over their destiny. Many preferred to control their fate by committing suicide. Once on board, even those opportunities would be limited.

How Dance Was Used to Seize Africans

During the times of celebration, invited foreigners would observe the structure of the African dance festivities. They viewed the intense focus on and in the circle. They saw the elation of the performers and connection to the drummers. Captors perceived this as an activity conducive to distraction. Africans were lured on to the ships and encouraged to sing, dance, and celebrate. As they were distracted, the crew would subtly raise the anchors of the ships. While participants would be deep in celebration, the ship would be drifting out to sea. At the opportune time nets would fall and Africans would then be subdued by the captors (Emery, 1988). Life with families would be a mere memory when the land of their ancestors, the motherland, disappeared as ships sailed further out to sea.

Middle Passage

The Middle Passage was the second or middle leg of the slavery process. It was the voyage across the waters to the final destination. The slaves were put on to the ships with resistance from the captives. If the enslaved could see an opportunity to escape, it was attempted. Mothers would throw children overboard willing to take control of their children's lives rather than have them eaten by cannibals as it had been rumored. Captives knew the danger of being devoured by sharks but even so they made the choice. Sharks' migratory habits shifted to follow slave ships. If captives did jump overboard and were not in shark-infested waters, they were pursued by the crew and severely disciplined openly to instill fear in the remaining slaves.

Conditions on the Ship

There were ships that held varying numbers of slave cargo. All ships were filled over capacity. Tight packers were used the most; human cargo were squeezed together in the hope that larger number of captives would make up for those who would die in the voyage.

Packers held 600 slaves aboard a ship that was only built to accommodate 400. Ship carpenters halved a vertical space to build shelves, so slaves might be packed above and below. Slaves could have 20–25 inches of head space. Captives sometimes maneuvered under higher shelving, which much later inspired the dance known as the limbo.

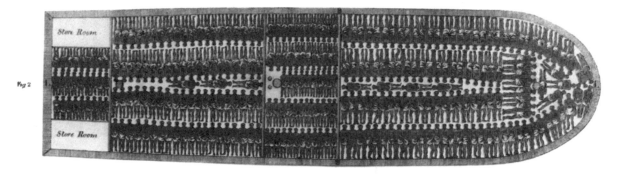

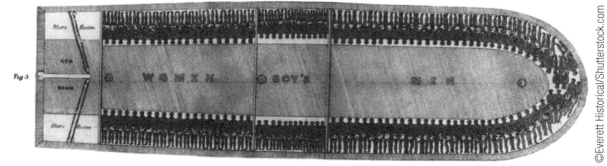

Slave Ship

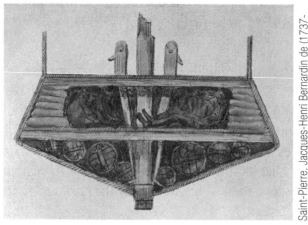

Cross-section of a slave ship

Slaves could be shackled with iron balls about the neck and crew were ordered to shoot those who attempted to escape. Captives were stripped nude and men were sometimes separated from the women who were shackled loosely for availability to the crew for their sexual pleasure. If a woman opposed the captor's advances, she was punished severely and made an example to the others. The psychological damage to an African leader, husband, father, relative, friend, or fellow captives stripped of power to be a protector was devastating. The sexual abuse extended not just to women but also to the youth. Women experiencing the indignity of such an assault forced upon their children was unbearable yet a reality nonetheless.

The bottom of the ships was a depository for the waste of the slaves including feces, urine, sweat, vomit, blood, personal body secretions on which human beings had to lie (Hine, Hine, and Harrold, 2006). The visual description was a revolting scene but did not take into account the smells accompanying the closeness of bodies in a space with limited ventilation. The darkness, chaffing of chains on human flesh, injured bodies cohabitating with rodents and insects and their secretions was unfathomable. Abolitionists, who fought against the unfair treatment of slaves, reported that the bottom of the slave ships resembled a slaughterhouse. The psychological effect the conditions had on the mind produced uncontrolled melancholy and lethargy.

Slaves occupied all spaces available in the bottom of the ships presenting a lethal health environment. Captors lost half of their cargo due to the incubation of diseases housed in unsanitary confinement. Dysentery, malaria, diarrhea, yellow fever, measles, smallpox, hookworm, and scurvy were among the many diseases contracted. Along with other diseases, ophthalmia, a form of blindness, was a frequent occurrence among slaves. On some ships ophthalmia affected everyone on board (Emery, 1988).

Slaves were fed twice a day. Those who revolted in an attempt to starve themselves were forced to eat by use of a utensil that pried the mouth open allowing captors to manually pour food into resistant captives(Emery, 1988).

Enslaved Africans would scramble to reach in a bucket of food with unsanitized hands creating a cesspool for diseases (Hine, Hine, and Harrold, 2006). Ship physicians were limited in any attempt to go below to administer medical assistance because they could not see those who were ill, the candles could not burn due to lack of oxygen. Consequently, if the crew suspected a slave had an incurable sickness they would throw them overboard and if they thought the disease had affected another both would be sacrificed.

There were recorded mutinies that took place during the Middle Passage. The most famous mutiny was aboard the La Amistad. A group of 54 African captives seized the vessel. Their destination was to return to Africa. Instead they landed on America's eastern shore. With the financial support of abolitionists and defense by John Quincy Adams, they sued for their freedom before the US Supreme Court and won (Glass, 2007).

The co-executive producer along with Steven Spielberg of the movie *Amistad* was the prolific award winning dancer, choreographer, producer, author, director Debbie Allen.

THE AFRICANS OF THE SLAVE BARK "WILDFIRE."—[FROM OUR OWN CORRESPONDENT.]

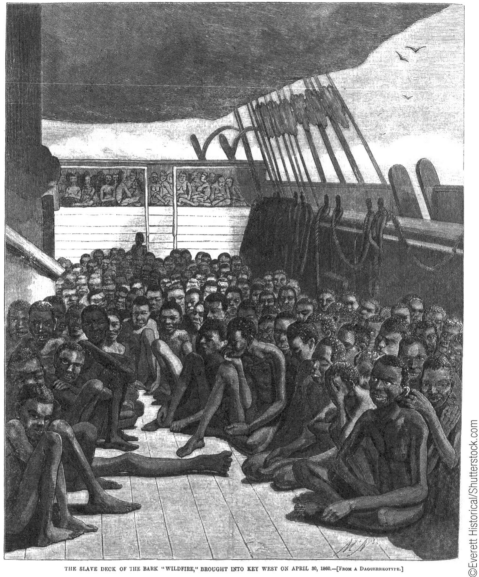

THE SLAVE DECK OF THE BARK "WILDFIRE," BROUGHT INTO KEY WEST ON APRIL 30, 1860.—[FROM A DAGUERREOTYPE.]

Slave ship deck

How Dance Was Used in the Middle Passage

It was common place for nearly 50% of captives to die during The Middle Passage voyage. (Thorpe, 1989).

Unnatural body positions wedged in cramped spaces, stress, lethargy, and disease-ridden filthy conditions took its toll on the body physically, emotionally, and psychologically. Captors recognizing African dance as an organic powerful tool of unification and celebration forced the slaves on deck in groups to dance. The free movement that was such an integral part of the lifestyle was tainted to represent involuntary exercise called "Dancing the Slaves."

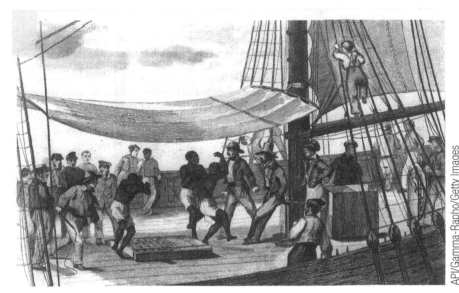

API/Gamma-Rapho/Getty Images

Dancing the Slaves

Diseases, physical and psychological, were affecting the enterprise of slavery. To alleviate delivering unhealthy distraught slaves, overseers who witnessed the effects of dance in Africa believed dance to be a healer and used it as a prescription for scurvy, suicide, and dementia. (Hazzard-Gordon, 1990).

"Dancing the Slaves" became a daily common practice usually after morning rations. Encouraged for economic reasons, exercised slaves were healthier and therefore sold for a higher price. Slaves were coerced to participate under the whip and cat-o-nine tails to the music of a sailor's fiddle. Male slaves were often forced to jump in their irons, until their ankles bled and skin peeled off the legs. Slaves were also forced to sing, which was another tradition captors observed along with the traditional African dance. The songs of the slaves on the ships were naturally somber and melancholic (Hazzard-Gordon, 1990).

Afraid that "Dancing the Slaves" presented an opportunity to mutiny, captains would in some cases position ship guns to be aimed directly at the dancing slaves to instill fear and discourage communication (Hazzard-Gordon, 1990).

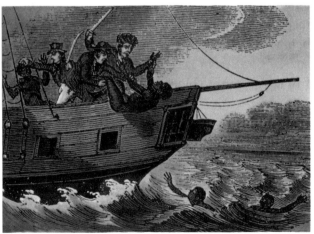

©Everett Historical/Shutterstock.com

Throwing Slaves Overboard

"Dancing the Slaves" was a regular practice on all slave ships for multiple functions other than exercise. During the forced movements on deck the crew would attempt to flush out bodily secretions, feces, blood, and vomit from the ship's floor. A head count could be taken to check for escapees. Doctors had access to captives above slave quarters and could examine their human cargo for incurable diseases.

Arrival at Destination

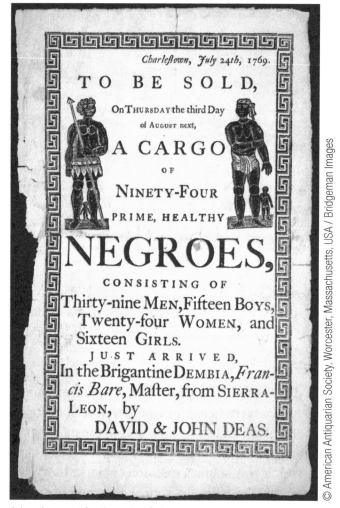

Advertisement for the sale of slaves

When the ships arrived at their destination, the process of humiliation for the slaves started all over again. The captors shaved heads, oiled bodies, accompanied with the degrading practice of the inspection of eyes, ears, teeth, private parts and backs which uncovered lash marks delivered for bad behavior. Although the frequency in which the crew used the whip cannot be estimated, none was spared scars from lashes (Emery, 1988). Ship's surgeons would plug the anuses of slaves suffering from dysentery to block the bloody discharge (Hine, Hine, and Harrold, 2006).

If a family managed to survive up to this point, they would most likely become fractured. The treatment of slaves like animals was displayed with the activity called the scramble. This process of selling slaves was sometimes referred to as "cornering the market," which originally applied to apprehending livestock for possession. In these barbaric and primitive practices, the captain established standard prices for enslaved Africans, that were then herded together in a corral. With a signal given, buyers rushed anxiously among the captives to grab and rope those slaves they desired. There was no regard for sex or age; this was a demoralizing experience (Hine, Hine, and Harrold, 2006).

How Dance Was Used During the Selling of the Slaves on the Plantations

In the slave pens or on the banjo-table, a structure for auctions, the slaves were forced to dance. The banjo music would be played while the slave moved. If a slave had the ability to both dance and play an instrument, the value of the performer would elevate, for entertainment was coveted (Emery, 1988). Though dance was presented as a negative by the Africans during the slave trade, it provided a link for the slave to the past. The benefits of being able to dance outside of being coerced was a source of psychological, emotional, and spiritual release. The next chapter focuses on the fourth segment, dance on the plantation.

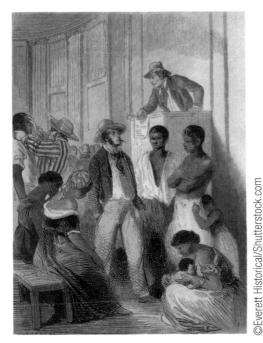

©Everett Historical/Shutterstock.com

Slave Market

Slave Advertisement

have lived in a drug store for several years. Use this as you think proper. Very truly, H. H. GEISIGER.
To Messrs. ROVE & Co. ap14

PUBLIC SALE OF NEGROES.—Under the authority of a decree of the Circuit Court of Albemarle county, pronouced in the case of Michie's administrator and others, on the 8th day of October, 1855, I will offer for sale, at public auction, on MONDAY, the 5th day of May next, being Albemarle Court day, if a suitable day, if not, on the next suitable day thereafter, at the Court House of Albemarle county, *Five Negroes*, of whom the late David Tichis died possessed, consisting of a Negro Woman, twenty years of age and child two years old, a woman fifty-five years old, a negro man twenty-five years old, who has been working at the slating business, and a negro man twenty-two years old, a blacksmith.— The above lot of negroes is equal to any that has ever been offered in this market.
TERMS OF SALE—Five months credit, negotiable notes with approved endorsers, with the interest added.
ap24—ctds GEO. DARR, Commissioner.

VALUABLE PROPERTY FOR SALE!—The subscriber, wishing to remove to a more Southern climate, offers for sale, his very desirable property It is situated in one of the

©I. Pilon/Shutterstock.com

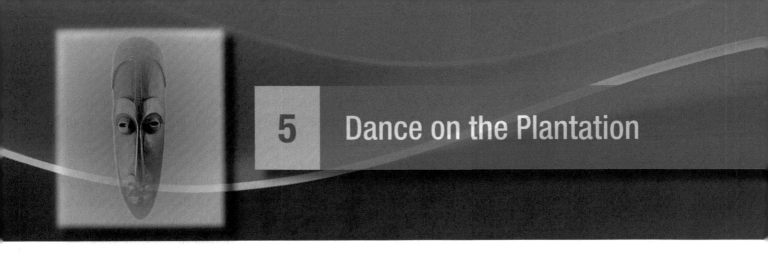

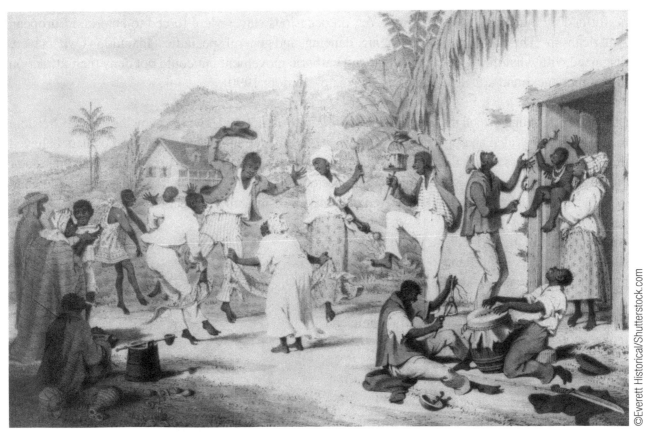

Afro-Carribbean Slaves

©Everett Historical/Shutterstock.com

Introduction

In 1916, approximately 20 African slaves were brought to Jamestown, Virginia, by the Dutch (Carter, 2003). At the beginning, the first Africans were treated the same as European American indentured servants-after the period of servitude they were released. However, the inability to retain indigenous Americans as slaves due to the plague of diseases brought to America by Europeans and the need for the cultivation of cotton, tobacco, sugar, and rice, America opted to look to Africans for forced labor. As the slave trade began to flourish, most plantations had enough slaves to form communities (Glass, 2007). Even though the European and American slavers hoped to destroy African cultural expressions among the slaves, dance of all the art forms was most difficult to erase from the memory of the African

people (DeFrantz, 2002). Slaves had the ability to transform the essence of their African culture to adapt to their new surroundings. The complex facets of dance survived the Middle passage and would survive life on the plantation.

In the new world, two cultures with two opposing approaches to movement confronted each other. A judgement was made by Europeans about the movement vocabulary of the African enslaved community. Their very erect single-unit body positions were diametrically different from the rounded earthbound multi-unit aesthetic of African Dance. The hips of the European Americans were stationary and positioned in direct alignment with the ribcage. The African free use of the hips, a multi-unit articulation of the torso, appeared sexual and undignified to Europeans Americans. It was felt the dance performed by the slaves was idolatrous. Yet, on occasions slaves were forced to entertain European Americans in "The Big House" with singing, dancing, and general specialties. Plantation owners were disgusted with what they viewed as vulgar and barbaric movement but could not deny their attraction to its uniqueness and artistic complexity (Hazzard-Gordon, 1990).

Landowners also understood the need of dance for the sake of morale. However, allowing captives freedom to dance also provided an opportunity for slaves to congregate in groups. Plantation owners believed this assemblage presented a threat because it gave an opportunity for slaves to exchange information or plot insurrections. Evidence substantiated that slave uprisings were either plotted at dances or scheduled to be carried out on occasions that involved dancing including religious gatherings and work.

Any dance format provided the potential for resistance. Africans often danced as a group, and group identity was key to the continuation of African-derived musical and dance forms, which sustained a connection to their ancestral homeland (Glass, 2007).

The slaves incorporated strips of cloth and a stick or staff into their dance, and landowners, for the most part, would allow the use of the instruments distinctive to African dance. This would include the bajar, known today as the banjo, and tambourine. Cow hide was stretched over cheese boxes to make tambourines. Both tambourine and bones became a traditional combination incorporated later in the minstrel show with the comedic bantering back and forth of Mr. Tambo and Mr. or Brother Bones (Emery, 1988). However, the most important instrument was the drum. The overseers of the plantation and the owners had no knowledge of talking drums, drum language, or the ability to communicate with the drum from one tribe to another.

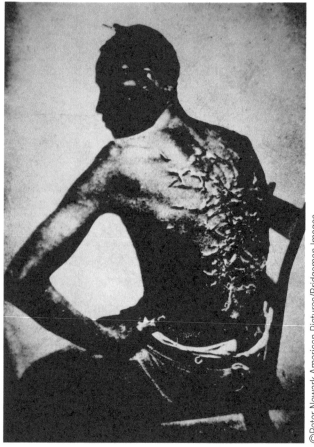

Scarred Back of a Slave

Harsh conditions bred a number of insurrections and uprisings. The "Cato Conspiracy" occurring on the plantation at Stono Bridge within 20 miles of Charleston was the most destructive. The slaves participating in this insurrection had marched from one plantation to another using the sound of drums. Once it was established that the drums were instrumental in the Conspiracy, they were banned on the plantation in the eighteenth century. The Stono Insurrection or Cato Conspiracy led to the passage of strict regulations. Prohibited was the assembly of large groups of slaves and the use of drums. The prohibition at first affected the dance but, with the same resiliency that slaves had emerged from the Middle Passage, the dance and music sustained itself and took on another form.

The rhythmic aspect of African dance was vital to the slaves-consequently, they created new methods to keep rhythmic phrasing. Cow bones were knocked together with percussive syncopation, and cooking utensils and sticks were used to keep time by striking rhythmically on large containers. Whistles were made of bark and weeds. Broomstick handles were at times used for resonate measured phrasing as well (Emery, 1988). African slaves set up portable structures or erected platforms for dancers. They used their feet to keep time and rhythmic pulsing, which was a segue to the evolution of tap. The rhythmic body sounds morphed into the patting juba and hambone.

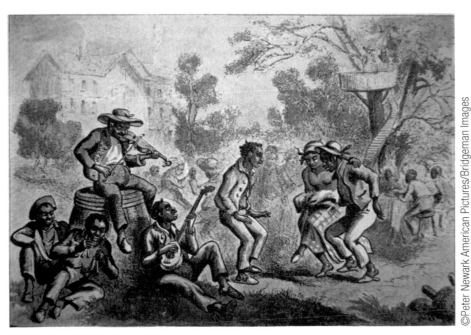

©Peter Newark American Pictures/Bridgeman Images

Celebration with Music and Dance

House versus Field

Household service by slaves on plantations enjoyed greater prestige than fieldwork. Slaves took pride in working closer to their owners. A caste system started to emerge on the plantation providing another method for plantation owners to control their investments, create division, and encourage those who would spy on others for selfish advantage. House workers, often referred to as house slaves, considered themselves the most privileged by working in the "Big House." These were the cooks, cleaners, nannies etc. They were privy to European culture and witness the dances and etiquette of their masters. Their knowledge of the inner workings of the house boosted their ego and fostered pride in a higher status than the field

workers who toiled from sun up to sundown. The manual labor required of the field hands was that of a beast of burden. They were the slaves whose plight seemed hopeless and therefore, most likely to escape or rebel. If that was their intent, the route they had to follow would be revealed during an opportunity to assemble. Dance was used as an occasion to gather under the landowner's sanction. If, however, the plot was made known to a house slave who would participate in the event, it would not be unlikely for that slave to report the attempt to the master. They, of course, would be well rewarded for the betrayal of their own.

House and Field Slaves

House slaves were at times allowed to eat the leftovers from the plantation meals, depending on the plantation owner's disposition that particular day. Slaves inside were spared the torture of enduring the weather and elements.

House slaves (depending again on the owner's disposition) sometimes were allowed to sleep in 15 minutes to half an hour later than field slaves, but they had to arise when ordered. If they did not arise when expected, they were horse whipped or severely chastised. House slaves lived a better life than those in the field; however, the life of a house slave was not comfortable.

House slaves were subject to the wrath and whims of owners, as well as passions of any member of the plantation family from youngest to the oldest. Although house slaves worked all day, they were required to remain in an upright position until the family retired. There were sexual threats and punishment when plantation owner's wives were jealous or dissatisfied with the job performed. Sometimes a family's duties were split, with some in the house and others in the field.

After a number of conspiracies, slave owners passed around a manifesto entitled *The William Lynch Letter and the Making of the Slave.* Written in 1712, it contained principles highlighting the warped mindset of viewing slaves as animals. Personally, not wanting to repeat the disrespectful demeaning words referring to the African slaves, I have substituted their derogatory reference as simply "slaves."

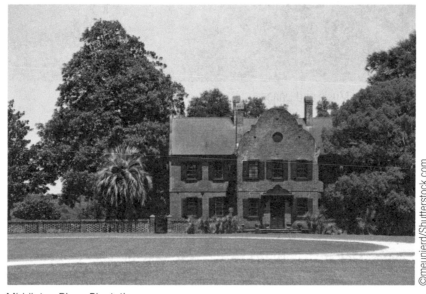

Middleton Place Plantation

Slave Quarters

Basically all principles were written with the premise that if the plantation owners were to sustain their economy, they had to break and tie the "beasts" together, the slave and the horse (Hassan-EL, 1993).

Types of Dances

Pigeon Wing

Also referred to as the Chicken Wing, the Pigeon wing appeared in large geographical arenas and was an authentic dance created by the slaves on the plantation. When men performed the pigeon wing, it was called Buck and Wing.

Jig

The jig dance was executed with quick articulation of the feet. It would not be unusual for slave owners to arrange competitions involving one slave pitted against another from a different plantation. Owners would often build a platform for the contests and slaves would also attend to view the best jig dancer. A jigger would start slow, then increase foot movements. The other would do the same and the audience would encourage them through vocalization. These contests generated much excitement as well as a form of preoccupation for the slaves (Emery, 1988).

Contest Dances

There were opportunities for dance contests. These dances lifted the spirit of the slave community and contributed to an environment of creative expression. The challenges expanded the movement vocabulary begetting new dance forms. The dances most conducive to competition were the jig, buck and wing, water dances, and the cake walk.

Buck and Wing

West Africa, where most of the slaves were kidnapped, created many dances imitating animals. The Pigeon Wing, Buck and Wing, and Buzzard Lope were examples of the tradition. Solo

dances performed by men were often referred to as the Buck. When the Pigeon Wing and Buck were executed together, it was called Buck and Wing. In both dances the performer would mimic the movements of a courting pigeon, strutting along while holding his arms bent close to his sides like wings (Thorpe, 1999). Eventually, the Buck and Wing were picked up by the minstrel shows. During the era of the hoofing style of tap, the Buck and Wing took on larger extended complicated qualities.

Breakdown

The breakdown or breakaway is a moment in a couple dance when the partners separate and add their own individual touches. There is a two-bar segment dubbed the break for solo improvisation. In set dances executed by performers in the late nineteenth century, there were sections called "breaks" for individually created steps. The word "break" in association with dance signifies original moves (Glass, 2007). This same technique would be used in breakdancing.

Buzzard Lope

The natives of Dahomey in Africa brought over the Buzzard Lope, which became popular on the plantation. It was an elaborate pantomime of the walking and pecking movements of a buzzard. Its ritual, community, earthbound posture, and use of pantomime identify its African origin (Glass, 2007).

Cake Walk

The slave owners had their bias against the posture of the Africans. The enslaved also looked at the European form of dance with puzzlement. Their way of commenting on the dance style of the plantation owners was to mimic them. With that frame of mind, the Cake Walk was conceived. Ex-slaves explained that the dance was a satirical pantomime of the pompous attitude of European Americans. The slaves took the idea of the single unit movement to the extreme by arching their backs beyond the up and down alignment. The dancers lifted their shoulders back, manuevered the head to a lifted high posture arching the upper torso into a sway-back, with high kicking feet forward (Glass, 2007). Making the movement extreme was their way of countering the disdain the plantation owners had shown toward their movement. In the rearing back position the slaves would also kick their legs higher than normal strutting height. The dance was originally called the chalk line dance. Used as a dance form in competitions, the champion of the chalk line dance would win a cake, which is why the title cake walk replaced the original name. During early slavery while executing the cake walk the slaves would put containers of water on their heads to add to the difficulty of the dance. The contestants who could perform and lose the least amount of water were the winners. Gradually, the pails of water were eliminated and the cake walk became a dance of sophistication.

In minstrelsy the dance was first presented as a comic belittling illustration of the dance of the slaves performed by European Americans in blackface. It is ironic that the performers of minstrelsy were imitating African enslaved men and women who had been mimicking the pretentious attitude of their masters (Glass, 2007). However, the dance gained popularity and survived all the way to the nineteenth century where it took America by storm. With the acceptance by European Americans the cake walk was included in the minstrel shows as well as on Broadway.

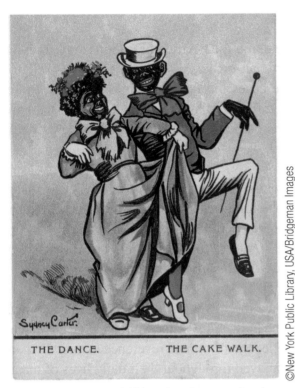

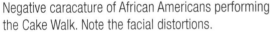

©New York Public Library, USA/Bridgeman Images

©Everett Historical/Shutterstock.com

Negative caracature of African Americans performing the Cake Walk. Note the facial distortions.

Depiction of European Americans performing the Cake Walk

Juba

Juba was similar to the jig with the execution of very fast foot movements.

Patting Juba

The Patting Juba had elements of clapping, stamping, and rhythmic patting of arms, torso, and thighs. The dance was frequently accompanied with comedic words combining rhythmic slapping movements to verse metrical composition such as Juba dis and Juba dat; Juba killed a yellar cat; Hey Juba, hey hey hey, Juba, etc. (Thorpe, 1999). Juba was performed with the hands, feet, belly, ankles, calves, thighs, elbows, wrists, and hips. It has survived today in the rhythmically body slapping movements of Hambone.

Ring Dance

One of the oldest dances executed in a circle. It was comparable to the dance of West Africa and the Congo. Moving counterclockwise, it instituted dance steps such as shuffle, stamp, and pelvic sways.

Water Dances

Water dances involved intricate movements balancing containers of water on the head. Africans transported clothing and produce by placing baskets on their heads, a custom that continued when the enslaved Africans were taken from their mother country. The addition of this tradition made contest dances more challenging. The victor was the one with the most complicated steps and maneuvered with efficiency maintaining a full container of water on the head.

Christian Influence

During the 1600s and 1700s the majority of slaves retained their African religions, and found for the most part their worship undisturbed by their christian owners. There were various religions recognized and exercised on the plantation. In some cases the faith practices appeared to be a combination of Catholic theology and African beliefs influenced by French and Spanish Catholics who introduced the slaves to saints that the Africans came to associate with their own deities (Hazzard-Gordon, 1990).

The most well known, most practiced, and reconfigured for the purpose of the enslaved, was Christianity. Slaves could relate to the plight of the Israelites and hope for a richer life in Heaven. The Bible gave a clear message that God was not only concerned about the condition of the slave but he also desired to free them from bondage as he did the Israelites. The stories of the Bible could be transposed into their experiences (Evans, 1995). Many of the songs slaves sang carried a biblical message.

The commitment involved in African religion disciplined the slaves such that they dedicated many hours to worshipping and completely surrendering to the indwelling of the Spirit of God as they had done for their ancestors. The slaves did not merely practice their love and reverence to their God only on Sundays or during a religious service, but it was displayed throughout their daily lives of manual labor. The soul reverence was a meaningful facet of their existence and the principles of God were personalized and stored within for strength.

Plantation owners ignored biblical and scriptural teachings such as "Love your neighbor as yourself" (James 2:8) cited as one of the greatest commands. This should automatically exclude any possibility for the justification of harsh oppression the slaves endured. The captives were, forbidden to learn how to read or write, affording slave owners an opportunity to distort scripture and keep the christian slaves submitted. The slaves, however, eventually retaliated by using their spiritual songs as a code to escape to freedom.

The use of dance and music executed in the African tradition during their worship was not acceptable to the plantation overseers. Plantation owners did not want to see the enslaved Africans worship with their rounded-over positions and swaying hips. Their dancing could turn into a frenzy that owners felt barbaric. The earthbound body freedom of expression seemed inappropriate to the landowners yet they saw the benefit of the worship and sense of hope that renewed the psyche. The slaves with a refreshed mind worked more efficiently.

Praise Houses

To eliminate having to see the African movement expression, the plantation owners allowed the slaves to build their own sanctuary of worship called "Praise Houses." These buildings could be old sheds or small shanties constructed by the slaves. They were places the slaves could freely express themselves without constant oversight of the master. Due to uprisings like the "Cato Conspiracy," owners did not want large numbers to congregate together. So the praise houses were required to be small. Eventually, "Secret meetings" were held in the Praise Houses and the slaves developed a system of signals to communicate between each other. For instance, one of the

slaves while working in the fields would sing "Steal away, steal away to Jesus" meaning when the sun goes down there will be a church meeting in the swamp or praise house-steal away to the service. (Evans, 1995).

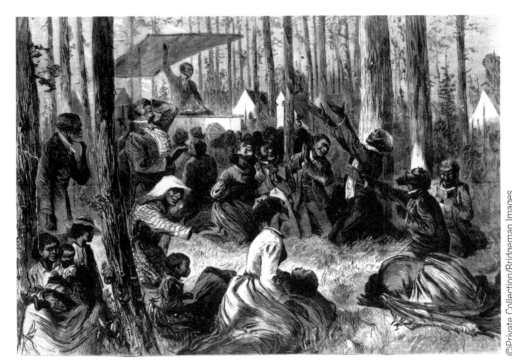

Church Meeting

The meeting of secret societies practiced in West Africa was mirrored in the praise meetings of slaves. The houses where these meetings took place eventually developed into independent churches (Kebede, 19). The Praise Houses became multipurpose sanctuaries, providing the slaves with a support system and haven of comfort. It was also the beginning of the experiential understanding of the fight for civil rights. The Praise Houses much later evolved into the African American churches. The birth of Civil Rights advocacy would initiate a platform for preaching about freedom. Many activists were church leaders with the ranking of Reverend, examples would be Rev. Martin Luther King Jr., Rev. Jesse Jackson, and Rev. Al Sharpton.

Ring Shout

The Ring Shout is the oldest African American religious dance. It is a dance moving in a counter-clockwise circle performed during religious worship. The ring formation perpetuated itself through the African diaspora and always brought communities together. The Shout and Ring Shout were sub-stitutes for African expressions common to Africa and the West Indies. There existed an opposition to the Shout because European Americans saw it as a strong preservation of the African culture, so they attempted to discourage its traditional practice.

The shout was presented in two forms. The Ring Shout was found in Georgia and South Carolina. The solo Shout was found in North Carolina and Virginia. Certain rules applied to the execution of the early shout and certain movements were taboo within the performance. First, the feet or legs must not cross.

Slaves believed the visual design of the cross was blasphemous. Second, the feet had to remain on the floor. (Emery, 1988). Despite restrictions a shuffle kind of movement was fashioned for the shout. Performers usually clapped with a cupped hand versus an open palm.

A general format existed for the execution of the Ring Shout. First the "songster" or lead singer began the musical phrasing. Beating a broom stick on the floor in rhythm alongside the songster was the "sticker" or stick man. Behind were a group of other singers called "basers" who answered the songster in call-and-response fashion accompanied with clapping hands and patting feet (Rosenbaum, 1988).

As participants moved in a counterclockwise direction around the circle they sang their own improvised hymns and shouts. They pantomimed the actions descriptive of the song's lyrics which told stories of centuries of oppression, struggle, and devotion to God. The dance form combined cultural and artistic religious material. Shout songs or "runnin" spirituals as they were sometimes referred to usually began slowly and accelerated up-tempo in tandem with rhythmically mirrored movements (Rosenbaum, 1988). Viewed by the more educated ministers and members as a questionable form of praise expression, a ban was sometimes placed on the shout as worship.

The Ring Shout clearly included circle formation, polyrhythms, pantomime, improvisation, and centrality of community participation. Orientation to the earth was important, for the shouters bent slightly forward as they moved around the circle counterclockwise. Syncopation, a dominant element, was part of the rhythm of the shout.

The present-day worship has limited itself to solo shouts seen often in charismatic, evangelical, and southern Baptist churches and still practiced in some areas of the south. To keep the tradition alive, there are companies of performers such as the Mcintosh County Shouters, traveling throughout the country educating America on the beauty of the Ring Shout.

McIntosh County Shouters

Holding the integrity of the early form, the ring shout has survived unbroken tradition and practice from slavery in the Bolden community in McIntosh County to the coast of Georgia. Remarkably, this small community along with the Mount Calvary Baptist Church have continued the shout annually to welcome the New Year. Founded in 1980, the company travels throughout America with the mission to honor God and evoke memories of departed ancestors a tradition linked to African roots. The McIntosh County Shouters performed in highly acclaimed national dance venues such as the National Folk Festival at Wolf Trap and Georgia Folklife Festival in Atlanta (Rosenbaum, 1988).

Opportunities to Dance

Saturday Night Frolics

Most slaves worked 5½ or six days a week leaving only Saturday night for enjoyment. They looked forward to Saturday night especially if amiable owners allowed slaves to visit local plantations. Slaves

would then have the opportunity to establish personal relationships. Owners recognized the visits helped to maintain morale.

Corn Shucking

Corn shucking was a plantation institution always accompanied with the dance. Any difference in the dull routine of the slave life was welcomed. This event could involve the assistance of other plantations. Corn shucking required many hours of labor along with the normal day's work routine. It drew the plantation slaves together communally and involved house slaves, field slaves, and all the children.

Shucking began with a trek to the hosting plantation. Upon arrival, the hosting master personally greeted the huskers. The labor of shucking was performed quickly. Huskers constructed handmade hardwood pins that hooked over a finger and inside of the palm ripping open the shucks. The job was executed with precision resulting in one pile of corn and shucks in another (Glass, 2007).

There were two captains in the corn shucking ritual. They had two functions. First to keep the pace, cadence, or rhythm by singing. Second was to make sure the piles gathered were evenly divided (Emery, 1988). Corn was sectioned in half by huskers, then captains selected workers. Workers could number as many as 100. The mountain of corn could pile up to a height of 30 feet. The captains invoked rapid work through songs in the call-and-response form (Hazzard-Gordon, 1990).

Corn shucking developed into an efficient production and initiated excitement, competition, singing, feasting, and dancing. It was an important part of the harvest in the South. The hosting master of the plantation provided a generous supper for the workers, and the evening ended with dance lasting far into the night (Glass, 2007).

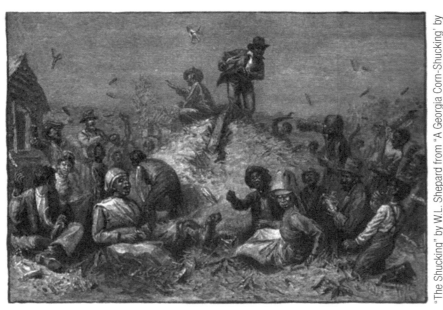

"The Shucking" by W.L. Shepard from "A Georgia Corn-Shucking" by David C. Barrow, *Century Magazine*, vol. 24, 1882

Corn Shucking

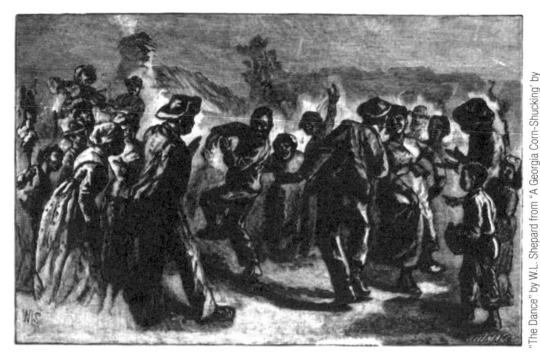

Corn Shucking Celebration Dance

"The Dance" by W.L. Shepard from "A Georgia Corn-Shucking" by David C. Barrow, *Century Magazine*, vol. 24, 1882

Weddings

Slave owners were not willing to invest time and effort to obtain legal documents for slaves seeking matrimony. The slaves would simply request permission from their owners to first wed and then participate in the ceremony of "Jumping the Broom." Jumping the Broom was a ritual that originated from West African tradition, holding great significance. The act of jumping the broom symbolized a new life for the newlyweds. The broom represented sweeping the past relationships including parental influences out of the life of the new couple. It was placed on the floor or lifted. The couple held hands and jumped over the broom into a new life together. As per the tradition, it was considered a bad omen for the future of the newlyweds if either touched the stick in the process.

Funerals

The slave owner did not want the slaves to miss work to attend a burial. Families had to bury their loved ones during the night. A procession of the community would carry torches to the grave site where, in some instances, viewers would move in a ring formation about the area. Attendees would take a lump of dirt and place at their door as proof of their participation. A feast was held after the ceremony.

Christian Holidays

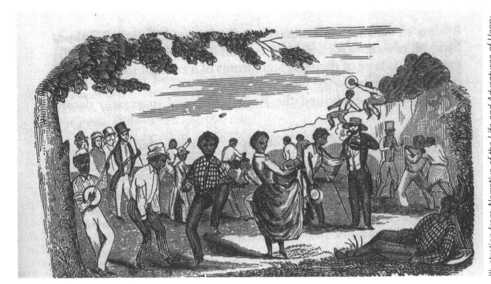

Illustration from *Narrative of the Life and Adventures of Henry Bibb*, by Henry Bibb, published in 1849

Occasion of Dance

Easter and Christmas were occasions on which slaves were encouraged to dance. On these holidays, the dancing was for plantation owners entertainment. Slaves would dress in their "Sunday Best" possibly wearing clothing bought for them by generous masters. The landowners often placed their slaves in wagered competitions with other plantations. Christmas festivities commonly included dancing, drinking, and extra food (Hazzard-Gordon, 1990).

Cotillions and Reels

European forms based on geometric configurations of dancers were experienced at corn shuckings and other festivities on plantations. African fiddlers commonly called out directions for dancers who could not read and did not have lessons (Glass, 2007).

Minuets, cotillions, and quadrilles were single-unit dances in rectilinear patterns with approximately six to eight couples. Seventeenth- and eighteenth-century European American dances were based on this essential unit. Men and women faced each other in lines, then paired, unpaired, and stepped to and out of the others' space. These dances and patterns were taught by dance masters—professional instructors who tutored proper technique for maneuvering from one dance form to another. Dance education for the rich separated the status level in society.

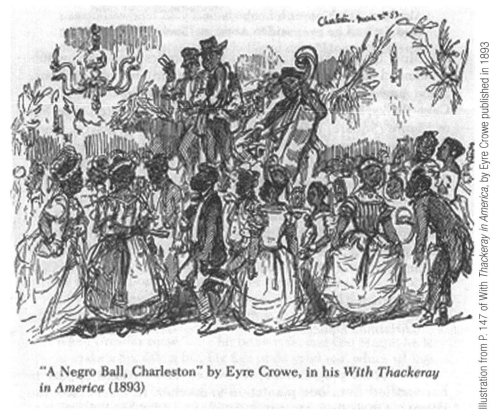

"A Negro Ball, Charleston" by Eyre Crowe, in his *With Thackeray in America* (1893)

Illustration from P. 147 of With *Thackeray in America*, by Eyre Crowe published in 1893

A Negro Ball Depiction

Quadroon Slave Balls

In the 1830s at Orleans Ballroom, the Quadroon ball was held specifically for wealthy European American males to meet African or mixed-blood women and acquire them as mistresses (Hazzard-Gordon, 1990). It was commonplace for Caucasian men in New Orleans to take African mistresses. The offspring, known as "mulattos," rarely became slaves (Thorpe, 1999).

A quadroon was one-quarter African, the offspring of a mulatto mother and Caucasian father. A quadroon woman was introduced to a European American man at the Quadroon Ball. Originally these balls were organized by quadroon women as a venue for themselves and their daughters to meet European American suitors. The admission price charged was high, and only upper-class European American men were allowed to attend. Quadroon women preferred engaging in an extramarital affair with a European American male to marrying a mulatto. These occasions were advertised locally (Thorpe, 1999).

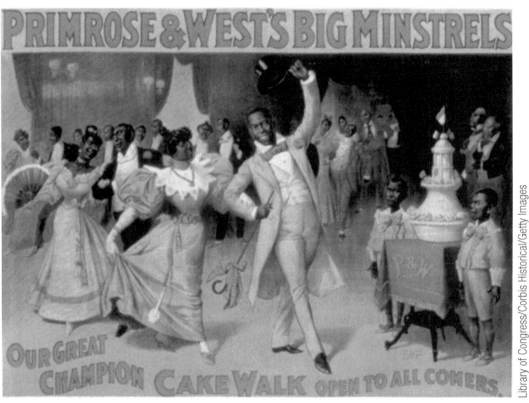

Cake Walk

Library of Congress/Corbis Historical/Getty Images

Introduction

Minstrel shows from 1840–1900 became America's most popular form of entertainment and a reflection of its racism. These shows were performed originally by European Americans in blackface. African Americans were not allowed to be seen in the minstrels until later. When they were accepted, they were required to appear in blackface. Minstrelsy was a contradiction. Burnt cork mixed with an oil-based solution covered the face avoiding eyes and lips. The lips and eyes were painted with white makeup. The eyes were painted to look larger and the lips went far outside of the natural lip line. The appearance was primal and was a demeaning stereotypical statement exaggerating the European American's view of the facial appearance of the African slave. In some instances the lips were painted red but in all instances it was an attack on the African race. The images, especially when drawn on sheet music and posters, were frequently grotesque.

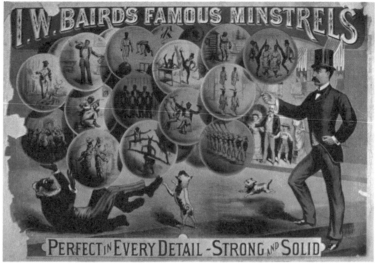

Notice African American shown as an animal on his back juggling the acts with hands and foot.

European American audiences who were consistently entertained by African American culture had contempt for and fear of African slaves. Instead, the public opted to view Caucasian actors' impersonations in blackface. European American performers were guilty of cultural theft and inauthenticity. Through the beginning years of the minstrel shows and black vaudeville, African Americans watched their dances being stolen by European American minstrel dancers who wanted to present convincing slave dances and codify the changing improvisatory dancing of enslaved Africans (Glass, 2007). European Americans condemned African-derived dance and yet preserved it to assure themselves the opportunity to watch it. To the public, minstrel shows made African slaves less fearsome and slavery less horrific. Falsely depicted, the plantation became a place of relaxation where enslaved African people were treated fairly and had off days to socialize with dance and song.

The minstrel show was created during a time when slavery was under attack. The anger toward the abolitionist movement was taken out on slaves. Yet blackface entertainment became popular when slavery sparked heated controversy (Glass, 2007). The general public appeared to be curious about the slave culture and wanted to see the reasoning for the controversy. Beginning in the 1840s, minstrel performances toured the nation and minstrels were invited to the White House to entertain President Tyler (Thorpe, 1989). African Americans were accepted into some minstrels and successful troupes were formed after emancipation in the 1850s. African American minstrels were owned and managed by European Americans, a necessary arrangement to play in European American venues (Glass, 2007).

As African Americans gained control over African American minstrels, there was a transformation in the minstrel format into a vehicle for African American cultural arts. European American minstrels used advertisements with "Negro Minstrels" and "Ethiopian Minstrels." African American minstrels were often labeled as "colored," such as "Howards Novelty Colored Minstrels" (Glass, 2007). Many African American minstrel shows advertised stories used from past experiences on the plantation

to guarantee their authenticity as true slaves in order to compete with European Americans whose imitation of slave culture was looked at as unrealistic, especially in Europe. Europe was curious about the plantation experience and desired the truth. The African slaves' pride in their identity and existence was finally recognized and became a positive feature when touring in European countries where African American slaves had never been seen on stage. Europeans wanted to see the untainted plantation experience (Glass, 2007). Early African American minstrels were shown with males as the performers but by late nineteenth century traveling shows opened up for women and children. The children were sometimes called "picks," short for pickaninnies, which morphed into a derogatory name for African American children.

Women transformed minstrelsy and also became Masters of Ceremony. They made the biggest impact performing the Cake Walk. Music offered by black minstrel shows was innovative and appealing, introducing ragtime and jazz. The dance and music brought pure black cultural arts to the audiences. African music was an influence on the minstrels.

There were a number of early banjo tunes, called jigs, used in minstrel shows, introducing a musical transformation known as syncopation. Syncopation is the practice of accenting a rhythmic beat that traditional European music would not normally stress. This method of accenting off beats was derived from the West African tradition.

Despite offensive images, African American dancers and other performers broke into show business through minstrelsy. Beginning in 1843, the shows lasted over 100 years. Minstrelsy was reconstructed by African Americans into the most popular form of entertainment for 50 years (Thorpe, 1989).

BlackFace

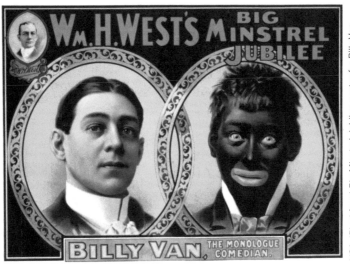

USA: 'Blackface' Big Minstrel Jubilee poster for Billy Van, New York, 1900 / Pictures from History / Bridgeman Images

Blackface Minstrel poster of Billy Van in 1900

Before the 1800s, many shows were presented with performers in blackface; however, it was a European American named Tea who projected dance as his focus. In 1828, blackface took on a higher status with shows under the direction of Thomas Dartmouth Rice. Considered the Father of Blackface minstrelsy, his caricature of the dance depicted African descendants as grotesque, docile, and awkward. The practice of blackface used as a staple in theatres persisted in rural areas until the 1930s. The minstrel shows falsely presented the demeanor of African Americans as comical. The performers portrayed plantation workers with rolling eyes accented in a large stare with the body slouched over, feet dragging, and lip enlarged, contributing to the creation of grotesque imagery (Thorpe, 1989).

The stereotypical caricature of the facial features and body movements for two decades became fixed in the mind of the populace and it continues to exist.

Thomas Rice

The story of Thomas Dartmouth Rice, a European American actor, talks about discovering the dance of a crippled African American livery stable worker named Jim Crow. This story has been conveyed with different interpretations due to the lack of a detailed account of the encounter. However, Thomas Rice was clearly privy to Jim Crow's dancing and singing, as he had been entertained by Crow. Rice, sometimes referred to as "Daddy Rice," decided to start traveling shows with his rendition of Jim Crow's dancing, attire, and singing. He played the character of Crow in his shows and literally stole everything about him, even his name. There is no research supporting or alluding to Crow receiving compensation for being Rice's inspiration. Thomas Rice executed the movements of Jim Crow with the body bent at his torso, waving his hands or one finger while limping, and jigging with a syncopated hop or jump. The minstrel shows performed by Thomas Rice were actually called *Jim Crow Jubilees*. As the shows grew in popularity, Rice made a fortune (Thorpe, 1989).

MR T. RICE
as
THE ORIGINAL JIM CROW

Thomas Rice as Jim Crow

Sheet Music Cover for 'The Original Jim Crow', written by Thomas Dartmouth 'Daddy' Rice (lithograph), American School, (19th century) / American Antiquarian Society, Worcester, Massachusetts, USA / Bridgeman Images

Jim Crow's name later was used to refer to African Americans who went along with the Caucasian stereotype of the negative characterization and ridicule of African Americans. Jim Crow laws, in US history, were statutes enacted by southern states and municipalities, beginning in the 1880s, that legalized segregation between African descendants and European Americans (Thorpe, 1989).

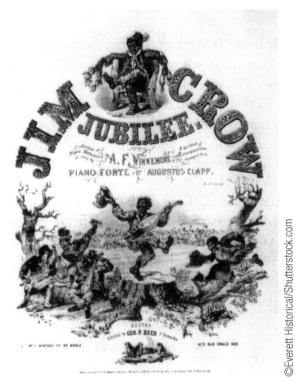

Sheet music cover

Minstrel Show Format

There was protocol regarding the minstrel shows with a distinct format consisting of three sections. (Emery, 1988).

1. **Overture**. All performers entered the stage in a circle.

 For the purposes of stage presentation, the circle was cut into a semicircle, facing the audience. Master of Ceremony was at the top-center of the semicircle with those providing accompaniment, Mr. Tambo and Brother Bones, both seated at each end.

 Questions and answers were bantered between the Master of Ceremony and the two comic end men, Mr. Tambo (tambourine) and Brother Bones or Mr. Bones (bones).

 The tambourine and bones were used for percussion accompaniment after the drums were banned.

 The overture may have included sentimental songs, and ended with a final circle called a walk around (developed from the Afro-Caribbean Ring Dance and the Juba). For approximately 15 bars, the whole company participated in a shuffle, circle formation, moving in a counter-clockwise direction; a performer jumps into the center and executes a Juba dance known as the breakdown. Soloists were showcased downstage, after which the entire group would dance patting with the feet or hands (Thorpe, 1989).

2. **Olio**. Variety of singing, dancing, and speaking acts were performed.

3. **Afterpiece**. Extravaganza performed by the entire cast in a drama that falsely depicted the plantation scene as a happy, jovial habitation.

Master Juba and John Diamond

Until after the Civil War (1861–1865), African American dancers were frequently banned from performing in minstrel shows. Master Juba, whose slave name was William Henry Lane, was the first free slave to join the minstrel shows. His specialties were executed in his unique style. No one could copy it. His manipulation of African rhythms and loose body style, intertwined with jig and clog dancing created a special style of new dance. Adopting the name, Master Juba, was suggested from the African slave dance on the plantation. Later, the Master competed in a series of challenges with the reigning Irish American jig dancer, John Diamond (Hill, 2010).

In 1840, after earning the name of honor, "King of all Dancers", Master Juba grew in global popularity to be one of the foremost entertainers of minstrelsy. His fresh, rhythmic blend became one of the earliest forms of modern American tap dance. His specialty dance led him to Europe where he performed for Queen Victoria. He was also an exceptional singer. Sadly, Juba died in London in 1852 at the age of 27.

Juba was born a free man from Providence, Rhode Island. Taught by a jig-and-reel dancer, "Uncle" Jim Lowe, he performed in dives, dance halls, and saloons in Manhattan's Five Points District. Mainly occupied by freed slaves and poor Irish workers, Five Points was a haven for brothels and rooming houses. Consequently, the Irish jig and juba dancing became intermixed into a hybrid juba, which was Lane's specialty. Master Juba joined the Ethiopian Minstrels and given top billing in the company of four European American minstrels in the show. Juba was the only African American artist of the time to achieve such notability. By the mid-1840s, he was receiving top billing with the minstrel group called *Pell's Ethiopian Serenaders*. Charles Dickens saw Juba perform at Five Points during his visit to America and under the pseudonym "Boz", wrote about him in his *American Notes* (Hill, 2010).

Juba at Vauxhall Gardens, London, from *Illustrated London News* (August 5, 1848)

Illustration Juba at Vauxhall Gardens, London from *Illustrated London News*, August 5, 1848.

Master Juba

Josephine Baker

Born in St. Louis, Missouri Josephine Baker rose through poverty and harsh treatment. Baker became enamored with dancing at a local theatre show. She auditioned and became part of the show's chorus, referred to as "ponies" in those days (Thorpe, 1989). However, she was fired after a few shows because she wanted to be seen separately from the rest of the chorus. She made faces, crossed

her eyes, and enacted other antics to draw attention to herself. Baker would replace choreography with her cheeky improvisation. Her mixture of dance, song, inventive attire, and daring choices was a part of her appeal.

Baker worked with Bessie Smith, performing in *Chocolate Dandies*. She earned a salary of $125 for Chocolate Dandies, which was an astronomical amount for a chorus girl. Unfortunately, she was only 15, and fired when her real age was discovered. At 16, Baker auditioned for Siskle and Eubie Blake's all African American full-length show *Shuffle Along*. A prestigious musical with African American cast, such as Florence Mills and Paul Robeson. The show received popular acclaim. In 2016, *Shuffle Along* was revamped for Broadway under the choreographic genius of Savion Glover (Hill, 2010).

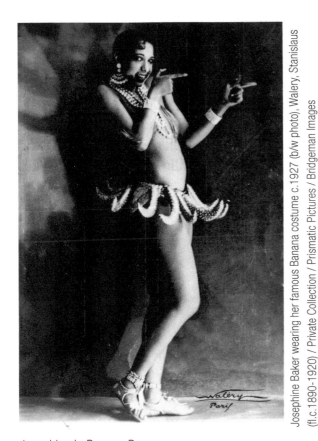

Josephine Baker wearing her famous Banana costume c.1927 (b/w photo), Walery, Stanislaus (fl.c.1890-1920) / Private Collection / Prismatic Pictures / Bridgeman Images

Josephine in Banana Dance

In 1916 Baker witnessed the destruction of her hometown by a Caucasian lynch mob, which ignited her passion in the fight for civil rights. With her frustration over racism in America building up, Josephine, under the encouragement of her manager, went to France. Her work afforded her a salary that only top Caucasian stars would receive in America (Thorpe, 1989). Baker performed in Paris with La Revue Negre in 1925 and in 1927, headlined at the Folies Berger. In Paris she opened her own restaurant, *Chez Josephine*. Her successful film, *Princess Tam Tam* revealed Josephine as a dancing-singing showgirl performing topless with only a banana skirt and necklace (Driver, 2000).

It was her famous *Banana Dance* that inspired performers. Audiences loved Josephine's eccentric dancing and high-pitched jazz singing. She wore provocative and classy attire with an inventive approach to theatre. Baker also introduced *The Charleston* and *Black Bottom* to European audiences. Her style was exotic and unique. In France, Baker was treated like a goddess. She wore theatrical costumes constructed by the world's greatest designers, drove a Delage with snakeskin upholstery, and appeared in public with her leopard, Chiquita. Romantically a member of European aristocracy, Josephine lived a lavish lifestyle. It has been said that she has received over 1,000 marriage proposals (Thorpe, 1989).

She had become recognized globally but when she returned to the states to perform on Christmas Eve 1935, she was snubbed. She had to use the kitchen elevator and could not use the public pool. Critics were harsh in their critique of her performance and some didn't mention her at all (Thorpe, 1989). She was called a communist by a popular newspaper columnist and radio gossip commentator of the time,

Chateau des milandes

Walter Winchell. The conflict between the two resulted in Baker losing her work visa in the states, forcing her to return to France (Thorpe, 1989). Not able to have children of her own, Baker adopted 12 children of different nationalities to make an experiential statement that all races could coexist and that racism is learned. She called them her "Rainbow Tribe." Baker would allow the public to visit her chateau to witness the children interacting with each other.

Josephine Baker

During World War II, Baker entertained troops in North Africa and Europe after the Allied Invasion. Baker loved France to the extent that she became a spy for the French Resistance and carried coded messages through her sheet music (Thorpe, 1989).

In 1950, Baker was invited to the Copa City Club in Havana, a city where segregation was strictly enforced. She accepted the invitation under the stipulation that the venue would allow all ethnicities to attend. Her performance was a success, but her Civil Rights stand was the greatest triumph (Thorpe, 1989). In 1963, Baker walked alongside Martin Luther King Jr. in the March on Washington. To honor her work in the Civil Rights Movement, the NAACP named May 20th "Josephine Baker Day." Thousands turned out to honor her (Thorpe, 1989).

Unfortunately, as time went on her popularity began to wane and her finances suffered. In 1968, Josephine was faced with bankruptcy and evicted from her chateau. She was relocated with the support of Princess Grace of Monaco, who found a permanent home for her and her children. (Thorpe, 1989).

Baker was invited back to America in 1973 to perform at Carnegie Hall in New York and was greeted with a standing ovation. She celebrated 50 years in show business. In April 1975, Josephine Baker performed at the Bobino Theater in Paris. Numerous celebrities including, Princess Grace of Monaco came to the show. Days later, on April 12, 1975, Baker died in her sleep of a cerebral hemorrhage. She was 69. More than 20,000 people lined the streets of Paris to pay homage to her and the French government gave a 21-gun salute, making Baker the first American woman in history to be buried with military honors. (Lane, 2015).

Florence Mills

Florence Mills and Josephine Baker brought the concept of social dance to Europe. Josephine introduced *The Charleston* and Florence the *Baltimore Buzz*. At the age of 5, child prodigy, Florence Mills won several cakewalk contests. She joined with her sisters and formed the Mills Trio. In 1921, she had her biggest break when asked to do a role in *Shuffle Along* with Josephine Baker, and countless other big names in African American entertainment. It was there that she introduced the *Baltimore Buzz*. More of a dance step, *The Buzz* became widely popular, drawing attention to the musical. A year later the producer of *Shuffle Along* launched *Plantation Review*, a folly-style musical that featured Mills singing and dancing. She became a featured player in Lew Leslie's *Blackbirds,* which was a great success in Europe. Throughout the show's run, she was called "The Little Blackbird" (Emery, 1988). Unfortunately, Mills succumbed to a tuberculosis-related ailment and died at the young age of 31 (Lane, 2015).

Bert Williams and George Walker

African Americans would often accrue jobs with medicine shows during the nineteenth and twentieth century. The dancer's responsibility was to gather the crowd and entertain them while the doctor prepared to deliver his spiel. This was an economic outlet for Eubie Blake, Bert Williams, and George Walker in the 1900s (Glass, 2007).

In 1903, In *Dahomey* (lyrics by the renowned African American poet Paul Lawrence Dunbar) was a well-received African American musical starring the comedy team of Bert Williams and George Walker. It was a success and ran for 53 performances. Williams and Walker always looked for the opportunity

to have their own musical (Lane, 2015). *In Dahomey* wrapped up the show with a finale competition of the Cake Walk, in which audience members chose the winner with applause. The success of the show presented an opportunity for a London run of seven months (Long, 1989). The popularity of the show also proved that an all African American show could be lucrative. It was the first African American musical (whose writers and production staff were all African American) to have its musical score published in the UK. After Walker died, Williams continued to perform, wearing blackface most of his career on Broadway (Glass, 2007).

Aida Overton Walker

Aida Walker, George Walker's wife, danced with the two (Walker and Williams) *In Dahomey*. Aida retired from show business to take care of her ailing husband. In 1912, shortly after Walker's death, she appeared on the same bill as Harry Houdini and Mae West. Aida highlighted her dancing onstage and performed the well-known dance role of Salome in the *Dance of Seven Veils*. She was considered the best African American female dancer of her time, with clean refined movement. She was acknowledged as the first black female choreographer whose unique work was aimed at breaking away from the tradition of minstrel shows. Aida transformed the view of dance into a more positive perspective of African American dance culture (Lane, 2015). She was determined to show the world that the black female artist was as dignified and talented as any other culture.

Dancing Shoes (oil on canvas), Cudworth, Nick (b.1947) / Private Collection / Bridgeman Images

Tap Shoes

Introduction

Tap is the only form of concert dance outside of ethnological dancing that includs the audible as well as the visual. Depending on the function of the movement, tap dance can be divided into two styles: the hoofing style and the theatrical or Broadway style. The hoofing style, which will be the focus of this chapter, has its roots in the movement of the African diaspora. Started and cultivated under the African American aesthetic with many of the general characteristics of African dance, the hoofing style has weathered the sands of time and is thriving to date. Rhythm tap is a term closely associated

with this style of dance. It differentiates between the organic expressive style of tap, accentuated into the ground, with strong percussive emphasis.

The Broadway style is influenced by the European American approach to movement and contains the essence of the major dance forms of ballet, modern, and jazz. The body is generally lifted and lighter on the feet with specifically designed arms. When the grounded hoofing style began to be recognized as a legitimate and valuable form, it was utilized more on Broadway, due in part to the thematic material of the Golden Age of the Musicals (1930s to late 1950s) in Harlem.

Tap in General

The combined elements of African and European dance styles produced the overall essence of the dance form known as Tap Dance. Early European colonists included Irish settlers and Irish indentured servants. The Irish, more than any other ethnic group, mixed with African slaves doing heavy labor. As slaves were given their freedom, the two lived alongside each other in slums so the natural exchange between the Irish step dances, like the jig and African Juba dances were inevitable. Tap, therefore, is the product of African rhythmic movement qualities, Irish jig step dance, and Lancashire English clog.

African Rhythmic Aesthetic

The essence of the dance brought to America through slavery with its rhythmic reference, multi-unit torso articulation, and use or nonuse of the drums produced different hybrids of movement. Having the drums banned on the plantation created a need to find substitutions to sustain the rhythmic necessity for grounded syncopated polyrhythmic beats. The natural use of the body was the first organic alternative, the feet. Slaves, borrowing from their African heritage, created dances with fast foot movements called "Negro Jigs" by the plantation owners. The jig and juba were the forerunners of the hoofing

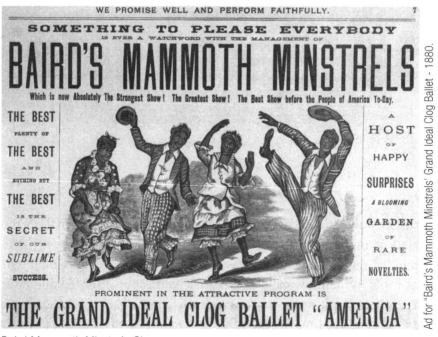

Baird Mammoth Minstrels Clog

style of tap. African movement qualities such as bent-over earthbound maneuvers, use of improvisation, challenges within the circle, singing while dancing, and freedom to articulate the whole body rhythmically characterizes the African rhythmic aesthetic.

Irish Jig

In 1849, during the Potato Famine, Ireland experienced the most extreme hunger it had ever known. It was the catalyst of a mass exodus that significantly reduced Ireland's population. Irish immigrants arrived in Boston and New York seeking work. They arrived ill, with various diseases including cholera. Families were forced to live in slums. The Irish men built canals and railroads, often working along with African American laborers. The women took on domestic jobs (Hill, 2010). Even though the Irish and African Americans found living amongst each other complicated they socialized, and some intermarried, thus creating the title "Black Irish." There were Black Irish ghettos such as the Five Points in lower Manhattan and Bucktown in Cincinnati. The two races developed a common culture, co-creating and exchanging dance steps.

©Sinelev/Shutterstock.com

Hard Shoes for Irish Dance

English Clog

Jig and the clog dance was articulated with quick foot movements from the knees down. The buck dance of African Americans encompassed the whole body with special freedom in the torso, arms, and pelvis (Hill, 2010). One of the greatest contributions of the clog dance to tap was the tap shoe. Wood on the soles of the shoes created a distinct sound. Eventually, coins and then metal was added at the bottom of shoes yielding the tap shoe as we know it today. Work clogs were used by workers in factories to protect the feet from being injured by the effects of the steam expelled from machinery.

© Art Wittingen/Shutterstock.com

Clog Shoes Attached to Post

The top part of the shoe protected the foot and the back allowed for ventilation. Workers would use the clogs for dancing recreationally during breaks. Eventually, the clog shoe for dancing evolved into the leather shoe with coins on the bottom and then metal.

Clogs were made from ash wood and were lighter than those worn to work. Some performers would even nail metal to the soles so that when the shoes were struck, sparks would emit from the bottom.

Women's Tap Shoes

©Rus S/Shutterstock.com

Men's Tap Shoes

©Pablo Serrano Huguet/Shutterstock.com

Hoofing

The hoofing style of tap evolved in the African American community as an outgrowth of the African Juba and Jig dancing. In the 1700s (when the drums were banned from the plantation due to their roles in conspiracies and uprisings) African Americans had to create new ways of maintaining their polyrhythmic DNA. They reverted to using other forms of accompaniment such as cow bones, cooking utensils, sticks, and the body. Use of the feet was a naturally organic mode of movement release that involved body articulation, rhythmic pleasure, and sound. By 1800 "jigging" became the general term for this new African American percussive hybrid of the Jig and Juba. Frequent competitions of jigging (The buck and wing), *Shuffling Ring Dances*, and *Breakdowns* grew in popularity on the plantation (Hill, 2010). Tap is a blend of the Irish jig, English clog, and African rhythms, a product of a new world's adoption of Old World styles. Irish jig and Lancashire clog-dance was mixed with the Juba and Ring Dances, which the slaves brought to America. The jig became an all-encompassing word, usually describing African American dance steps. Clog dancing was performed on the balls of the feet in wooden soles (Driver, 2000).

The focus of this study is on the hoofing style of dance developed on the streets in African American communities. The low economic conditions in which African Americans resided did not allow for professional training in concert dance forms. Movements executed came from the experiential education of dance in the neighborhoods. Just as African Americans developed their voices through practice on street corners and learned from each other, the hoofing style followed suit. It had the posture of

African cultural dance with earthbound, bent over at the waist and focused movement, accented into the ground. Hoofing style in the African American community was a language. Hoofers would tie their shoe by the strings and throw them over their shoulders. When they greeted each other, they put on their shoes and continued to communicate through rhythmic phrasing executed on the street pavement. Most men in the community would challenge each other and learn new movements and rhythms. Hoofing became a male dominated dance form due in part, to its competitive nature.

Hoofers Club

The hoofing style came off the streets. Its vocabulary expanded through competition and stealing of steps. The participation in challenges was an unavoidable exercise. The challenges were from African tradition where one dancer confronted another through the dexterity of rhythm and footwork. It was a necessity in the hoofing style, but considered a friendly form of competition. One hoofer feeds on another and adds additional steps to complicate the original rhythmic timing or phrase. The center of this continual exchange was a backroom at *The Comedy Club* in Harlem,

Hoofing

Cuba: Natty street dressers tap dancing in the Plaza de la Catedral, Old Havana / Pictures from History/David Henley / Bridgeman Images

New York. Throughout the tap dancing world, this room housed "The Hoofers Club" (Driver, 2000). The club was male dominated and originally did not allow women on the premises. The club's owner, Lonnie Hicks, loved dancing and donated his space for the development of steps (Driver, 2000). The room located just past the stage door of the Lafayette Theatre simply consisted of a used piano and a few benches. In the Hoofers Club, steps could be practiced, created, enhanced, and analyzed. Many hoofers who had not broken into the mainstream, showed themselves to be innovators and stylists (Driver, 2000). The greats icons passed through the Hoofers Club including Honi Coles, Bill Robinson, Toots Davis, Eddie Rector, and King "Rustus" Brown, all considered masters in their own right.

Acts

With the many communal hoofers available on the street, those who wanted a career in performance had a strong pool of competitors and not enough opportunities or venues to showcase their talent. Hoofers had to be creative with their style, names, and other aspects of their performance. Specialty acts or gimmicks existed to sustain careers. For instance, names such as *Buck and Bubbles*, *Chuck and Chuckles*, *Stump and Stumpy*, and *Salt and Pepper* (not the rappers), were memorable to an audience. Specialties within acts ranged from tapping up and down stairs to tapping on sand. With the abundance of acts, promoters labeled specialties in smaller categories: Class acts and Flash acts.

Class Acts

The class act was executed with grace and style. The performers were debonair in their attire and physical execution of movements. Usually in dinner jackets or top hat and tails, their grace did not limit the intricate rhythmic perfection all hoofers strived to attain. Honi Coles and Cholly Atkins were the epitome of the class act (Thorpe, 1989).

Coles and Atkins

Honi Coles and Cholly Atkins were icons of the class act hoofing style marked with classy dress and graceful sophisticated moves. Coles had been working as a soloist in 1940 with Cab Calloway's swing band when he met Atkins, who with his wife, performed a song-and-dance act. Coles had a polished style that combined high-speed tapping with a close-to-the-floor presentation. Atkins, who had danced with and choreographed for the renowned Cotton Club Boys, had a lofty rhythmic sense and was an expert buck and wing dancer. Coles' emphasis was speed and complex combinations. Atkins'style was light-footed.

The two joined the Army in 1946. After the war, Coles and Atkins combined their styles and were hired to perform at the Apollo Theatre. They were flawless and proved their dexterity in their impeccable footwork. Their performance involved sections that included fast attention-getting taps, methodically slow rhythmic tap phrasing with smooth seamless slides, and turns. A somewhat vocal challenge dance was a part of their finale, with each showcasing their specialties, working exclusively with a drummer highlighting their percussive rhythmic dexterity(Hill, 2010). Once the act disbanded, Coles became Production Manager at the Apollo and made cameo performances on Broadway. Atkins began a long career choreographing vocal groups for Motown (Glass, 2007).

Flash Acts

Flash acts were a variety of gymnastic and acrobatic feats entwined in rhythmically timed executions. The stunts were artfully performed with clarity of rhythm. Exactness of tap rhythms was the first priority in rating execution. Flash acts had the expertise to execute incredible physical demonstrations, ending perfectly on rhythm to the amazement of an audience. The Nicolas Brothers and the Berry Brothers were the top representatives of this act style.

The Nicolas Brothers

Fayard and Harold, born in Philadelphia, formed the Nicolas Brothers act. At four years old, the oldest brother, Fayard took interest in hoofers that included Bill Bojangles Robinson and Alice Whitman (Thorpe, 1989). Fayard loved hoofing and recruited his brother into practicing their own routines on street corners. By the time they became teenagers, they were showcased on a local radio program. Once spotted by a New York producer, they were hired at the Lafayette Theatre in New York. Eventually, they were given the opportunity to perform at the prestigious Cotton Club. Dressed in top hat and tails, exciting and full of energy, the brothers quickly became a huge hit with audiences. Known for their incredible feats (running up the side of a wall executing a back somersault while in midair to land in a split and recover to a standing position on the beat) was just one of their spectacular specialties. From The Cotton Club, they went to Hollywood, appearing in *Kid Millions* (1935) and *The Big Broadway*

Cast of 1936. Then they went back to live theater with *Ziegfeld Follies, Blackbirds*, and a Broadway musical, *Babes in Arms,* choreographed by the famous Russian ballet master, George Balanchine (Thorpe, 1989). Their most notable performance was the footage excerpt in the all African American cast of the film *Stormy Weather* highlighting their tapping on a piano, drums, and a specially constructed grandiose white staircase. Another notable appearance was in the film *Sun Valley Serenade,* where both shared the stage with Harold's wife, the exquisite Dorothy Dandridge, singing their rendition of "Chattanooga Choo Choo" (Hill, 2010).

20th Century Fox/RGA

Nicolas Brothers

Berry Brothers

The sensational Berry Brothers, Ananias, Warren, and James, performed in top hat and tails combining tapping with props and innovative, perfectly executed acrobatic feats. Their Flash Act began with singing followed by flamboyant strutting. The Berry Brothers experimented with rhythmic interludes ending with breathtaking, precisely timed splits, jumps and somersaults while passing airborne canes to one another. The brothers never wore taps; their precision timing and rhythmic stepping alternated with movements called "freeze and melt", a contrast between posed immobility and sudden action (Thorpe, 1989). They were regular performers at the Cotton Club.

The Berry family lived on the West Coast. Two of the brothers entered an amateur contest in Hollywood and one, Jimmy, won a coveted job in the *Our Gang* comedies. In 1929, Ananias and Jimmy performed with Duke Ellington at the Cotton Club sporatically for four years. The three brothers formed their act in 1935 and successfully performed together for another decade. Their movements were precisely syncopated. A specialty of their act included intricate stunts with canes tossed between the three of them. They were a great trio and have been credited with introducing "splits" into flash act dancing. Their most notable film was *You're My Everything* (Thorpe, 1989).

The Berry Brothers were challenging rivals for the Nicolas Brothers.

Hoofing Venues

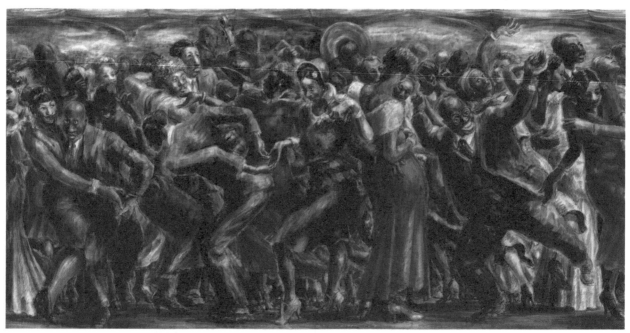

Savoy Ballroom*

Most African American neighborhoods did not have the economic luxury to build theaters, ballrooms, or clubs to showcase community talent. A few were owned by African Americans. Still, venues that did exist were instrumental in spreading the knowledge of African American music, dance and other forms of cultural expression. Most of the major venues mentioned in this chapter were located in New York's Harlem community, with the exception of one that was established in Las Vegas-the Moulin Rouge. The venues located in Harlem and areas of New York, approximately from 125th Street up, were vital attractions for the city. They were the hot spots of entertainment, a mecca for the Harlem Renaissance explosion. European Americans who lived downtown would venture uptown for a night of entertainment. Consequently, some of the dances uniquely created by Harlem residents were taken back to the European American communities and imitated. The difference would be the approach and design of the body alignment of the movement. For example, the Charleston, created in the African American community, was executed with knees bent low to the ground. The body was rounded at the waist and the focus of the movement was into the earth. When the same basic movement was imitated and taken downtown, the residents performed the Charleston with the single-unit torso positioning, which brought the carriage of the movement straight up and down with lifted torso alignment. This positioning is seen in early flapper movie footage representing the "Roaring Twenties", a time that socially embraced the Charleston movements.

The night club spots of Harlem became famous because they were pillars of the community and contributed much to the arts. The major venues discussed in this segment are *The Apollo*, *The Cotton Club*, *The Savoy*, *Small's Paradise*, and the *Moulin Rouge* in Las Vegas.

** Savoy Ballroom, 1931 (tempera on masonite), Marsh, Reginald (1898–1954) / Detroit Institute of Arts, USA / Bridgeman Images. © 2018 Estate of Reginald Marsh/Art Students League, New York/Artists Rights Society (ARS), New York*

Apollo Theatre

The Apollo Theatre, located on 125th Street in Harlem, still stands. It was to be destroyed. However public outcry insisted upon establishing the Apollo as a historical landmark. Apollo Theatre has had a few television shows centered around its reputation for being a vehicle for the discovery of major talent. An artist did not go onto the stage unless his gift was top-notched. Heckling or unsympathetic responses from the crowd could be devastating to a performer. Even the well-known hoofer "Sandman" Sims, who later was a clown at the Apollo tapping off losing performers, made several attempts before being accepted by the audience. The Apollo crowd had the reputation of being a tough crowd to appease. Starting at 10 a.m. it offered four to five shows per day. Its program order began with a short film, a newsreel and feature film, followed by a revue (Malone, 1996). Under management by African American producers, the Apollo revues changed each week but maintained its own line of chorus girls, an impressive format at the time. The chorus line dancers were high priority in the development of stage entertainment.

Apollo

The importance of chorus girls was often overlooked by musicians and dance historians (Malone, 1996).Originally, constructed as a Burlesque theatre in 1913, it transformed in 1934 under new management. The marquee was changed to the Apollo and reopened to showcase African American talent. Apollo competitions were broadcast live, via radio on a national network of stations. The theater launched new talent nationally and continues to do so to date. The careers of performers such as the Nicolas Brothers, Honi Coles, "Sandman" Sims, Ella Fitzgerald, The Supremes, Aretha Franklin, James Brown, and countless others were given a national and international boost through their affiliation with the theater. In 1983, the Apollo received official status as a notable city landmark (Lane, 2015). The acts seen on the Apollo stage underwent much scrutiny; however, the ultimate entertainment was the hoofing challenges executed behind the theater on a readymade wooden platform. Greats like John Bubbles, Bunny Briggs, Chuck Green, Sandman, and others challenged each other with their best improvisational hoofing rhythms .

Cotton Club

Purchased by a prominent mobster to create a nightspot that would be a successful outlet for his brand of bootleg beer, the Cotton Club (located in Harlem) was a popular nightclub for European Americans. It opened in 1923 and engaged high caliber African American entertainers and dancers. The Cotton Club, as the Apollo, maintained an impressive chorus line. Despite the discriminatory

policies and stereotypical themes in its shows, the club highlighted African American talent. Top quality radio broadcasts provided exposure nationwide. Politicians, celebrities, socialites and the elite made the journey from affluent New York neighborhoods and other states to enjoy the entertainment of the floorshows. Opening nights of the Cotton Club show were reviewed by top New York critics. The entertainment was crafted to satisfy the sensual mystique European Americans often found in African American culture. Chorus girls in abbreviated attire overlaid with fur or feathers invoked an exotic or primitive atmosphere. Semi-nude girls graced the artwork of menus and sheet music. The interior of the establishment was based off a scene from a southern plantation with a band area, for greats like Duke Ellington and Cab Calloway. African American performers, service staff, waiters, and bouncers were allowed in the Cotton Club only to perform their designated tasks. African Americans were not allowed as clientele. Entertainers were not allowed to sit at tables or be served.

The Cotton Club in Harlem, New York, in 1938 (b/w photo) / Bridgeman Images

The Cotton Club

Smalls Paradise

Smalls Paradise was owned by an African American, Ed Smalls during the Harlem Renaissance. It opened in 1925 and was located in a large basement at 2294 Seventh Avenue. Smalls employed waiters who sang and danced on roller skates. The basement held nearly 1,500 attendees who danced to the tunes of the big bands. It operated all night until the sun came up and offered a breakfast dance show with its own set of dancers starting at 6 a.m. Smalls Paradise was always integrated and held the distinction of being the longest-operating nightclub in Harlem. In the 1960s, the great basketball player Wilt Chamberlain bought Smalls and dubbed the club *Big Wilt's Smalls Paradise*. The club closed in 1986.

keepingupwiththejones-markjones.blogspot.com/.../today-in-black-historysmalls-par.

Savoy

The Savoy, a mecca for African Americans, united the community with diverse opportunities for socialization. Most establishments like the Cotton Club offered African American visual entertainment but would not allow African Americans to be clientele. The Savoy had an open door policy and would allow diverse activities to be presented from wedding receptions to debutante balls, floor shows, novelty performances, and church functions. An establishment open to dance functions and competitions, the Savoy was the birthplace of many popular social dances including *Balling the Jack, Big Apple, Black Bottom, Charleston, the Mooche,* the *Shimmy,* and *Lindy Hop* (Thorpe, 1989). The famous Whitey's *Lindy Hoppers Team* was a staple at the Savoy. Films such as *Stompin' at the Savoy,* a television special directed and choreographed by Debbie Allen, paid tribute to its invaluable contribution to African American culture of its day (Emery, 1988). The Savoy Ballroom was the ultimate facility for big bands and owed much of its recognition to the famous *Battle of the Bands,* staged with dancers who created visualizations of the music. Chick Webb, an audience favorite performed at the Savoy for most of the thirties (Hill, 2010).

Stomping at the Savoy

Savoy (photo) / Buyenlarge Archive/UIG / Bridgeman Images

Moulin Rouge

The Moulin Rouge was a nightclub hot spot available to African Americans in Las Vegas. Off of the Las Vegas strip, it was the first integrated hotel casino in Nevada. It was a stunning facility with an exquisite showroom that featured walls painted with images of African Americans dancing, drinking, playing instruments, and celebrating the joy of socialization and gaiety. Frequently, African American headliners would perform on the strip, but stay at the Moulin Rouge due to segregation laws and the convenience of escaping the environment of racism that African American performers had to endure on the road. The establishment was a lavish, eye-catching facility which, unfortunately, after many efforts to restore, was closed due to arson in 2010.

Artists Responsible for the Evolution of the Hoofing Style of Tap

The four acts which have been recognized for being responsible for the promotion, development and evolution of the mainstream hoofing style of dance were King "Rustus" Brown, Eddie Rector and Toots Davis, John "Bubbles" and Ford "Buck" Washington, and Bill "Bojangles" Robinson.

King "Rustus" Brown

King "Rustus" Brown did much of his performing in the vaudeville circuit. Those who saw him considered him a master. Brown brought to tap many of the innovations credited to Bill Robinson (Driver, 2000). Nevertheless, his contributions were vital to the art of hoofing. A frequent visitor of the Hoofers Club, he was famous for his performance of buck dancing—a flat footed combination of shuffles and tap. King was one of the first celebrity hoofers (Glover and Weber, 2000).

Eddie Rector and Toots Davis

Eddie Rector had already made his name in the Harlem show *Darktown Follies*. Rector contributed to the development of the smooth cool style that would become known as the class act (Driver, 2000). He and his hoofing partner divided the acts: Eddie was class and Toots Davis was flash. In *Darktown Follies,* they unveiled two recognizable steps in their repertoire, which will later be used by Nicholas and The Berry Brothers, called over the top and through the trenches (Driver, 2000). Because the hoofing style was born and nurtured on the streets, its familiarity in the community presented a problem for those who wanted to seek a career in that dance form. Since everyone could perform hoofing to some degree, career seekers had to find a way of making their act unique. Some had specialty movements like Jimmy Slyde, "Sandman" Sims, and Bill Robinson with "the stair dance." Another novelty were the names of acts such as Stump and Stumpy, "Snake Hips" Tucker, Buck and Bubbles, and Chuck and Chuckles.

John William "Bubbles" Sublett , and Ford Lee 'Buck' Washington

Commonly known by their stage persona, "Buck and Bubbles," the two met as children and were partners most of their career. Originally, they performed together with Buck playing the piano while Bubbles sang. Bubbles learned how to hoof, and made many contributions to the tap world, such as slowing down the tempo and bringing more focus on the heel. He realized he could get extra beats by incorporating the heel in his routines, and introduced aspects of the Lancashire clog-dance (Driver, 2000). Slowing the tempo allowed him more time to fill up the music with intricate steps and complex rhythms. The combination came to be known as rhythm tap, and Bubbles has been recognized as the Father of Rhythm Tap. As they traveled the New York variety circuit starring in the *Ziegfeld Follies* and appearing at the Lafayette Theater, their special artistry crossed cultural divides of the era (Driver, 2000). Bubbles took a break from the vaudeville circuit to play the famous role of "Sportin' Life" in Gerswhwin's groundbreaking opera *Porgy and Bess* (1935) (Driver, 2000).

Bill "Bojangles" Robinson

Born Luther Robinson, Robinson started dancing when he was six. Unhappy with his name, he adopted his brother's name, William. With phenomenal tap technique, Bill "Bojangles" Robinson achieved popularity in the vaudeville circuits. Due to the ruling that African Americans could not perform solo, Bill teamed with George W. Cooper. The duo danced together for 12 years. Afterward, Bill Robinson earned as much as $3,500 a week headlining at New York's prestigious Palace Theatre. Robinson was the first African American to perform without blackface. He performed with his own style of shoes, preferring shoes without metal but wood on the soles, and is recognized for his ability to create nearly any rhythmic sound produced by the drum. In 1918, he introduced his specialty of dancing up and

down stairs, "the stair dance." As he tapped, he used intricate tap rhythms on each step.

Robinson made his Broadway debut in *Blackbirds of 1928*. Other Broadway shows followed, such as *All in Fun, Memphis Bound*, and *The Hot Mikado*. While starring in the latter show, he turned 61 and celebrated his birthday tapping down Broadway from Columbus Circle to Forty Forth Street (Lane, 2015).

Having performed in at least a dozen films, Robinson was one of the few who sustained a decent movie career. He appeared in two of the first all African American movie musicals, *Harlem Is Heaven* and *Stormy Weather,* with choreography by Katherine Dunham. Many of his films were made with Shirley Temple, with whom he shared a great relationship on and off screen. *The Little Colonel* (1935) was their most popular film. They performed together again in *The Littlest Rebel* (1935), *Rebecca of Sunny Brook Farm* (1938), and *Just Around the Corner* (1938) (Lane, 2015).

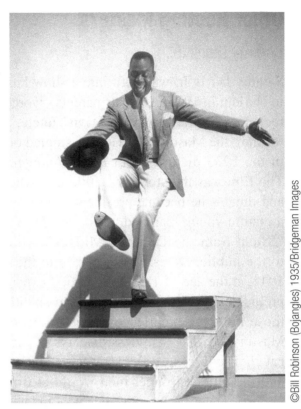

Bojangles Stair Dance

©Bill Robinson (Bojangles) 1935/Bridgeman Images

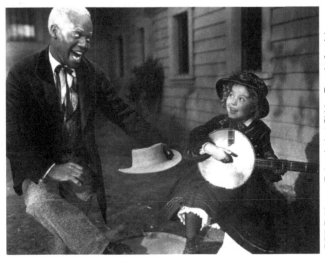

Bill Bojangles and Shirley Temple

©Bill Robinson (Bojangles) et Shirley Temple (banjo) 1935/ Bridgeman Images

With an infectious smile, Robinson was a crowd pleaser. Another part of his appeal was his charitable contributions to many causes. He became a founding member and honorary president of the Negro Actors Guild, which was formed to create better opportunities for African American performers (Lane, 2015). He purchased a stop light at a street corner crossing that was dangerous for African American children. Robinson set a world record for the 75-yard backlash dash (Lane, 2015) and ate 4 quarts of ice cream a day (Emery, 1988). Robinson coined the word "copacetic" from his song "*Is Everything Copasetic?*" Copasetic can be found in dictionaries meaning "excellent".

Other Hoofing Masters

Sammy Davis Jr.

Sammy Davis Jr. was born into a show business family in Harlem in 1925. After his parents divorced, his father took him on the road with Davis' uncle, Will Mastin, forming the Mastin Trio. He was singled out to perform in the 1933 picture debut *Rufus Jones for President*. The film was the story of a little boy who falls asleep and dreams he became president. Because he was such a mature young man and performer, Davis was dubbed "Silent Sam the Dancing Midget," which appealed to the public. Davis was drafted into the US Army in 1942, at the age of 18. There he first experienced racial prejudice. His father and uncle had shielded him from those kinds of experiences when he traveled with the Mastin Trio. The senseless displays of racial prejudice caught Davis by surprise. He was a slight man in stature, and the taller, stronger men would at times treat him unfairly. Davis believed his talent would be his salvation and a way to fight back, and made up his mind that he would be the best performer in the world. When he was

Sammy Davis Jr.

transferred to Special Services, he got his chance. He performed in Army camps across the nation, where the servicemen honored him and gave him respect. (Hill, 2010).

After his stint with the Army, Davis went back to the Mastin Trio in 1946. There, he exhibited his impressions of famous movie stars and singers, showcased his gun twirling, and perfected his flash act style of tapping. In addition, Sammy Davis Jr. played the drums and trumpet. During this time he met Frank Sinatra and eventually became part of the famous "Rat Pack." Sammy also signed a recording contract with Decca Records. After recovering from the loss of one eye in a car accident, he made his Broadway debut in *Mr. Wonderful*. His use of guns allowed him to spray machine gun bullets and hoof at the same time in the movie *Robin and The Seven Hoods* featuring the Rat Pack. In the late 1950s and 1960s, fans traveled to Las Vegas to see Sammy Davis Jr. perform. Although he had to accept accommodations in a rooming house (as did all African American performers in Las Vegas) (Hill, 2010), there was one venue in Vegas that gladly welcomed Davis and other African Americans-the Moulin Rouge.

Clayton "Peg Leg" Bates

"Don't look at me in sympathy. I'm glad that I'm this way; I feel good and I'm knocking on wood." These are the words of a sharecropper's son who lost his leg in a cotton milling accident at the age of 12, Clayton "Peg Leg" Bates (Hill, 2010). Bates was born in Fountain Inn, South Carolina, in 1907 (Hill, 2010). He began dancing at the age of five much to his mother's dismay. Being a Southern Baptist, his mother was against dancing. At the age of 12, Bates convinced her to allow him to work

Peg Leg Bates

in a cottonseed mill. She reluctantly agreed. Approximately three days into the job the lights went out in the mill. Bates fell into a conveyor belt and mangled his left leg. Due to the segregation laws at the time, he was not admitted to the hospital and the leg was amputated on his mother's kitchen table. When Bates was well enough to maneuver, his uncle made him a wooden peg leg. He began dancing again, executing the rhythm steps of tap dancers and added his own unique style and gymnastic movements. With his special talent, he worked himself through the minstrel and vaudeville circuits (Hill, 2010). At Broadway's Paradise Restaurant in Harlem, Bates had his peg leg painted to match the different colors of his suits for every number. This became a distinct fashion statement throughout his career. In the 1930s, he performed in *Black Birds* and became a featured dancer at the Cotton Club. In 1950, Bates made his first television appearance on the Ed Sullivan Show. He was the first African American to appear on the highly rated and popular variety program. Bates was invited more than 18 times to the Ed Sullivan show. His last performance was in 1965 (Hill, 2010).

In 1951, he and his wife, Alice, purchased a large farm in New York's Catskill Mountains and converted it into a resort. The Peg Leg Country Club was the largest owned and operated resort in the country for African Americans who had no vacation facility due to segregation. (Hill, 2010).

Charles "Chuck" Green

Chuck Green was part of the team "Chuck and Chuckles," which were the protégé act of "Buck and Bubbles." As "Buck and Bubbles" matured in age, they wanted a group to continue their legacy. Charles "Chuck" Green and James Walker were their protege act, 'Chuck and Chuckles." They played soft knee Stepin-Fetchit-like characters and evoked laughs with their molasses-like locomotion.

In 1944, Green was admitted to a mental institution for personal reasons. When he was released 15 years later, he was introverted and introspective. Friends thought it was miraculous that he could still dance. During his time in the institution, Green used tap as therapy. While experimenting with rhythmic patterns and innovative approaches to bebop music, Chuck created his own bop-influenced style of rhythm which was suave and improvisational. (Hill, 2010). Chuck Green's journey through his tap dancing career along, with Sandman Simms and Bunny Briggs, is a major focus in George T. Nierenberg's tap documentary *No Maps on My Taps*.

Henry Le Tang

Born Henry Christian Le Tang, Henry studied under the famed black choreographer and teacher, Clarence "Buddy" Bradly, who choreographed stars of all races. As a teenager, he became Bradly's studio assistant, where he learned all styles of tap dancing. The late great "Bubbles" took Le Tang under his wing and tutored him in steps and effective presentation of tap choreography. Le Tang opened a studio on Broadway and West 47th Street in 1937 and became known as the "teacher of the stars." His classes were consistently filled to capacity, as he was very hands-on and had a unique ability to teach different levels at once. Le Tang was known as a teacher and choreographer, and he was comfortable in those positions. He did not pursue stardom; however, he received great respect and accolades from his star-studded students. He was Maurice and Gregory's mentor. Gregory rarely performed in a tap show, special television spot, or film without having LeTang's consultation. LeTang choreographed many notable Broadway shows, but his most critically acclaimed work was the musical *Black and Blue,* which he choreographed with dancing icons Cholly Atkins, Frankie Manning, and Fayard Nicolas (Hill, 2010). Henry Le Tang was one of many choreographers of the movie *Cotton Club,* which was about the mobster control of the club. Gregory and Maurice were given a secondary story about two brothers working through their relationship challenges. It was a touching element of the movie with footage of the two tapping together. Francis Ford Coppola shot many dance scenes reminiscent of the Cotton Club aesthetic. Unfortunately, because the main focus of the film was centered on the gangster connection, much of the dance footage was not used. Henry received the rights from Francis Ford Coppola to take many of the dances and present them in a revue performed at the Aladdin and then the Dunes in Las Vegas. Le Tang and his wife spent the rest of their lives in Vegas.

Jimmy Slyde

Slyde was born James Titus Godbolt in Atlanta, Georgia, in 1927. He was trained to play the violin at the Boston Conservatory (Hill, 2010). Attracted to the tap performers he had seen at Boston and being discouraged about sports by his family, Godbolt decided to put the violin down and pursue dance. He began studying tap with Eddie "Schoolboy" Ford whose favorite step was a slide, which he taught to Godbolt. There was a sound of the slide, which gave both pleasure in executing. The audible slide movement was as important to Godbolt as the sound of any other tap step. As he matured in his art, he adopted the name "Slyde" and studied the works of the greats, "Stump and Stumpy," Coles and Atkins, the Berry Brothers, and the Nicolaus Brothers. However, it was the style of Bunny Briggs that became his favorite.

Bunny Briggs

Bunny Briggs was born in Harlem in 1922. After seeing the great Bill "Bojangles" Robinson at the Lincoln Theatre, Briggs was convinced he wanted to be a hoofer. Bunny focused with a disciplined persistence

on the tap steps he had seen and practiced religiously. While still a boy, Bunny was known to dance at half-time in basketball games and received enough appreciation money from the crowds to keep his mother comfortable and a rent-free tenant. After practicing diligently, Briggs ventured out and became a part of the dancing group "Porkchops, Gravy, Rice and Beans," a kid dance group performing in local ballrooms. When he was 20, he danced with swing orchestras and big bands. One such swing orchestra was the famous Duke Ellington's band. After Briggs appeared with Duke in 1960, he was known as "Duke's dancer." His trademark was his own pantomime style of 16th note paddle-and-roll tapping (Hill, 2010).

Alice Whitman

In her time, Alice Whitman was known as the "Queen of Taps." Alice was a proficient dancer who could do it all. She incorporated ballet in her tap, and achieved a reputation through her ability to out-hoof many of her male counterparts (Hill, 2010). Alice came from a talented family-she and her sisters, Mable, Essie, and Alberta, formed the Whitman Sisters-a powerful unit who had their interests in several areas of entertainment. They sang, danced, played guitar, and established themselves as a family-run business that played most of the vaudeville circuit. Mable was the overseer of all the bookings, Essie designed and constructed the costumes, Alberta was the music composer, and Baby Alice was the star (Hill, 2010). Alberta dressed in men's attire when she would introduce Alice as "Queen of Taps." Alice would then perform high-kicking, snake-hipping movements in a baby doll outfit, shimmying while delivering a hard-hitting dynamic style of hoofing (Hill, 2010). Alberta would later reenter the stage to escort Alice into the wings.

Howard "Sandman" Sims

All acts attempted to have some kind of gimmick or specialty that would separate them from other hoofers. Jimmy Slyde made use of sliding as he performed, "Bojangles" was known for his stair dance. "Sandman" tapped on sand. After starting a career in boxing, Sims received more attention with the movements he would perform in the resin box at the corner of the ring than he did for boxing. He left the sport and pursued tapping. Once he put sand in a box and tapped on it, his novelty was born. Bill Robinson saw his act and told him to continue with that effect because it would keep him working and so he did. He made a large box, placed a mike at the corner of the box for specificity of the rhythms so that the audiences could hear his rhythmic clarity. As the new music started to emerge in the 1960s, and the appeal of hoofing waned, Sims was hired to work at the Apollo as a clown whose job was to usher off those performers that had been rejected by the audience. He worked in that capacity steadily. Sims was invited by Gregory Hines to be one of the lead characters in the movie *Tap*.

Shift in Aesthetic

With the introduction of rock music in the 60s, hoofing slowed down almost to extinction. Rock and roll and rhythm and blues influenced mainstream American youth. The music was not conducive to the movements of the past. Broadway choreographers from dance instruction schools entered the scene. Their forte was modern, ballet, and jazz dance. Most had never tapped in their career. Consequently, by the 1960s, many hoofers were either too old to compete with new forms or had sought alternative employment.

New Generation

The golden age of the movie musical where tap flourished on screen ended in the late 1950s. The key to the survival of hoofing existed in the ancestral teachings of the African griot, where the youth were embraced, and traditions were handed down to the children. In the African community, the adults allowed the children to join them in the dance, and the traditional hoofers did the same. While the seasoned hoofers were participating in challenges at the back of the Apollo, they were also inviting young tappers like Maurice and Gregory Hines to participate. During the time of rock and roll and disco, the hoofing form of tap could have become extinct. However, two young men who performed in a Broadway musical, *Eubie*, brought to the show the experiential essence they had learned from their challenges with the masters.

In the act *Hines, Hines, and Dad,* Maurice and Gregory savored their experiences with the competitive challenges witnessed behind the Apollo and the knowledge obtained from the tappers of the Hoofer's Club. In 1978, a new musical opened in New York that communicated to a new generation the tap heritage of the past and the life and compositional works of Eubie Blake. Blake's work with Noble Sissle had been a leading force in the music of the Harlem Renaissance of the 1920s and was given a rebirth in the Broadway musical, *Eubie* which offered a nostalgic look at the jazz age. Producers began to hire choreographers to replicate the dance era of the all African American cast musicals with the 20's–50's aesthetic (Driver, 2000). Henry Le Tang and Billy Wilson were chosen to choreograph the musical. To represent the acts of the day were two of the performers of *Hines Hines and Dad*, Maurice and Gregory Hines. Both Maurice and Gregory learned hoofing at a young age under the tutelage of Henry Le Tang. As they began to perfect their craft, they were billed as *The Hines Kids* following a long tradition of child tap acts. They traveled through the circuits and were later joined by their dad to form *Hine Hines and Dad*. Eventually the trio broke up with Maurice Jr. following a concert tap career and Gregory, forming a rock jazz band called Severance.

Gregory and Maurice Hines

Their careers lies at the center of the tap revival. Gregory was in his early 30s when he appeared in *Eubie*. The brothers were primarily instrumental in sustaining the life of the hoofing style of tap. When tap had waned during the era of Rock and Roll and Disco the talent, dedication, and love the brothers showed for their hoofing gurus and the knowledge bestowed on Maurice and Gregory was the lifeline that pulled the hoofing style out of the trenches in the 1970s. When the opportunity to perform in *Eubie* presented itself, both brothers were well prepared for the nuances the era portrayed. In the musical, they performed as an act of the past, as they did in Ford Coppola's movie *Cotton Club* (1984).

Maurice and Gregory were instrumental in passing information to younger tappers through master classes and performances. They both had a knack for projecting their movements into the contemporary realm without taking away from the raw earth-bound essence of the hoofing tradition. Both went in different directions in spreading the history of the hoofing style of tap. Maurice educated dancers on Broadway and Gregory ventured into film.

Gregory's initiation of the movie *Tap* reawakened the status of the power of the hoofing style and the contributions of the icons who developed and sustained its existence. Gregory gives back in the movie *Tap* by reintroducing and acknowledging all the elder hoofers who were able to show their technical power in the spirit of challenge and Hoofer's Club tradition. The phenomenal song and dance man Sammy Davis Jr., who starred in *Tap*, gave the movie a classic status. The cast received offers to go on *The Donahue Show* and other talk shows that educated the viewers about the renaissance era of Harlem and the rich heritage of an explosion of creativity in all fields including jazz music, visual artists, and innovative dance (artistic and social). In the movie *Tap*, Gregory also brought to focus the value of stellar female hoofers such as Diane Walker.

The Movie Tap

©Serie tele Tap Dance in America avec Gregory Hines 1989/Bridgeman Images

Gregory starred in several groundbreaking Broadway shows, one of which was *Sophisticated Lady* alongside the modern dance icon and Ailey muse, Judith Jamison. Gregory played the role of "Jelly Roll" Morton in the Broadway musical *Jelly's Last Jam,* earning him a Tony and Drama Desk Award. He made appearances in several sitcoms and starred in his own CBS television variety series, *The Gregory Hines Show*. He initiated a PBS special with Harold Nicholas of *The Nicholas Brothers*, Jimmy Slyde, Bunny Briggs, Henry Le Tang, "Sandman" Sims, and other hoofers from his past.

In the film *White Knights*, Gregory Hines performs a fusion of tap and modern with the ballet impresario Mikhail Baryshnikov. He showcased the talent of the youth in the movie *Tap,* exemplified by the role of Savion Glover who he also casted in *Jelly's Last Jam*, and *Bojangles,* a story of the late great Bill Robinson, for which Gregory received an Emmy Award in 2001. Gregory passed the torch to Savion, whose name means Savior. Savion continues to run with the torch even after Gregory's early passing.

Maurice has made incredible inroads into Broadway. His starring role in the outstanding musical *Uptown . . . It's Hot!* earned him a Tony Award nomination as Best Actor in a Musical. An especially noteworthy musical tribute was *Tappin' Thru Life: An Evening with Maurice Hines*, honoring his younger brother, Gregory and their careers, along with the singers who inspired their work. (Driver, 2000). In that musical, Maurice introduced two up and coming brothers, *The Manzari Brothers*, John and Leo. Gregory and his brother, Maurice were continually giving back and exposing new talent, both of whom refused to let the hoofing tradition be lost. Their contribution in promoting the hoofing form of tap has made them deeply responsible for the life of the art form. (Driver, 2000).

Maurice Hines and the Manzari Brothers

Diane Walker

In 1978 Diane Walker, a 27-year-old mother of two working as a staff psychologist in Boston, met Willie Spencer, a hoofer of many years. Intrigued with his style of movement, Walker inquired about his expertise while informing him that she had learned tap as a young child, but was impressed with his attack of the dance form. Willie suggested Diane study with a knowledgeable instructor, Leon Collins. She later became Collins' protégé. Diane codified his tap dancing technique, taught it, and became one of the major activists in the revival of rhythm. (Lane, 2015)

This was a woman who, like Alice Whitman, proved that females could be a force to be reckoned with. "Lady Di"(Diane Walker) gained the respect of Gregory Hines. He instantly hired her for the movie *Tap* as one of the "Shim Sham Girls." Today, she is considered by many African American female tap dance artists as a pioneer in the acceptance of African American women in the hoofing style of tap.

Miss Walker was born Diane Taylor in Boston in 1951. When she was about 15 months old, she contracted polio. To correct the articulation in her legs, she was sent to study ballet. Her heart was in tap, so when she was introduced to Leon Collins, she absorbed everything she could and became his apprentice. (Lane, 2015). Diane performed in the all African American Broadway musical *Black and Blue*, choreographed by Henry Le Tang. Savion, in the same musical, gravitated to Diane. She taught him all she could. They fed off of each other. Diane's work in *Black and Blue* reflected her proficiency in a way that made a significant distinction in her tap style. She continued to hoof after the run of *Black and Blue,* instructing and performing in the historic *Women in Tap Conference of America* (Lane, 2015).

Savion Glover

"Drummers play drums, dancers play the floor" are words of Savion Glover.

Savion's mother gave him his name after being prompted in a dream with the word meaning "Savior." He has been a type of Savior for the art form of the hoofing-style dance idiom. Savion Glover was called the "Pied Piper" by Gregory Hines (Glover and Weber, 2000).

Exhibiting a natural talent to dance, Savion was 4½ years old when he was enrolled at the Newark School for Performing Arts. He placed out of the Suzuki classes and was put in class with older students (Glover and Weber, 2000) and given a scholarship to play the drums (Glover and Weber, 2000). Savion's mother heard the announcement that Frank Hatchett, the founder of the famous Broadway Dance Center, was taking enrollment for dance school. The opportunity exposed Savion to the dance (Glover and Weber, 2000). His mother did not have the additional income to buy tap shoes, so Savion would take class in cowboy boots. He later started performing in tap festivals with icons like Jimmy Slyde, Bunny Briggs, and Chuck Green. He auditioned and received the leading role in the Broadway show *Tap Dance Kid* at approximately 12 years of age (Glover and Weber, 2000). During the early 90s, Glover was a regular on the children's television series, *Sesame Street*. In 1988, he went to Paris to perform in *Black and Blue,* choreographed by Henry Le Tang, Cholly Atkins, Frankie Manning, and Fayard Nicholas of *The Nicholas Brothers* who collectively, won a Tony for their choreography. (Glover and Weber, 2000) *Black and Blue* was a classy musical tribute to the blues music artistry of Duke Ellington, W.C. Handy, Jimmie Lunceford, and Fats Waller.

Savion, along with Gregory Hines and many hoofing icons, appeared in the movie *Tap*. His onscreen performance was charismatic as a young boy raised in a dance studio by a single mother. In most scenes, Glover is seen artfully executing basketball maneuvers. A good addition to the story for the purpose of recruitment of youth in the sports field. His skill with the basketball was destined to play a role in his career when he was asked to be the consultant for the highly rhythmic Nike commercial, featuring freestyle basketball movements cloaked in dance routines. (Glover and Weber, 2000) The Hines and Glover relationship surpassed that of mentor and student and developed into a father–son partnership (Glover and Weber, 2000). They appeared together again in *Jelly's Last Jam*. In the summer of 1995, African American artists such as Ann Duquesnay and poet Reg. E Gaines joined Savion to team with the director of *Jelly's Last Jam,* James George Wolfe. They create a new show focusing on the history of racism through tap (Glover and Weber, 2000).

The show was titled *Bring in da Noise, Bring in da Funk*. It boosted Savion's visibility and won him a Tony Award for choreography. He was the youngest choreographer to ever receive a Tony. *Bring in da Noise, Bring in da Funk* introduced hoofing to the hip-hop culture and those of his millennium generation the way no other show had attempted (Glover and Weber, 2000). *Bring in Da Noise, Bring in Da' Funk* focused on the journey and themes from slave ships, to the exploitation of African American labor in factories, the Harlem society, and hip-hop street life. It represented the syncopation of the juba dance to the hip-hop sound of young African Americans. Savion used the Broadway show to honor the hoofing style and its practitioners in the African American experience (Glover and Weber, 2000). Utilizing buckets, pots and pans, and garbage can lids as drums in the musical was reminiscent of the

slaves' plight to employ everyday utensils to accentuate percussive musical phrasing during the days the drums were banned on the plantation. The night of the Grammy Awards show, Gregory Hines was the presenter for the Best Choreographer category. It was touching to see Hines hand Savion the Tony, distinctly symbolic of passing the torch of the hoofing style to Glover to continue to maintain the existence of this style of tap.

Hines and Glover

Savion has appeared in commercials and movies such as *Tap, Bojangles, and Bamboozled*. He has also appeared on television shows like *Jamie Fox Show*, *So You Think You Can Dance*, and *Dancing with the Stars*. Savion's unique "hitting" approach to hoofing was the inspiration and body posture for the character of Mumble in the highly successful movie, *Happy Feet*.

His choreography in 2016's *Shuffle Along, or, the Making of the Musical Sensation of 1921 and All That Followed* earned Glover a Tony Award nomination for Best Choreographer and won him a Drama Desk Award.

Jason Samuels Smith

Jason Samuels Smith was born into jazz dance in 1980 to a jazz dance instructor mom, Sue Samuels and father, Joseph Benjamin Smith, aka Jo Jo Smith, a renowned jazz dancer and choreographer (Hill, 2010). Jason Smith began studying in Frank Hatchett's children's program at the prestigious Broadway Dance Center. At the age of nine after receiving training in ballet, jazz, and tap, Smith made appearances on the well-known children's TV show *Sesame Street*, a PBS-TV educational program. *Sesame Street* featured the popular Savion Glover as the tap dancing cowboy. Smith, inspired by Glover, took his master classes at the Broadway Dance Center where he caught the bug to pursue hoofing. Smith found similarities between the way Savion looked and the kind of music he enjoyed. At the age of 15 he became a member of the *Bring in Da Noise, Bring in 'Da Funk* cast. Smith conducts master classes, choreographs, as well as performs. In the new millennium, Smith carries the torch of hoofing into his generation along with Savion, combining their multitalented influences with all avenues of tap dance.

Sean and John Scott

Sean and John Scott TAP TWINS

Sean and John Scott are twin artists in the hoofing arena. They have developed a tap fusion of traditional hoofing and hip hop. Their long-time professional instructor, Alfred Desio, worked with the twins since the age of 16. Sean and John Scott attended The Colburn School of Performing Arts. They did numerous high-profile television shows, such as *America's Got Talent, Disney's Shake It Up,* and *Nikelodeon's Yo Gabba Gabba, and X Factor.* They were also featured on *VEGAS! The Show, The Variety Show,* and in Beyonce's *I Am . . . Tour.* As with the other hoofing artists listed in the New Generation Renaissance section, the twins are pushing the boundaries of the hoofing style and giving back to the generation following. (Seanandjohn.com)

Broadway

There have been struggles and challenges, resistance and discouragement, but African Americans have endured in order to break down some of the racial barriers. Those artists, performers, dancers, singers, poets, and actors pressed through with determination and creativity to bring their potential to the stage. The major venues were the Broadway stage and film. Only a few stellar musical shows or films focusing on dance had an all African American cast. They are listed below:

Film

Stormy Weather: Choreographed by Katherine Dunham, with greats such as Lena Horne, Bill "Bojangles" Robinson, and The Nicholas Brothers.
The Wiz: Choreographed by Louis Johnson. Starring Diana Ross, Michael Jackson, Nipsey Russell and Ted Ross.

Wiz Movie

Dream Girls: Choreographed by Fatima Robinson. Starring Jennifer Hudson and Beyonce.

Beat Street: Choreographed by Lester Wilson.

Bamboozled: Featured the hoofing style of tap, starring Savion Glover.

African American Broadway Shows

House of Flowers: Geoffrey Holder, Alvin Ailey, Louis Johnson, and Carmen De Lavallade were cast members.

Shuffle Along (1921): Popular stars were Florence Mills and Josephine Baker.

Shuffle Along, or, the Making of the Musical Sensation of 1921 and All That Followed: Choreographed by Savion Glover.

Running Wild: Musical comedy that introduced The Charleston.

Black Birds: Starred Bill Robinson. Peg Leg Bates also appeared in a version of the musical.

Bubbling Brown Sugar: Choreographed by Billy Wilson. Honi Coles was one of the stars.

Eubie: Maurice and Gregory Hines performed together on Broadway.

Five Guys Named Moe: Choreographed by Charles Augins.

Dream Girls: Co-choreographed by Michael Peters.

Sarafina: Broadway musical and film. Michael Peters choreographed the movie.

Timbuktu: Directed, costume designed, and choreographed by Geoffrey Holder. Eartha Kitt was the leading lady.

Sophisticated Lady: Starred Gregory Hines and Judith Jamison, soloist from the Alvin Ailey American Dance Theatre.

Guys and Dolls: Directed and choreographed by Billy Wilson.

The Wiz: The first African American to win a Tony Award for Best Choreography, George Faison.

Raisin: Debbie Allen held major role. Donald McKayle choreographer.

Purlie: Choreographed by Louis Johnson.

The Color Purple: Choreographed by Donald Byrd.

Arms Too Short to Box with God: Choreographed by Talley Beatty.

Ain't Misbehavin: Starred Neil Carter.

Black and Blue: Tony Award for Best Choreography: Cholly Atkins, Henry Le Tang, Frankie Manning, and Fayard Nicolas.

Bring in 'Da Noise, Bring in 'Da Funk: Tony Award for Best Choreography, Savion Glover

Jelly's Last Jam: Tony Award for Best Performance by a Leading Actor in a Musical, Gregory Hines

Shuffle Along: Choreographed by Savion Glover.

Fela!: Tony Award for Best Choreography, Bill T. Jones

The Lion King: Tony Award for Best Choreography, Garth Fagan

Advertisement for Bubbling Brown Sugar

The Lion King

Introduction

Ballet has existed for over 400 years. It is a universal dance form whose terms were codified in French. Therefore, a student of the ballet can take a class anywhere in the world if there is knowledge of the steps associated with the terms.

Ballet traveled from Italy as court dance to France and Russia before it came to America. Like all dance forms, ballet started from the common folks of the street, the peasants. The elite admired the dancing of the lowly and took the essence of the dance and selected those elements palatable for their status level and formed the Italian court dances. As the seeds of ballet were planted and nurtured, its appeal traveled to France where Louis XIV embraced it and asked his ballet master Pierre Beauchamps to codify and document the movements specific to the dance form. Consequently, the terms were written in the French language (Kraus, Chapman-Hisendager, and Dixon, 1999).

Ballets' popularity grew and became prestigious as it moved into Russia. Russia took Ballet in another direction with the founding of the Ballet Russes by Serge Diaghilev, a member of Russian nobility. The company would advance the caliber of the aesthetic of this precise, demanding art form. Under Diagilev's management, and with the especially gifted choreographers and members trained within the company, Russian ballet received the status that raised the bar of dance and its representation in the artistic arena. Ballet Russes utilized the greatest artistic talents in every realm of artistry. Picasso was the costumier and set designer. Stravinsky, Debussy, and Satie were among other greats who composed the music. Fokine, Nijinsky (considered the greatest male ballet dancer of all time), Massine, and eventually George Balanchine (a younger man at the time) were the top choreographers (Kraus, Chapman-Hilsendager, and Dixon, 1999).

When Diagilev died in 1929, the Ballet Russe dissolved. Balanchine began choreographing throughout Europe. Lincoln Kirstein, a patron and organizer of American Ballet, invited Balanchine to America. They formed the Ballet Society, which later joined forces with the New York City Center of Music and Drama under the title of the New York City Ballet. From the 1950s through the 1970s the New York City Ballet developed an impressive repertoire and gained international acclaim (Kraus, Chapman-Hilsendager, and Dixon, 1999). Because of its popularity, other companies tried to pattern Balanchine's choreographic works to compete with New York City Ballet, taking on similar aesthetic and look of the dancers of the company. Balanchine was the greatest influence of ballet in America.

For the purpose of this study, three categories of ballet will be mentioned: the classical ballet, the neoclassical ballet, and contemporary ballet.

The Classical and Neoclassical Ballet

Thematically, classical ballet stories focused on heroes, cultural myths, tales, and the supernatural (Steel and Farmer, 2014). The general stage attire for the ballerina was pointe shoes, tights and tutus, short full stiff skirts showing legs from upper thigh to the feet (contingent upon the theme and time period of the production).

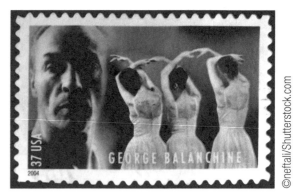

Balanchine postage stamp

There is a ballet hierarchy within a classical ballet company. The highest, which is reflected in pay, is the dancer with the most talent and company experience. The principal male, premier danseur, and female prima ballerina, rank the highest. There are other rankings in the hierarchy, but for the purpose of this African American historical study, the category necessary to define is the corps de ballet (the chorus). This includes newer members which add a group aesthetic to further the story, or add to its ambience.

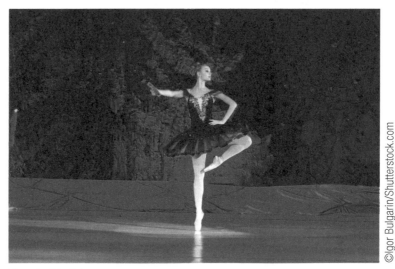

Classical Ballet

Neoclassical ballet uses traditional ballet vocabulary but is less rigid than classical ballet. It plays around with rhythmic tempos and focuses on structure and shapes. George Balanchine was noted for his neoclassical works. Many times in neo-classical works, the themes of space and design are broken down and there is the deconstruction of sets and tutus, and less adherence to the strict requirements of classical ballet (Kraus, Chapman-Hilsendager, and Dixon, 1999).

The Contemporary Ballet

Contemporary ballet resembles classical in the similar use of movement vocabulary and the selection of exceptionally trained dancers. The contemporary in all dance forms is up for debate for the specifics of their description. It may use abstract music and focus on the avant garde or present day themes. There can also exist elements of other forms of movement in contemporary, influenced and inspired by previous works (Kraus, Chapman-Hilsendager, and Dixon, 1999).

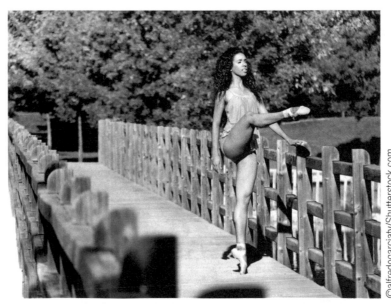

Jazz influenced contemporary ballet dancer.

Ballet, originally a European art form, presented the corps de ballet with all members of the same complexion and body type. George Balanchine's aesthetic included a classical look of the slight framed ballerina. The attire of the ballet dancer incorporated the pink tights for women to match the skin tone of the face and arms unless a performance called for a particular character or color palette. However, the attire for a ballet class was and still is strict and unyielding. Ballet is a very disciplined and demanding dance form. Those who seek membership in a ballet company have to adhere to required body standards to ensure visual uniformity.

It takes approximately 10 years to become a well-trained professional ballet dancer. Parents need to start prepare their child for ballet as a profession at the age of six. At that age the body is still flexible for the demands of the technique. Also, the child is

Jazz influenced contemporary ballet dancer with pedestrian attire.

old enough to be introduced to the required French terms. Ballet technique is structured around the use of the turnout. Turnout is a 90° rotation in the hip sockets that enable clearer visibility of the steps of the ballet movement vocabulary. In order to acquire and maintain that kind of articulation, a hopeful participant needs to start to train the body to maneuver with turned-out positions early. As the human body advances past the 6-year beginning age, the natural anatomy begins to change and the flexibility is usually lost or impeded.

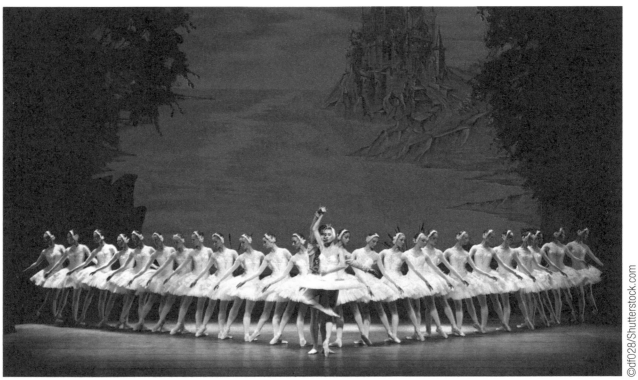

©df028/Shutterstock.com

Corps de ballet

Ballet Classroom Attire

Women's Attire

1. Ballet is a European-based dance form. Pink tights are one of the staples for the classroom attire.
2. Pink soft ballet shoes (canvas or leather) are worn to allow flexibility of the feet and to extend the look of the legs.
3. Black leotard is a safe color fitted for the body contour. Some academic schools alternate colors that coincide with different levels of training. Toddlers may wear pink leotard, next level sky blue, then maroon etc.
4. Hair is severely pulled into a bun in the back of the head or on top. Whispy strands around the face are usually pulled back with hair spray to provide a smooth clean look.

Ballerina Shoes

©Roman Prishenko/Shutterstock.com

5. If the dancer is trained enough to wear pointe shoes to allow her to elevate herself onto the pointe, those shoes should also be pink.
6. Depending on the rules of the studio or academy, ladies may be allowed to wear a ballet skirt, usually black to match the leotard.

Pointe shoes

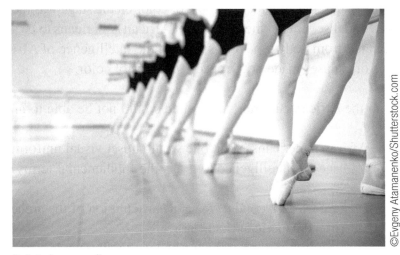

Ballet shoes or slippers

Men's Attire

1. Men's tights are thicker. Usually for a dance class, black is the acceptable color.
2. Men wear similar ballet shoes as women but constructed for the male foot made of leather or canvas. The color of the ballet shoes for men is most often black or white. Short thin white socks can also be worn.
3. Traditionally, men do not dance in pointe shoes unless the class dictates it for foot strengthening or other purposes.
4. On the upper part of the body men wear leotards with thick tights pulled up on the outside of the leotard, or a sleeveless t-shirt, preferably white or black.
5. If the hair for the male is too long, it should be secured in the back. Not with traditional bun of the ballerina, but off the face.

Male ballet attire

Ballet attire and lessons were only for the elite at one time. With economic conditions of the African American community and some European Americans, ballet was a dance idiom expensive to maintain, especially for parents of the young. The price for shoes and class attire is more expensive when smaller children are involved. Children grow quickly, which means repeated purchases for changing bodies and foot sizes, in addition to the high prices of classes add up to quite an expense. If an African American family did have the financial ability to invest in ballet classes, the absence of people of color represented in ballet productions was a discouragement for such a commitment.

Stereotypical Myths

Outside of possible financial issues, the absence of people of color on the stage was racially motivated. Stereotypical myths tainted and discouraged the attempts of African Americans to be seen as equals in the ballet world. Myths ranged from body type to assaults on the intelligence of African Americans. Stated below are examples of excuses made not to accept trainees of color:

1. African Americans with the African cultural background would not be able to grasp a European dance form.
2. The varying hues of the African Americans' skin tone would upset visual uniformity.
3. African Americans did not have the intelligence to grasp the fundamental terms associated with ballet movement.
4. African American foot structure was not conducive to the articulation of the arched foot. In other words, it was believed that African Americans had flat feet.
5. The African American frame was too muscular for the balletic body type.
6. The texture of African American hair was too coarse for the versatility needed to wear headdresses or buns/hair style.
7. African Americans were not disciplined enough for the rigor of the training.

Early African American Ballet Companies

It was only fitting for African Americans to rise above their obstacles and attempt to establish their own ballet companies to showcase the beauty of different races. Some companies are listed below.

American Negro Ballet (1930s)

In November 1937, an African American dance company made its debut at the Lafayette Theatre in Harlem. The American Negro Ballet under the direction of Baron Eugene Von Grona, was met with poor reviews. Nearly all the reviewers felt that the Negro was much better suited to perform other types of dances, not ballet (Emery, 1988).

While the American Negro Ballet performance was not an astounding success, it was a beginning, and a move in the right direction.

The Hollywood Negro Ballet company (1940s)

Founded by Joseph Rickard. (Long, 1989).

New York Negro Ballet (1955)

The New York Negro Ballet was founded by Ward Flemyng. Dancer and codirector Thelma Hill achieved eminence as an instructor. Members of the company included Delores Brown and Sylvester Campbell, who was a product of the Jones–Haywood School of Ballet in Washington D.C.

Capitol Ballet (1961)

Capitol Ballet, founded by two African American women, Doris Jones and Claire Haywood, was an extension of the Jones–Hayward school of Dance in Washington D.C. Their performances were impressive and many African Americans who came out of the school and company achieved recognition in ballet and the dance world at large. Louis Johnson, Virginia Johnson, Sylvester Campbell, and Sandra Fortune–Green, Broadway icons Chita Rivera, Hinton Battle, and Rene Robinson of the Ailey company were disciples of the Jones and Hayward training. Capitol Ballet presented works by Arthur Mitchell, founder of the Dance Theatre of Harlem (Long, 1989).

Negro Dance Theatre (1954)

The Negro Dance Theatre, an all male company, was founded by Aubre Hitchins (Long, 1989).

National Center of Afro-American Artists in Boston (1947)

The National Center of Afro-American Artists in Boston was founded by Talley Beatty, a modern dancer. In 1971, Billy Wilson became artistic director and transformed the company into an all-male African American ballet company (Long, 1989).

The Dance Theatre of Harlem (1969)

The Dance Theatre of Harlem (DTH) was founded by Arthur Mitchell and co-director Karel Shook.

Arthur Mitchell

Arthur Mitchell, who was Harlem born, attended New York's High School of the Performing Arts in 1952. After his graduation, Mitchell received a scholarship to the American Ballet Theatre, one of the leading ballet companies in the United States. He also performed for highly acclaimed modern dancers such as Donald McKayle and Alvin Ailey. His acceptance into the New York City Ballet company was a landmark for African Americans. He was the first to become a lead male dancer in the company.

Balanchine was known for choreographing his own distinct style. He came to America with no preconceived prejudice or bias in regard to race, even though he came from a background of Russian dancers who appreciated the concept of visual uniformity. He was a nonconformist, which was part of his appeal as a unique artist.

©Oliver Morris/Hulton Archive/Getty Images

Arthur Mitchell

Balanchine, respectfully referred to as Mr. B by company members, inducted Arthur into the New York City Ballet. He choreographed roles that challenged Mitchell's training. One famous role, *Agon*, a duet created for Mitchell and one of Balanchine's select prima ballerinas, became a famous ballet receiving diverse responses. An African American male and a European American female participating in physically intertwined movements invoked mixed reactions. Balanchine frequently partnered Mitchell with European American ballerinas and performed those works globally (Emery, 1988). Most venues welcomed any choreographic works presented by the great George Balanchine. He did, however, receive resistance from some Southern theaters for the performance of *Agon*.

The Dance Theater of Harlem

Dance Theatre of Harlem honors Gladys Knight

©Adela Loconte/WireImage/Getty Images

Mitchell continued to train and perform with the New York City Ballet until the day of Dr. Martin Luther King Jr.'s assassination in 1968. The event was life changing for Mitchell, emotionally as well as professionally. He felt his expertise should be used as a service to young African American youth who did not have the exposure he was fortunate to receive. That day he decided he would found a school of ballet in Harlem, where he was raised. His desire was to expose and give others an opportunity to learn the ballet idiom without the pressure of expensive instruction rates. He approached Balanchine with his plan, aware that he could not dance professionally and successfully open a school. After receiving Balanchine's blessings, the school began with only two teachers and 30 students in a church basement (Emery, 1988). Within a few months he had approximately 400 students. With the support of George Balanchine, under the artistic direction of Mitchell, and training being provided by Mitchell and ballet master Karel Shook, Dance Theatre of Harlem (often called DTH) became an internationally acclaimed ballet company. Mitchell received accolades for his fortitude, dedication, demand for perfection, and beating the odds of the opposition by his European American artistic peers. Mitchell dispelled the myths against African Americans performing ballet-not through verbiage but through the presentation of brilliantly traineds. Dance Theatre of Harlem ranked with top ballet companies, such as the New York City Ballet and American Ballet Theatre.

The company has struggled financially because of the continual search for backers, a perpetual necessity in the ballet arena. During the late 1960s and 1970s, an African American Ballet company was unique and in vogue at a time when African American identity was a movement and everyone wanted to be a part of it. After the novelty had worn off, there was a constant need for financial support. DTH went on hiatus several times but never totally disbanded. As Arthur matured and the constant struggle for money and maintenance became wearisome, he got the company back on its feet and retired, passing the torch to his prima ballerina for many years, Virginia Johnson.

African American Pioneers

Even though African Americans were discouraged from pursuing ballet, there were a few who were not deterred. These pioneers weathered the criticism and struggled to fight for control of their own legacies.

Hemsley Winfield

Hemsley Winfield was born in Yonkers, New York, in 1906. His mother was a playwright and he was introduced to the artistic world early in his life. At the age of 25, Winfield organized the Negro Art Theatre Dance Group. In 1933, he directed the ballet for the Metropolitan Opera, *Emperor Jones.* In the production, he also played the role of the Witch Doctor.

Winfield was the first male African American to dance at the Metropolitan Opera. Unfortunately, he died of pneumonia at the early age of 27 (Emery, 1988).

Janet Collins

Known for her performance in the role of "Aida," Janet Collins was the premiere danseuse of the Metropolitan Opera Ballet from 1951 to 1954. She trained on the West Coast prior to her New York debut in 1949 (Emery, 1988). She had once auditioned for the Ballet Russes but was not accepted because of her race. She was told that either special parts would have to be created for her or she would have to paint her face white, which she refused to do(Emery, 1988). Collins continued to train and teach at the prestigious School of American Theatre and at the Inner City Cultural Center in Los Angeles (Emery, 1988). Having a body type that fit the accepted requirement of a ballerina, Collins became the first African American ballerina. Her contributions made inroads for other African American women.

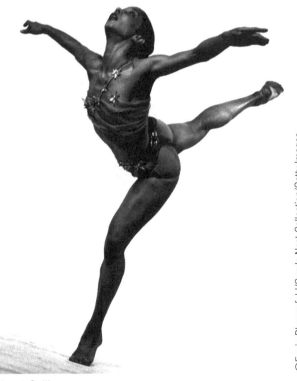

Janet Collins

Geoffrey Holder

A multifaceted artist, Geoffrey Holder has been gifted with outstanding tools to support his many ventures as a dancer, choreographer, costume designer, photographer, singer, visual artist, actor, and writer. At the age of 18, Holder inherited his brother's dance company based in Trinidad, where Holder was born. Eventually, he moved to New York to perform in the 1954 Broadway show *House of Flowers,* an all African American musical. He became the first male African American in the Joffrey Ballet, one of the top-tier ballet companies.

Holder left ballet and became the pitchman for 7-Up commercials. Geoffrey's distinctive thick Trini-dadian accent opened the way for many movie roles and voice-over opportunities. His film credits include *Annie*, *Boomerang*, and the James Bond movie *Live and Let Die*. He won a Tony Award for his direction and costume design for the critically acclaimed and successful Broadway musical *The Wiz*. He also designed the costumes for *Timbuktu* starring Eartha Kitt, a noted singer and dancer who was previously a Katherine Dunham company member. Geoffrey Holder went back to his ballet roots, choreographing and costuming an astounding ballet for the Dance Theatre of Harlem, entitled *Dougla Suite.* (Emery, 1988).

Geoffrey Holder with half of his face painted white in the James Bond movie *Live and Let Die.*

Louis Johnson

Louis Johnson started studying at the Jones–Haywood School of Dance in Washington D.C. Johnson was granted a scholarship to study at the School of American Ballet, which was a training ground for the New York City Ballet's potential company members. However, he did not graduate to the company

because of his race. He did perform in 1952 with the company in Jerome Robbins' *Ballade*. As most dancers of color, Johnson went to Broadway for work. He was exceptional in the *House of Flowers* and *Damn Yankees* musicals (Emery, 1988). Johnson began to receive accolades as a choreographer demonstrating his balletic background in his dance works. He choreographed *Lament* for Alvin Ailey, a lovely suite of Negro Spirituals, *No Outlet* and *Ode to Martin Luther King*. Johnson became the third African American choreographer at Metropolitan Opera where he created dances for *Aida* and *La Gioconda*. His groundbreaking choreography was recognized in *Treemonisha*, an opera found after the death of ragtime composer Scott Joplin.

Louis maintained his home in Washington D.C. where he codirected the D.C. Black Repertory Dance Company (1972–1977) with founder, Mike Malone. His most memorable choreographic work "which has become a classic in African American musical films" was *The Wiz*, starring Michael Jackson, Diana Ross, Nipsy Russell, Lena Horne, and Ted Ross.

The Wiz movie

Mike Malone

Malone was also cofounder of the Duke Ellington School of the Arts in 1974 with Peggy Cooper Cafriz. Charles Augins, chairman of the Duke Ellington School of the Arts dance department, was the ballet master for the D.C. Black Repertory Dance Company. Malone founded the based company Washington D.C. in 1971. Although ballet-trained Malone graduated from Georgetown University, he received a master's degree and studied French culture at the Sorbonne in France. While there, he met Josephine Baker who took him under her wing (Shinhoster Lamb, 2006.) Malone choreographed Broadway's *Great White Hope* (starring James Earl Jones) *Owen's Song*, and *The Black Nativity*. Most of his career was dedicated to exposing the youth to the arts using Street Theatre musical performances. The award-winning dancer, choreographer, and director Debbie Allen attributes Mike Malone for

reigniting her excitement for dance after her disappointment of being rejected from the North Carolina School of the Arts because of her physical body type. Mike was also instrumental in the training of Anthony Anderson ("Blackish") and Taraji Henson ("Empire"). He passed away at the age of 63.

Billy Wilson

Wilson was born in Philadelphia where he also trained. At the age of 19, he performed in the production of Carmen Jones at the City Center and in several other Broadway shows before moving on to join London's Production of *West Side Story*. For four years, he danced with the Dutch National Ballet starring as "Othello."

Returning to the states after 10 years in Europe, Billy Wilson taught dance at the Harvard University and Boston's National Center for Afro-American Arts. In the 1980s he created his own company, Dance Theatre of Boston. With Henry Le Tang, Wilson co-choreographed the Broadway show *Eubie*, and choreographed the hit *Bubbling Brown Sugar* in 1976.

He was nominated for three Tony Awards and he created, directed, and choreographed the all African American production of *Guys and Dolls,* along with choreographing the Emmy Award winning television show "Zoom."

Wilson also staged ballets in the Netherlands (Dunning, 1994)

Raven Wilkinson

Raven Wilkinson trained early but took ballet seriously at the age of nine after seeing Janet Collins perform in the 1950s. She started pursuing her career at the age of 15, leaving school to perform full time. In 1955, Wilkinson auditioned for the Ballet Russes de Monte Carlo and was accepted on a six-week trial. Wilkinson was fair skinned and her parents were warned not to let the public know she was African American. She kept her race a secret and performed with the company in the segregated South. Racial discrimination followed her professionally. She often was discouraged from furthering her career as a ballet performer. Exhausted from years of racism, Wilkinson left Ballet Russes De Monte Carlo. She auditioned for other companies but was not accepted.

Wilkinson joined a nunnery. However, in the 1960s she was invited to be a member of Holland's National Ballet. She left for Holland in 1967 and did not return until 1974. Misty Copeland acknowledged Wilkinson as an inspiration and admired her tenacity in overcoming racial struggles. Misty had to fight exactly the same conditions herself (Wilkinson n.d.).

Contemporary Times—New generation of African American Ballet Dancers and Choreographers

Oddly enough in this day and age, there is still much work to be done to break barriers regarding ballet protocol. Companies have held on to their archaic approach to the ballet dance form. African Americans were not deterred from dancing on the plantation, and ballet would not deny the African American dancer's use of the idiom for artistic movement expression. The New Generation created new ways to

produce their work. An overview follows, but because there are so many exciting examples of the relentless spirit of the African American, they cannot all be acknowledged in this study due to space and time.

Virginia Johnson

Virginia Johnson possessed a special gift of embodying a character in such a way that the audience could embrace the soul of the personality she portrayed. Not only technically strong, but also beautiful in her impeccable execution of movement, Virginia was a true performing artist. After retiring from performing for many years as a principal dancer at Dance Theatre of Harlem, Johnson embarked on a new project becoming the founder and editor-in-chief for POINTE magazine, the only dance magazine dedicated exclusively to the world of ballet. This periodical helped dancers prepare for the professional ballet world by developing educational seminars, lectures on health, auditions, and career preparation.

http://www.dancetheatreofharlem.org/directors

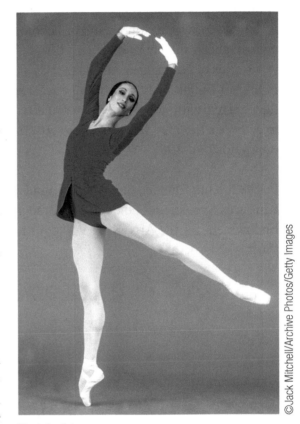

Virginia Johnson

©Jack Mitchell/Archive Photos/Getty Images

Born in Washington D.C., Johnson graduated from the Academy of the Washington School of Ballet. She started performing with Dance Theatre of Harlem (DTH) in 1969. Her principal roles were in *Agon*, *Street Car Named Desire*, *Fall River Legend* (for which she won the ACE award from Bravo Network), and *Swan Lake*. Her honors include the prestigious Dance Magazine Award, Young Achiever Award from the National Council of Women, Outstanding Young Women of America, and Pen and Brush Achievement Award. When Arthur Mitchell made the decision to retire, he passed the baton to Johnson. She is, to date, the Artistic Director of the Dance Theatre of Harlem.

Lauren Anderson

Lauren Anderson was a former principal dancer with the Houston Ballet. She was one of the first African American ballerinas to receive this position with this acclaimed ballet company. Ben Stevenson, the Artist Director of the Houston Ballet was responsible for her progression within the company. Anderson was inspired to dance when she attended a performance of the Dance Theatre of Harlem. She was shocked and thrilled to see young dancers of color on the stage performing in the ballet genre. She attributed the Houston Ballet as a trailblazer for African Americans in 1990. At that time she was named a principal dancer and remained with the company for over 25 years.

Bishop, Amy. 2016. "Up Close With Houston's Lauren Anderson" *Dance, Houston Public Media, A service of the University of Houston*. (Last updated: January 18, 2016, 9:51 am)

Lauren Anderson has retired from performing and manages the Ben Stevenson Academy's education and community outreach programs.

Alonzo King

Alonzo King's family history is closely linked to the African American struggle for political and social equality. Known as Americans of accomplishment his father, Slater King and his uncles inspired and advanced the cause of US civil rights. King is a choreographic legend who has worked in the repertories of companies such as the Alvin Ailey American Dance Theatre, Dance Theatre of Harlem, Frankfurt Ballet, and the Joffrey ballet. His choreographic style is centered on clean, classical ballet lines mixed with non-Western spirituality. King's signature creative movements require his dancers to be hyper-flexible, willing to push past their individual comfort zone. http://www.blackpast.org/aah /king-alonzo-c-1952

In 1982, King founded the Alonzo King LINES Ballet, an internationally acclaimed ballet company. King was a recipient of the NEA Choreographer's Fellowship, National Dance Project, and National Endowment for the Arts. King was a former commissioner for the city and county of San Francisco (Sofras, 2006).

Dwight Rhoden and Desmond Richardson

©Jack Mitchell/Archive Photos/Getty Images

Desmond Richardson, choreographer Dwight Rhoden, middle, and Christine Johnson.

Dwight Rhoden began dancing at the age of 17, a late beginning for a dancer. He was studying to be an actor before working as a principal dancer with the Alvin Ailey American Dance Theatre, The Dayton Contemporary Dance Company, and Les Ballet Jazz de Montreal. Rhoden has dedicated approximately 10+ years to the development of the critically acclaimed Complexions, Inc. along with Desmond Richardson. With Rhoden's artistic direction, Complexions has become a dance institute leading the way to innovation and cutting-edge programming. He has created over 80 ballets and choreographed on five continents and over 20 countries for companies such as the Alvin Ailey American Dance Theatre, BalletMet, Dance Theatre of Harlem, Joffrey Ballet, and New York City Ballet.

Richardson, hailed by the *New York Times* as "One of the great modern dancers of his time," was also a principal dancer for the Alvin Ailey American Dance Theatre. He performs in a vast range of dance genres. Richardson's roots began with hip-hop, he then mastered modern, classical, and contemporary ballet. He has been a guest artist of many notable companies such as the American Ballet Theatre, Royal Swedish Opera Ballet, and Aspen Santa Fe Ballet. Rhoden and Richardson built Complexions from the ground up and have used dance along with multimedia to express unity of art, creative passion, and diversity.(Sofras, 2006).

Misty Copeland

Misty Copeland did not have the economic status of most pursuing a career in ballet. Copeland found ballet while living in a hotel sharing a room with five siblings. At the age of 13 she demonstrated a natural gift for ballet technique. A prodigy, Copeland was dancing on pointe within three months of her first ballet class. She studied at San Francisco Ballet School and American Ballet Theatre's Summer Intensive. In 2001, Copeland joined American Ballet Theatre as a member of the corps de ballet. In 2015, Misty Copeland made history as the first African American female principal dancer with American Ballet Theatre. She was the first African American woman to be promoted to the position in the company's 75-year history.

Her accomplishment was realized through persistent fortitude to prove her value and break the stereotypes of her race and muscular body type. Her effort was a triumph for children of color who dream to dance in a ballet company. Critics of the African American being suitable for a European art form had to bow to Copeland's historical breakthrough.

Misty Copeland

Copeland took advantage of unconventional opportunities to expose her gift, even if it was not on the stage with a ballet company. She collaborated and toured with Prince, showcased her talent in commercials, promotions, and endorsements. Copeland was one of the faces of Under Armour's, "I Will What I Want" commercial going viral in 2014. In the midst of other opportunities, Copeland never lost sight of her dream of being honored by the American Ballet Theatre as a principal dancer.

One of Misty's passions is to advance the training of young aspiring ballet dancers. In 2014, President Obama appointed her to the President's Council on Fitness, Sports, and Nutrition.

http://mistycopeland.com/about/

Michaela DePrince

©Gallo Images/Getty Images

Michaela DePrince

Michaela DePrince was born in an orphanage in Sierra Leon. Her father was killed by the "debils" (Rebels and Devils in tandem) and her mother died of Lassa fever. Throughout her life in Africa, Michaela was called the "devil child," the "spotted child," or "the witch child" due to a skin condition. She saw many atrocities growing up, including the brutal killing and mutilation of her favorite teacher. In the midst of Michaela trying to flee from the rebels, a magazine blew in her direction during a strong wind. A ballerina gracing the cover, standing on her toes appearing happy and free, was to her a picture of beauty and freedom. She held on to this image of hope. (DePrince, 2014).

DePrince (known as Number 27 at the orphanage) had another friend, 26. They both were adopted together. Away from the hostile environment and the struggle for survival, the picture of a ballerina became the dream that began with her adoption. Accompanied by the support of her adoptive parents and love for the ballet, Michaela pursued her dance studies at the Rock School in Philadelphia. Eventually, she was accepted at the Dance Theatre of Harlem where she received ballet education of a

different sort. Michaela learned how African Americans had to adjust to the principles of the European dance form. Europeans wore pink tights to match their skin tone, which made their legs appear longer while the pink shoes extended the look or line of the feet. It accentuated the turnout and revealed the pronounced but subtle musculature resulting from ballet training. At Dance Theatre of Harlem Michaela learned how African Americans compensated for that particular ballet aesthetic. Ballerinas of color dyed their tights and shoes (ballet and pointe shoes) to match their skin tone. (DePrince, 2014).

Dance Theatre of Harlem is considered a neoclassical ballet company, heavily influenced by George Balanchine. Consequently, Michaela received invaluable training under the tutelage of Arthur Mitchell. DePrince was invited to join the contemporary company, Alonzo Kings LINES ballet, but declined; she was more interested in the classical ballet aesthetic (DePrince, 2014). DePrince appeared in the movie *First Position* and has become a member of the prestigious world-famous Dutch National Ballet.

Aesha Ash

At the age of 13, Aesha Ash was accepted into the School of American Ballet, which was a coveted honor. She also won the Mae L. Wien Award for Outstanding Promise, and the New York City Ballet, another coveted honor, was bestowed on Aesha at the age of 18. She then moved on to be a soloist at the Bajart Ballet in Switzerland in 2003. Aesha's career is a storybook journey with the acceptance in three of the top-tier ballet companies in the world. Her next adventure involved working in a contemporary ballet company, the Alonzo King LINES Ballet, one of the most innovative premier ballet companies globally. Ash's heart however, was with the youth. She retired in 2008 to start the Swan Dreams Project to inspire her community of impressionable young people and especially girls. She started by posting her photo around the community to give young ladies a sense of worth and possibility. The power of a photo has been proven through the life story of Michaela DePrince. A photo of a ballerina sustained her through horrific experiences and struggles as a young girl in her war-torn living conditions. For her work to that end, Ash has received an award from the National Women's History Museum and was featured in The Ballerina's Little Black Book.

https://www.dancemagazine.com/aesha-ash-rochester-tutu-2307053851.htm

Modern Dancer

As discussed in the previous chapter, requirements for fulfilling a ballet career for an African American had its share of challenges due to stereotypical restrictions and archaic mindsets in line with European aesthetics. It was judicious for African Americans and other cultures of color to venture into a dance career that offered some stability, an art form with no restrictions on age, ethnicity, or body type.

Americans wanted to identify their own dance form, a new form that was not imported. They resisted themes of fairies and enchanted beings in beautiful sparkling costumes and stories which in their view, did not challenge the mind intellectually. This group of dance pioneers sought to comment on issues relevant to the contemporary time. They were determined to define a new genre. It was called Modern Dance.

Modern dance began as a rebellion against ballet. Elements of modern dance philosophy were direct opposite of ballet. A dancer aspiring to become a professional ballet artist would have needed to start training at the age of 6 in order to establish the unnatural turned out positions necessary for ballet technique. In contrast, modern dance had no strict turnout requirement. Its focus was the natural anatomical use of the body. Age was not a factor to begin preparation for a career in the dance idiom. Ballet was performed in ballet shoes or pointe shoes. Modern dancers enjoyed the feel of the floor and required no shoes.

Bare feet satisfied a natural connection to the earth. Classical ballet embraced themes with a storyline. Modern dance explored thought provoking material or contemporary issues. It utilized the turnout but recognized that it was not a natural way for the body to move and, consequently, developed techniques that were initiated by organic movements such as jumping, skipping, walking, running and parallel leg positions. Parallel is a natural position with toes facing in a frontal direction. The concert stage for classical ballet was often extravagant. The modern dance concert stage tended to be simplistic or abstract in the use of sets and props. Ballet specialized in the articulated pointed foot. Modern dance utilized the pointed foot but also chose to use the flexed foot. This concept was consistent with the philosophy of natural movement. Realistically, the fetal position of the foot in the womb was not pointed, but flexed.

Leading choreographers of the early period sought to explore and develop their own movement vocabulary. African Americans recognized that this dance idiom was more conducive to the messages they wanted to convey and that through this they could give voice to their own ideologies. For African Americans, modern dance allowed the freedom to express social realities as understood by the artists. It offered a psychological and therapeutic response to the challenges of the daily struggles of the culture-not to solicit public pity but to proclaim the victory that resulted from the bold confrontation of the socioeconomic or political issues of the time. African Americans used the dance to celebrate their fortitude and triumph that pushed past obstacles to success. Racism was not absent altogether in modern dance. Nonetheless, with certain freedoms available, a door of expression was opened.

Modern dance was guided by natural rational themes of movement. Philosophy was a major element in the choreographer's mind. Techniques were developed with cerebral cognition. Ballet used its technical precision for visual choices. Modern dance took anatomical considerations into account and revisited movement using a philosophical motivation with the added knowledge of the body and its natural alignment. Personal revelations birthed different approaches to movement technique. Two examples would come from the European American icons, Martha Graham and Doris Humphrey who solidified two modern dance techniques.

Martha Graham, an European American known as the "Mother of Modern Dance," based her technique on the concept of contraction and release, the connection of movement to the rhythm of the breath in the inhalation and exhalation of the body. In her work she followed the reality that human life in birth comes from the pelvic area and movement should begin and end from that region of the body. One of Martha Graham's admirable contributions to American modern dance was her addition of people of color to her company during a period that had practiced limitations on diversity (Kraus, 1999).

Humphrey, another European American modern dance pioneer, viewed all human movement as existing in a transitional balance state of equilibrium, a view that led to the creation of the technique "fall and recovery."

Modern dance went through various stages of growth. Choreographers seeking new ways of moving investigated elements, explored qualities of movement, and established innovative techniques . This evolution can be divided into three periods: Early, Middle, and Late (or Contemporary). African American pioneers contributed in all three periods.

The Early Period (1900–1945)

The early period of modern dance was that of exploration. Attempting to find the seeds to nurture techniques, African Americans saw the benefit of approaching dance from a natural perspective. The concept of contraction and release was not foreign, even though the approach to the execution of the movement was different. African Americans had experienced a similar awareness in their cultural roots of African Dance. The concept of the power of movement centralized from the pelvic region was the crux of African Dance movement. Pioneers of African Dance looked within the aesthetic elements of the African dance diaspora to find physical truths on which to base their techniques. Even though there were less restrictions for African Americans in modern dance, the performance opportunities were still limited. Therefore, African Americans had to strike out on their own to create a platform for expression.

The two prominent African American icons exploring movement within the perimeters of the Early Period were Katherine Dunham and Pearl Primus.

Artists of the Early Period

The Early period of modern dance was a time of exploration. Katherine Dunham and Pearl Primus had similar motivations for seeking out related movement initiatives. Katherine Dunham centered on the Afro-Caribbean movement, particularly Haiti and Pearl Primus focused on the continent of Africa. Both knew the essence of the African aesthetic had been overlooked on the concert stage and studying the roots would provide personal cultural consciousness and knowledge in addition to the research material needed to share their findings with the arts community and world at large. Both women's contributions were discussed in Chapter 3; however, it is pertinent to note that each of these legendary icons revealed the legitimate value of the African American dancer/choreographer and ignited African American pride.

Graham dancer

©lev radin/Shutterstock.com

The Dunham technique is a strong demanding movement vocabulary that has existed through time. It is a very specific and detailed execution of movement dynamics that involve strength and stamina in the entire body. Dunham developed progression of movements across the floor—one movement phrase evolved into an extended and more difficult movement. Those phrases were then challenged in the next movement progression.

The Dunham technique satisfied several dance idioms: African, modern, and jazz. Both Pearl Primus and Katherine Dunham choreographed works to themes focused on their research and civil

rights. One of Pearl Primus' signature works was *Negro Speaks of Rivers*, a piece using the poetry of Langston Hughes, a famous African American social activist, novelist, playwright, and author. The theme of her work *Strange Fruit* focused on the lynchings of African Americans in the south. Dunham's signature piece, *Shango* was a production educating the audience on the essence of the ritual movement of Haiti.

Similarities between Katherine Dunham and Pearl Primus

1. Grant recipients
2. African American female anthropologists
3. Company founders
4. Owners of dance academies
5. Teachers, dancers and choreographers
6. Highly respected by the cultures they researched
7. Civil rights activists

The Middle Period (1940–1970)

The Middle period established modern dance techniques and modern dance masters who were trained disciples to disseminate their concepts. It is in this period that ballet dancers and modern dancers developed a healthy appreciation for their respective dance forms. They previously looked at each other with disdain. Each were very territorial and held their techniques as sacred but the influence of modern dance on Russian ballet encouraged modern and ballet dancers to see value in both dance forms. One technique enhanced the other.

It was clear to the African American dancers that focusing on achieving expertise in only one dance form would not provide a functionally economic lifestyle for survival. Consequently, the African American became proficient in multiple dance forms.

Artists of the Middle Period

Talley Beatty

Talley Beatty was one of the nine original Dunham dancers. Beatty performed in 1937 with the company in New York's *Negro Dancing Evening*. In 1940 he performed with Le Jazz Hot. He was featured in the minstrel-ballet for the Ballet Society. Talley founded his own company in 1946. The company survived for five years touring the United States and Europe. He used the Dunham technical formatting in the creation of his dances (Emery, 1988). His full work entitled *Southern Landscape* contained a section, *The Mourner's Bench*, which became Talley's signature piece. "The Road to Phoebe Snow" was another popular and impressive piece recreated on many companies including the Alvin Ailey American Dance Theatre. The work was extremely demanding and the dancers were required to be technically proficient, along with the ability to execute extremely quick movements.

Donald McKayle

Donald McKayle, born in New York City in 1930, was inspired to dance after seeing Pearl Primus perform. Winning a scholarship to the New Dance Group gave McKayle the opportunity to study with Primus. In 1955, he won another scholarship to the Martha Graham School to study with Graham and perform in her company. During his career McKayle danced with numerous companies and was able to experience the Broadway stage.

He appeared in *Bless You All*, choreographed by modern dance icon Helen Tamaris and legend Daniel Nagrin. McKayle performed in *House of Flowers* and became dance captain for *West Side Story*. His association with Daniel Nagrin afforded him an opportunity to choreograph his own works. Nagrin and McKayle were instrumental in forming the Contemporary Dance Group. Through their joint concert at Hunter's College, McKayle's work *Games* was debuted and eventually became a classic. It

Donald McKayle

was his first choreographic piece using movement motifs of children from different ethnicities playing games created on the streets of an urban community (Emery, 1988). In 1959 he created what I consider his signature piece, *Rainbow Round My Shoulder*. This work was inspired by the music and rhythmic nature of the work of the chain gangs. A large cast of males wearing pants, but shirtless filled the stage. The men crossed their hands to give the illusion of being bound by chains. There was one woman in the piece who symbolized love and hope, performed by the beautiful and stunning African American Graham dancer, Mary Hinkson. This work is in the repertoire of the Alvin Ailey American Dance Theatre. In 1986, McKayle restaged his Games for the Chuck Davis African American Dance Ensemble.

Some of McKayle's Broadway credits include Sammy Davis Jr's *Golden Boy* and Disney's production *Bed-Kobs and Broomsticks*. McKayle was nominated for a Tony Award for his contribution to the choreography of *Sophisticated Lady* starring Gregory Hines and Judith Jamison.

Walter Nicks

Katherine Dunham had many disciples. Two of the strongest were Talley Beatty and Walter Nicks. Nicks trained with Eleanor Frampton at the well renowned Karamu House in Cleveland. He became certified as a master teacher of the Katherine Dunham technique and associate director of the Dunham School from 1947 to 1953. With iconic mastery, Nicks was trusted by Dunham to spread her technique worldwide.

Nicks was a part of the black modern dance renaissance in the 1950s. He performed in one of Donald McKayle's iconic choreographic works, *"Games"*, and choreographed several television specials

for Harry Belafonte. As a historical tribute to the performing history of African-Americans, Nicks choreographed a bold work entitled "Jump, Jim Crow".

Eleo Pomare

Eleo Pomare was born in Colombia, South America but raised in Panama and Harlem. In 1958, Eleo started his own company in Europe with rave reviews. Europe became his home until James Baldwin, the acclaimed African American author, invited him to return to the United States to participate in the "March on Washington." He was so impressed with the Civil Rights Movement that he moved to the United States and in 1966 made his major New York debut. Among Pomare's works was *Blues for the Jungle*. His signature piece, *Junkie*, emerged from this work about life on the Harlem streets. He was also recognized for his works *Desenamorados* and for *Roots*. Pomare produced strong confrontational works and was fearless in his sometimes controversial choreographic themes.

Rod Rogers

Rod Rodgers grew up in Detroit before moving to New York. He studied with dance legends Honya Holm and Erick Hawkins, becoming a member of the Eric Hawkins dance company. When Rogers struck out on his own, his works were centered on purely abstract movements. His signature work was entitled *Rhythm Ritual*. He also choreographed *King . . . the Dream*, a dance honoring Martin Luther King, Sr., who died the week it opened (Emery, 1988). Rodger's company works have gone into the repertoire of major African American Ensembles such as Philadanco and Cleo Parker-Robinson Dance.

Mary Hinkson

Martha Graham *

Mary Hinkson

Letter to the World (The Kick) from Martha Graham (F. & S. 389) 1986 (screenprint in colours), Warhol, Andy (1928–87)/Private Collection / Photo (c) Christie's Images / Bridgeman Images. (c) 2018 The Andy Warhol Foundation for the Visual Arts, Inc./Licensed by Artists Rights Society (ARS), New York

Mary Hinkson was the first African American woman accepted into the Martha Graham dance company. Graham, considered the mother of modern dance, welcomed diversity in her aesthetic. Hinkson became the quintessential Graham dancer. She would inherit many of Graham's own roles.

Hinkson majored in dance at the University of Wisconsin. In 1951 she went to study at the Graham School in New York and became a member of the company. While her principal activity was in the Graham Company, she also appeared in *Carmina Burana* with the New York City Opera and George Balanchine's *Figure in the Carpet* with the New York City Ballet. In 1964 and 1966 she was an invited guest performer in *Rivercare* with the American Ballet Theatre (Long, 1989). Hinkson received the prestigious Martha Hill Dance Award and broke racial barriers during the Civil Rights Movement.

Carmen de Lavallade

Carmen de Lavallade was a strong influence on Alvin Ailey. Due to their friendship, Ailey became a dancer and was affiliated with the legendary Lester Horton, a European American who loved the beauty of diversity and celebrated it in his choreography and company membership.

De Lavallade's diligence to attend dance classes drew Ailey's attention. She invited him to accompany her. Eventually, they joined Horton's company. Ailey and De Lavallade continued to work together after the Horton company disbanded. When Ailey started his New York company, The Alvin Ailey American Dance Theatre, De Lavallade was one of his principal dancers.

She performed with the Metropolitan Opera Ballet as a prima ballerina, 1955–1956. In 1966, Carmen was awarded the prestigious *Dance Magazine Award*. Along with Ailey, she performed in the *House of Flowers* on Broadway. She was a guest artist for Donald McKayle and her husband Geoffrey Holder. Being Holder's wife and Janet Collin's cousin, De Lavallade was surrounded by dance. (Emery, 1989).

DeLavallade, left, Baker, right

©AGIP/Bridgeman Images

Because employment was scarce for a dancer (except for African Americans who fit the ballet mold, performing mostly as characters in ballets) modern dance became another dance form to use alternately. African Americans became crossover dance artists. Carmen de Lavallade and her cousin, Janet Collins were two such performers.

Alvin Ailey

Revelations

Born in Texas in 1931, Alvin Ailey attended a concert as a junior high school student and was mesmerized as he sat and watched the Katherine Dunham Dance Company. An athletic student, Alvin participated in sports but did not venture into dance study until after he graduated. As a Romance language major, Ailey enrolled in UCLA where he was introduced to the Lester Horton Dance Theatre by Carmen de Lavallade(Thorpe, 1989). He became a major member of the company, taking it over upon Horton's death. He was invited to the Jacob's Pillow Festival, a prestigious festival highlighting highly acclaimed companies. Ailey performed in the production of *House of Flowers* while continuing his training with Martha Graham, Doris Humphrey, Hanya Holm, Ana Sokolow, and Karel Shook. Ailey also partnered with Mary Hinkson in Harry Belafonte's *Sing, Man, Sing*.

Ailey presented his first concert in New York City featuring Talley Beatty as a guest artist. He was soon to form the Alvin Ailey American Dance Theatre, which was based on the idea of the total dance theatre experience. The company was integrated, but primarily composed of African Americans.

Although they embraced modern dance more than ballet, African American modern dance company founders still struggled in regard to funding. Even European American companies did not receive high ranking for grant considerations. Dance was not a priority. Board of Directors were charged with the issue of seeking donations and support. The wealthier the members

Young Alvin Ailey

of the Board, the more money was likely to circulate as support. Most modern dance companies struggled because the wealthier donors tended to give to ballet. Recognizing the plight of free-lance choreograpers, established companies would allow emerging artists to use their members to produce work. This idea was graciously implemented by the Alvin Ailey American Ballet Theatre. Ailey wanted his company to be a haven for the talent that didn't have the opportunity to show their work or didn't have the financial capability to start their own company. He desired his company to be a conduit for African American artistic expression. Ailey hired stellar dancers to be used choreographically by himself and by new emerging and established artists. Among those dancers were Carmen de Lavallade, Judith Jamison, Dudley Williams, George Faison, Michell Murray, and others throughout the years.

Ailey's choreographic aesthetic was eclectic, meaning it moved from jazz to classical ballet, ethnic, Dunham, Graham techniques, and could include innovative styles of emergent choreographers. His signature work was *Revelations*, staged at every performance with no exceptions. *Revelations* is a suite of Negro Spirituals visualized through the choreography of Ailey and the blood memories of his early years worshipping in church.

Under the auspices of US Department of State, the Alvin Ailey American Dance Theatre traveled throughout Australia and the Far East. The company received 20 curtain calls in Sydney. It has been one of America's cultural ambassadors, touring the United States, Europe, Asia, and Africa.

To date, Robert Battle is the Artistic Director of the Alvin Ailey American Dance Theatre.

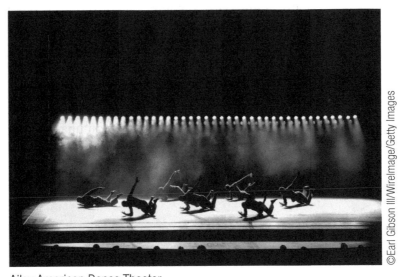

Ailey American Dance Theater

Judith Jamison

Judith Jamison was born in Philadelphia in 1944. Her study began at the Judimar School of Dance at the age of 6 with a focus on ballet. She attended Fisk University in Nashville, Tennessee majoring in psychology, but her heart was in dance. Jamison was discovered by the great choreographer Agnes De Mille who put Jamison in her signature work, the *Four Marys*. In 1965, The American Ballet Theatre

employed the *Four Marys* team to perform for their spring season. The employment afforded Jamison the opportunity to attend classes at the American Ballet Theatre.

Jamison was a tall dancer, an attribute not coveted in the ballet field. She had an opportunity to audition for Donald McKayle. She didn't get the job but did catch the eye of Alvin Ailey who was sitting in the audience. He tracked her down and in 1965, Jamison made her debut as a member of the Alvin Ailey American Dance Theatre. By 1970 Jamison was a principal dancer with the company and was invited to perform with other icons including the legendary Mikhail Baryshnikov. She was said to be Ailey's muse and performed one of his greatest solos, *Cry*. Jamison also had a principal role in Ailey's signature work, *Revelations*. In 1981 Jamison took a leave of absence to perform a leading character in the Broadway hit *Sophisticated Lady* sharing the stage with the iconic hoofer Gregory Hines.

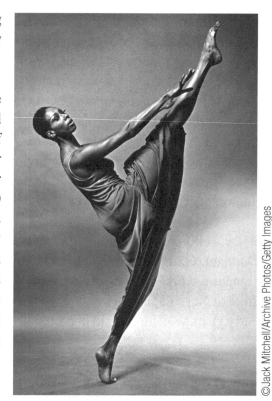

Judith Jamison

©Jack Mitchell/Archive Photos/Getty Images

Jamison eventually struck out on her own and founded her own company, the Jamison Project in 1988. The company presented Jamison's choreography and had a successful run until 1989 when Alvin Ailey passed away and she was invited to become the Artistic Director of the Alvin Ailey American Dance Theatre. Jamison's signature piece, *Hymn*, was a beautifully crafted work choreographed with movement and spoken word, which paid tribute to a man who influenced a generation of artists, Alvin Ailey.

Judith Jamison accepted her unique physicality and was an inspiration to young African American girls desiring to become professional dancers. They saw her perform with dignity and grace, in a majestic manner even though she did not have an idyllic ballet body. Jamison unapologetically maintained a short Afro in a profession that demanded compliance to rules and acceptable European American visual aesthetic. Her short Afro may have been misconstrued as militant to those who didn't understand her celebration of her African heritage.

Robert Battle

Robert Battle's journey to become the Artistic Director of the Alvin Ailey American Dance Theatre began with his training in Miami, Florida at a high school arts magnet school. Afterward, Battle studied at the Julliard School in New York. Professionally, Battle performed with the Parsons Dance Company and also set a work on the movement theatre. Battle then founded his own company, "Battleworks Dance" in 2001. He was honored at the Kennedy Center as one of the "Masters of African-American Choreography". Battle became known for his fast-paced energetic treatment of his creations, and was commissioned to choreograph a work for Ailey II in 1999, which began his relationship with the Alvin Ailey American Dance Theatre company. That opportunity opened the door for more of his

works to be presented by the company, notably *Juba* (2003) and *In/Side* (2009). In 2010, upon the retirement of Judith Jamison, the company's then Artistic Director, Battle was passed the torch to be her successor. He has only been the third to head the Alvin Ailey American Dance Theatre. Within the company, Battle established the New Directions Choreography Lab, targeting aspiring and gifted choreographers. The program granted fellowships, feedback and support to hopeful choreographers. The effort was to guide awardees and share fine tuning tools for works of promise.

Robert Battle received the prestigious Statue Award of the Princess Grace Foundation-USA, Honorary Doctorate from the University of the Arts and was named 2015 Visiting Fellow for the Art of Change.

Encyclopedia Britannica, Bauer, Patricia Robert Battle American Dancer a Choreographer https://www.britannica.com/biography/Robert-Battle http://pressroom.alvinailey.org/alvin-ailey-american-dance-theater/directors/robert-battle

Johnny Nunez/Getty Images Entertainment/Getty Images

International Association of Blacks in Dance

The opportunity for freedom in movement expression was greater in modern dance than ballet. African Americans continued to fight for their company's survival and ability to articulate innovative art. Even if African Americans had the qualifications for funding, they were at the bottom of the artistic totem pole for grants, fellowships and other avenues of funding. African Americans knew their application would be considered only if there was money available after everyone else was supported.

Joan Myers Brown had the brilliance and foresight to address those needs when she, with the support of four prestigious African American female artistic directors of established African American companies, founded the International Association of Blacks in Dance (IABD). Joan Myers Brown had been successful as an African American entrepreneur who had established her company PHILADANCO in Philadelphia. Cleo Parker-Robinson a ground-breaking artist in Denver became the founder and Artistic Director of Cleo Parker Robinson Dance. Ann Williams brought a representation of African American dance to the rich state of Texas by directing and establishing the Dallas Black Dance Theatre. Jeraldyne Blunden, an African American pioneer from Ohio, created a company of dancers, the Dayton Contemporary Dance

Company (DCDC) now under the direction of Debbie Blunden-Diggs, her daughter. Lula Washington founded and assembled the Lula Washington Dance Theatre in Los Angeles, California. Denise Saunders Thompson is, to date, the president and CEO of the IABD. The first five African American women initiated and pioneered the IABD over 25 years ago. It has been the oldest, largest, and only one of its kind.

A national service organization for Black dance professionals, the International Association, has become a Mecca for administrators, artists, choreographers, dance companies, directors, educators, scholars, and those interested in artistry, black dance issues, and performance presentations. Founded in 1991, IABD responded to and initiated dialogue around issues that impact the African American dance community as well as the dance community at large. IABD has developed national prominence and allowed the Black dance community to come together on issues of importance. The conference and festival of IABD has grown to include approximately 700 global participants.

IABD has established archives with the National Afro-American Historical and Cultural Museum (Wilberforce, Ohio) the Afro-American Museum (Philadelphia, Pennsylvania) the Moorland-Spingarn Research Center, and Howard University (Washington DC).

Throughout the years (along with those previously mentioned) The Association and Conference has been shaped by board members and prominent individuals in the dance community including Chuck Davis, Walter Nicks, Eleo Pomare, Carmen de LaVallade, Donald McKayle, Muntu Dance Theatre, Rod Rodgers, Carol Foster, Charles Augins, Abdel Salaam, Sherill Berryman Johnson, Yvonne Walker, Dora Rae Vactor, Vivine Scarlett, Katherine Smith, Linda Cleveland Simmons, Beverly Harper, Malik Robinson, Sandra Foster-King, Tamica Washington Miller, and Vikki Baltimore Dale, to acknowledge only a few.

Over four days, participants of IABD conferences engage in invaluable professional networking opportunities, workshops, panel sessions, and performance presentations which include dance organizations from around the country and abroad.

In 2016, IABD (spearheaded by Joan Myers Brown and organized by Denise Saunders Thompson and Cleo Parker Robinson) successfully provided the first audition platform for ballet companies to come to Denver to audition ballerinas of color. This (the first of its kind) afforded an opportunity for representatives from ballet companies, who chose to offer more diversity, to audition ballerinas of color at one time, in one place, with an abundance of stellar talent for selection.

http://www.iabdassociation.org/highlights-and-milestones

Many of the African American artists discussed below have birthed and nurtured their own companies and established them as vital artistic and educational outlets of training for young aspiring African Americans to find their voice in the dance world. So often the mainstream art world wants to label a company and focus on its works more than another, especially regarding companies of color. There remains the token concept. The most acclaimed African American ballet company was Dance Theatre of Harlem and modern company, the Alvin Ailey American Dance Theatre. The list then pauses, but there are a large number of growing and established companies that are on par with the above honored companies. A few will be mentioned, but many more exist.

Joan Myers Brown—PHILADANCO

Joan Myers Brown founded the Philadelphia Dance Company, PHILADANCO, and the Philadelphia School of Dance Arts. Brown has established an internationally acclaimed dance company of proficient technicians. The company travels globally and Brown commissions original works by emerging freelance choreographers such as Christopher Huggins and Ray Mercer, as well as celebrated dance legends. As an artist and entrepreneur, Brown has been successful in creating a safe place where young talented dancers of color could find a home in the performance landscape. Joan is an iconic visionary in the dance world. She was trained in ballet and projects the discipline and work ethic of her prolific career onto her students and professional dancers.

Joan Myers Brown serves as honorary chairperson for the International Association of Blacks in Dance, which was established in 1991. She has received honorary doctorates from the University of the Arts and Ursinus College in Pennsylvania. In 2011, her legacy was documented in a publication by scholar Brenda Dixon Gottschild, *Joan Myers Brown & the Audacious Hope of the Black Ballerina: A Biohistory of American Performance.*

Brown received the prestigious 2012 National Medal of the Arts presented to her by President Barack Obama at the White House in 2013.

Joan Myers Brown received the 2012 National Medal of the Arts presented by then President Barack Obama.

©Mandel Ngan/AFP/Getty Images

http://www.philadanco.org/about/brown.php

Cleo Parker-Robinson

©Cyrus McCrimmon/Denver Post/Getty Images

Cleo Parker Robinson and dance company

Cleo Parker Robinson is known as the ambassador of love. Her philosophy, "One Spirit, Many Voices," was reflected in the spiritual interpretation of movement as expressed in her teaching, choreography, and relationship with her company and staff. Her reference to anyone she encounters and her immediate nickname for them is "Sugar." Her philosophy of "One Spirit, Many Voices" gives her the drive necessary to be a pioneer of the African American aesthetic she has exposed globally as a cultural ambassador.

Cleo Parker-Robinson was born of mixed parentage, her mother was European American and father African American. Her experiences of race relations ran deep in her psyche seeing what her parents endured to stay committed to their marriage through weathering many racially provoked circumstances. At the age of 10, when her parents separated for a brief period of time, Cleo lived with her mother in Dallas where she had to drink out of the "colored fountain" and her mother the "white-only fountain." As a child she had health concerns that debilitated her for a period of time. She viewed mustering up the strength to survive as a defining life experience. (Eichenbaum, 2004).

Cleo studied with the legendary dance pioneer, Katherine Dunham. This introduction to the celebration of cultural awareness with its differences and similarities sparked the elements of dance with which Cleo could make physical sense. Cleo knew her deepest desire was to expose African American dance to the African American and European world. She established the Cleo Parker Robinson Dance Ensemble out of Denver, and has become a cultural ambassador performing with her Ensemble in places as diverse as Iceland, Singapore, Hawaii, Nassau, Belize, Israel, Egypt, Turkey, throughout Europe, and throughout the African continent. Cleo matured her company with commissioned freelance choreographers' works of different genres like Donald McKayle, Ron Brown, Christopher Huggins, Vikki Baltimore-Dale and others, as well as herself. Always with African rooted aesthetic or representation.

Cleo Parker-Robinson's accomplishments make a long list of awards and accolades, which include an Honorary Doctorate from Denver University (1991). In 1998, President Clinton named Ms. Parker Robinson as one of two artists to be appointed to the National Council on the Arts where she served until 2005. Cleo received a Kennedy Center Medal of Honor during the Center's "Masters of African American Choreographers" series, in 2005. In 2008, she was awarded the President's Award of the Greater Metro Denver Ministerial Alliance, the Civil Rights Award of the Anti-Defamation League, and the Civil Rights Medallion of the Rachel B. Noel Distinguished Visiting Professorship program. In 2017, she received the prestigious Dance USA Award.

Ann M. Williams

Ann Williams is the founder & Artistic Advisor of Dallas Black Dance Theatre. In May 2014, Williams officially retired as Artistic Director of the organization. Ann M. Williams is a founding member of the Dance Council and The International Association of Blacks in Dance. Ms. Williams received her formal dance training under Barbara Hollis (a member of the Katherine Dunham Dance Company), Doris Humphrey, and Charles Weidman. She took further training under legends Alvin Ailey and Arthur Mitchell. Williams earned a Master of Arts Degree in Dance and Related Arts from Texas Women's University, honorary Doctor of Humanities degree from Northwood University, and in May 2008 was awarded an Honorary Doctor of Philosophy in Dance from TWU. In 2005, Williams was honored at The Kennedy Center in Washington DC as a part of the Masters of African American Choreography series. For nearly 40 years, Williams has directed Dallas Black Dance Theatre from a community-based and semi-professional organization to a full professional

dance company. The company has traveled internationally and performed works by Ulysses Dove, Christopher Huggins, Milton Myers, David Parsons, and others. Ann Williams has a street named after her in Dallas, Texas.

http://www iabdassociation.org/ann-williams

Lula Washington

Lula Washington and Dance Company

Lula Washington and husband, Ewin saw a need for a creative outlet to guide minority artists of dance in the inner city. Together they pooled their resources and founded the Lula Washington Dance Theatre (LWDT) in 1980.

Lula had her first experience in dance at the Harbor Community College. After seeing a performance of the Alvin Ailey American Dance Theatre, she pursued dance as a career. She applied to the University of California, Los Angeles (UCLA) for a dance course but was rejected because of her age. She was 22. Unrelenting and through sheer determination, Lula convinced the dean that she deserved an opportunity to prove herself, which she did. During her time of matriculation at UCLA, Lula performed extensively on television and in films. The experiences prepared her for the choreography she created for the highly acclaimed movie *AVATAR*.

Lula founded her company with a repertoire that included works by Donald McKayle, Katherine Dunham, Donald Byrd, Rennie Harris, Louis Johnson, and Christopher Huggins, in addition to her and her daughter, Tamica Washington-Miller's works. Choreographically, Lula's movement vocabulary incorporates modern, street, theatrical, ballet, and hip-hop dance.

In 1983, she opened a dance school providing youth training with free classes to students in the neighborhood. The instruction operated through an after-school program entitled "I Do Dance, Not Drugs."

http://www.lulawashington.org/foundation/about-lula-washington/

Jeraldyne Blunden

Jeraldyne Blunden studied with Martha Graham, José Limón, George Balanchine, and James Truitte, instructors who later became her professional peers and personal friends.

In 1968, she established Dayton Contemporary Dance Company (DCDC), a culturally diverse dance company which still exists under the artistic direction of Blunden's daughter, Debbie Blunden-Diggs.

Blunden has been awarded the Katherine Dunham Achievement Award (1998), the Dance Magazine Award (1998), the National Black Festival's Lifetime Achievement Award (1998), and Dance Women Living Legend Honors (1997). Blunden was awarded honorary doctorate degrees from University of Dayton and Wright State University.

In 1999, Jeraldyne Blunden passed at the age of 58, having built one of the nation's leading performing dance arts companies, the Dayton Contemporary Dance Company.

http://www.dcdc.org/founder

Denise Saunders Thompson

Denise Saunders Thompson has extensive experience in both nonprofit and for-profit, established or start-up, organizations. She is sought by organizations for administrative, programmatic, and fundraising issues including strategic plans, policy and procedures, communications programs, budgeting and contracts. Denise is the president and CEO of the International Association of Blacks in Dance.

Denise Saunders-Thompson, formerly a professor at Howard University as Theatre Manager/Producing Artistic Director for the Department of Theatre Arts and Manager of Cramton Auditorium, also held positions at The John F. Kennedy Center for the Performing Arts, Debbie Allen Dance Academy, Alliance Theatre Company, and National Black Arts Festival. She is the business of show business. http://www.iabdassociation.org/denise-thompson

Modern Dance Attire

As in ballet, modern dance classes had protocol regarding classroom attire. Clothing was not as strict as in ballet but there were specific requirements for being accepted in the class. Modern dance did not insist on pink tights. In fact, it was somewhat frowned upon due to its overemphasis in ballet. The original, traditional look was different from what might be seen in a modern dance class today. Most colors were acceptable if they were earth tones such as dark brown, olive green, dark blue, black, gray, and others in the vicinity of those hues. Loud colors were not allowed. Bright colors like yellows, vibrant reds, neon greens, and strong oranges were not acceptable. Modern dance required the student to be barefoot, wearing a leotard and tights or a unitard with the feet exposed. Hair did not have to be in a bun, but worn away from the face.

Women's Attire

1. Leotards of black or earth tone.
2. Tights can be black or an earth tone and must accommodate for bare feet.

3. Shoes are not required.
4. Unitards are acceptable.
5. Hair out of the face but does not have to be severely pulled back in a bun.

Barefooted dance looks

Men's Attire

1. Tight-fitting shirt or tank top (leotard), earth tone color or black acceptable.
2. Thick black tights that fit over the leotard or loose pants of stretch material.
3. Hair out of the face.

Modern Dance Attire

The Late Contemporary Period Part I (1970–Today)

Modern dancers of this period began to look at Middle modern dance with its traditions in the same way the Early modern period looked at ballet. Modern dancers and ballet dancers were at odds with each other in The Early Period, but gained a healthy respect for their techniques in The Middle Period. In The Late Period the new generation of modern dancers looked at the established modern dance companies such as the Katherine Dunham Dance Company, the Martha Graham Dance Company, even the

Alvin American Ballet Theatre, as being traditional. This divided the Late Contemporary period into two camps for the purpose of this study—the Traditional camp and the Experimental camp. Traditional dance companies, such as the Dunham company still existed and thrived artistically. In dance classes the Dunham technique continued to be taught. Alvin Ailey, who taught the Lester Horton technique, continued to teach the technique as a basic skill set. But the new breed of choreographers/dancers wanted something new and fresh. They started to experiment with new concepts of movement, new areas of motivation, exploration, and interpretation. They broke down the traditional elements of dance and restructured the idea of music, attire, movement, company names, and performance venues. They also chose to put their artistic expression first, as opposed to wanting to be distracted by efforts to please the audience. If audiences desired to participate in the avant-garde approach to movement expression or didn't, choreographers were not deterred from their quest for experimental artistic movement exploration. Nevertheless, each category could be investigated in depth; however, concepts of the Late or Contemporary Period will be described in the simplest terms for the sake of brevity and simplicity.

Music could mean the use of repetitious musical phrasing known as minimalism which applied to the dance as well. Dancers and composers approached the concept that all sound was music. Using unmelodic sound through the total work was an example of the searching of the experimental mindset. The music of the Middle Period, in the traditional sense, maintained a relatable melodic flavor more palatable to an audience. The *attire* did not have to be costumes with the usual color coordination of special material or embroidery, but any contemporary clothing, including a pedestrian look that may utilize tee shirts and jeans or clothing from vintage stores. Any attire was acceptable including no clothes at all. *Movement* could be aerobic, minimalistic (repetitious), or no movement at all. *Company names* were not always that of the founder. Bill T. Jones and Arnie Zane's company was originally called the American Dance Asylum and Garth Fagan's company was originally called the Bottom of the Bucket, But. . . . Dance Theatre. Concerts were not relegated to the proscenium arch stage. Performances could be observed in museums, lofts, malls, on the grass, or in gardens. There are many platforms for dance to function other than in the conventional theatre. These new groups of artists broke through the lines of traditional dance. Not that one approach was better than another. The two interests choreographically made for a larger canvas of expression, traditionally or experimentally.

Dance Artists of the Late or Contemporary Period

Garth Fagan

Garth Fagan began his career in Jamaica working with the Jamaican National Dance Company. He was influenced by Pearl Primus before he came to the states. Once in New York, he fell in awe of Martha Graham, Alvin Ailey, Mary Hinkson, and Dudley Williams. He received a professorship at the State University of New York where Fagan began teaching inner city youth at Rochester' Educational Opportunity Center.

Garth Fagan received a Tony Award for The Lion King musical

©New York Daily News Archive/Getty Images

The young dancers Fagan worked with had no formal training. They were cheerleaders, basketball players, or simply kids hanging out on street corners. With these novices, Garth Fagan founded his dance company, Bottom of the Bucket, But . . . Dance Theatre, in 1970 and created his first work in 1987 on the Dance Theatre of Harlem. Fagan draws on diverse influences, such as the use of reggae music and Jamaican dance movements (Emery, 1988). His Signature Piece is *From Before*. Garth Fagan was the recipient of the 1988 Tony Award for Best Choreography for the Lion King musical.

Bill T. Jones

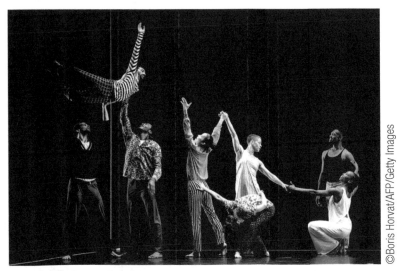

Bill T. Jones Dance Company

Bill T. Jones started the study of dance at the State University in New York. After graduating, he went to Amsterdam. When he returned to the States he started The American Dance Asylum with Arnie Zane and Lois Welk in 1973.

Jones went against the traditional. Along with his creative application of music, he also used words and gestures. His works were provocative, exploring themes that at times, may have been uncomfortable for an audience. In his signature piece *Last Supper at Uncle Tom's Cabin/The Promised Land* (1990), Jones tested his boundaries using dancers who were not of the typically expected physical body proportion. He also incorporated everyday people who were not dancers at all. The narrative associated with the work was introspective and thought-provoking. His work, *Still/Here*, a two-act, evening-length theatrical dance drama celebrated survival in the face of illness through a musical score made from edited interviews.

Jones, 1 of 12 children of migrant farmworkers, grew up in Wayland, New York. He attended the State University of New York at Binghamton. There he met Arnie Zane. The two, along with Lois Welk and Jill Becker, formed the American Dance Asylum. In 2011 the company merged with Dance Theater Workshop to form New York Live Arts, for which Jones served as executive artistic director. After the company's partnership ended Jones, oddly enough took the opportunity to work as a choreographer on the Broadway show *Spring Awakening*, which won him a Tony Award for choreography. Later Jones

co-wrote the book, choreographed, and directed the musical *Fela!* (2008), about the life of a Nigerian musician and activist Fela Anikulapo-Kuti. This won him another Tony Award.

https://www.britannica.com/biography/**Bill-T-Jones**

Camille A. Brown

Camille Brown graduated from the LaGuardia High School of the Performing Arts and received a B.F.A. from the University of North Carolina School of the Arts.

Camille A. Brown

Brown, a prolific daring choreographer with a musical background (clarinet) used her musical interpretations to formulate her storytelling and perspective on the female gender. She guided her dancers through the investigation of narratives and ancestral consciousness. She has a talent of illustrating historical concepts within contemporary culture. Her range of choreography, which includes linguistic theatrics and dance drama, was thought-provoking. Brown has choreographed Broadway shows including *Once on This Island*. She has also entered into the television medium with the debut of *Jesus Christ Superstar Live in Concert!* on NBC.

Ms. Brown strives to instill cultural introspection through outreach activities to students, young adults, and the incarcerated. She was a four time time Princess Grace recipient, and a TED speaker. She won the 2015 Doris Duke Artist Award, the Bessie Award (2014 and 2016), Jacob's Pillow Dance Award, and the 2016 Guggenheim Fellowship. Camille Brown's Signature Piece was *The Evolution of a Secured Feminine*.

http://www.camilleabrown.org/camille-a-brown/

Kevin Iega Jeff

Kevin Iega Jeff matriculated at The Juilliard School in his teens. He was noted for his technical genius and strength of movement, dramatic focus, and ability to execute movement using his total expanse of physicality. Jeff, at least 6´3˝, had a special talent to bridge different dance forms in a seamless manner. Adept in all genres, Iega preferred the modern dance idiom.

Iega Jeff founded his first company, JUBILATION!, at the age of 21in New York City. JUBILATION! was created out of a need to provide a forum for African American artists to be nurtured holistically through dance. For 10 years the company toured nationally and internationally, bringing the stories,

histories, contemporary dance, and art of the African American to a global audience. In 1994, he left New York to become the Artistic Director of the Joseph Holmes Chicago Dance Theater. In 1995, he cofounded and took on the position of Artistic Director for Deeply Rooted Productions in Chicago. His company is predominately African American due to the content of his thematic choices. The name of the company is a window into the kind of work subjects Iega explored. Kevin Jeff has received commissions to create new works for the Alvin Ailey Dance Theatre, River North Dance Company, Dallas Black Dance Theater, the Cleveland Contemporary Dance Theater, Cleo Parker Robinson Dance Ensemble, and the Wylliams/Henry Danse Theatre. He received the BTAA Best Choreography award for his signature work, *Church of Nations* and a Merit Award from the International Association of Blacks in Dance.

Gardner Arts Network, Presenters Corner: Kevin Iega Jeff.

www.gardnerartsnetwork.com/choreographer/kevin-iegajeff

Dianne McIntyre

Choreographer, dancer, and director Dianne McIntyre was born in 1946 in Cleveland, Ohio. Following her move to New York City in 1970, McIntyre founded her own company, Sounds in Motion, in 1972. McIntyre's special interest in history and culture as it relates to dance has led her to fresh projects in the areas of concert dance, theatre, film, and television. A few of her original works were *Union* (culmination of her research in Haiti) and *Their Eyes Were Watching God* (from Zora Neale Hurston's novel). Other dance and dance theatre works are *Take Off from a Forced Landing* (her mother's aviator stories), and *I Could Stop on a Dime and Get Ten Cents Change* (her father's stories of Cleveland), and *Open the Door, Virginia!* (school civil rights events). Dianne McIntyre has been commissioned to choreograph for Alvin Ailey American Dance Theater, Cleo Parker Robinson Dance Ensemble, Dayton Contemporary Dance Company, Dance Theatre of Harlem, and Dallas Black Dance. For film, McIntyre's work appears in *For Colored Girls Who Have Considered Suicide When the Rainbow Is Enuf, Langston Hughes: The Dream Keeper* and *Miss Evers' Boys,* for which she received an Emmy nomination (DeFrantz, 2002).

BeBe Miller

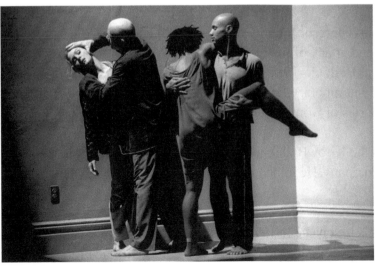

©Hiroyuki Ito/Hulton Archives/Getty Images

BeBe Miller Company Theatre Concert

Bebe Miller, a native New Yorker, first performed her choreography at NYC's Dance Theater Workshop in 1978 after receiving her MA in Dance from The Ohio State University in 1975. She formed Bebe Miller Company in 1985. Miller's philosophy of mixing dancing with fundamental humanity and her use of spatial design stands out in her works along with her unconventional movements. Her choreography has been produced nationally and internationally in Europe and Africa.

Her work has been commissioned by Dayton Contemporary Dance Company, Oregon Ballet Theater, Boston Ballet, Philadanco, Ailey II, and the UK's Phoenix Dance Company. She has been honored with four New York Dance and Performance "Bessie's," and named a United States Artists Ford Fellow in 2010.

Miller is a Distinguished Professor in OSU's College of Arts and Humanities and received an Honorary Doctorate of Humane Letters from Ursinus College in 2009. She was honored by Movement Research as an honoree for their 2015 Gala. Her signature piece is, *Going to The Wall*.

http://bebemillercompany.org/about/bebe-miller/

Blondell Cummings

Blondell Cummings focused her personal choreography on urban life experiences such as cooking or washing. Cummings studied with Martha Graham but began her career with the company, The House (an example of Late Contemporary Period company names) was started by Meredith Monk in 1968 before founding her own company. Her signature piece, *Chicken Soup*, was performed as a part of the Jacob's Pillow Dance Splash Festival.

Chicken Soup allowed Cummings to connect to women from her history as well as the present. She became one of the first to perform on the Inside/Out stage at the prestigious Jacob's Pillow. Danceinteractive.jacobspillow.org

http://danceinteractive.jacobspillow.org/blondell-cummings/chicken-soup/

Ulysses Dove

Ulysses Dove's work was energetic, highly dynamic, and intense with a sense of urgency. He used sound to convey the quality and attack of his movements in the rehearsal process. Doves *Episodes*, created for the London Festival Ballet in 1987, was inspired by a friend's death. *Vespers*, choreographed in 1986 for the Dayton Contemporary Dance Company in Ohio (also performed by the Ailey company) was drawn from memories of women in his family.

Dove studied dance at the Kirov Ballet, moved to New York, and accepted a position in the legendary Merce Cunningham Company. He joined Ailey in 1973 before starting a lucrative career as a freelance choreographer.

Dove choreographed his first piece in 1979 for the Alvin Ailey American Dance Theatre. The success of that work led to other commissions to choreograph dances for the French Ballet of Nancy, the Basel

Ballet, the Cullberg Ballet of Sweden, Les Ballets Jazz de Montreal, the Swedish National Ballet, Dutch National Ballet, American Ballet Theatre, New York City Ballet, Dayton Contemporary Dance Company (DCDC), and the London Festival Ballet (Dunning, 1966).

www.nytimes.com . . . /ulysses-dove-creator-of-dark-driving-dancing

Christopher Huggins

Christopher L. Huggins is a former soloist of the renowned Alvin Ailey American Dance Theater and Aterballetto of Reggio Emilia, Italy. Huggins attended State University of New York at Purchase, the Juilliard School at Lincoln Center, and was a fellowship scholar at the Ailey School.

As a master teacher and choreographer, he worked in Italy, France, Norway, the United Kingdom, Switzerland, Slovenia, Austria, Japan, Korea, Jamaica, South Africa, and throughout the United States. Mr. Huggins has served as Adjunct Professor of Dance at University for the Arts in Philadelphia and Ailey/Fordham in New York City.

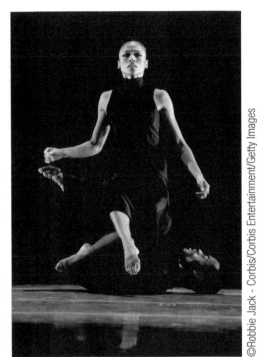

Anointed choreographed by Christopher Huggins

Huggins crafts his work similar to an award winning Sundance film. His work-fresh, dramatic, and intensely captivating is technically strong. Huggins is a 2002 and 2008 recipient of the Alvin Ailey Award for best choreography and from the Black Theater Alliance in Chicago for his works *Enemy Behind the Gates* commissioned by Philadanco and *Pyrokinesis* created for Gus Giordano Dance Chicago. Huggins is a silver medal winner at the 3rd International Contemporary Dance Competition in Seoul, Korea; was named in the "25 Choreographers to Watch" by the NPR in 2008; and was the sole choreographer in 2008 for the Alvin Ailey American Dance Theater's Opening Night Gala for their 50th Anniversary Celebration.

http://joffrey.org/people/christopher-l-huggins

Urban Bush Women

Urban Bush Women is an all-female dance company. The company intertwines contemporary dance, music, and text with the historical and spiritual traditions of African Americans and the African Diaspora. The company delves into the struggle of a people and converts it into an opportunity for growth and survival. Under the artistic direction of its founder Jawole Willa Jo Zollar, Urban Bush Women investigates through choreographic inventiveness issues regarding race, body image, culture and social justice themes. The ensemble performs choreography by Zollar but is also highly collaborative. With an emphasis on women's experiences, focus is placed on the value and understanding of the gender's approach to life in all its levels of stamina, bravery, and spiritual strength.

Urban Bush Women share their messages to diverse audiences in the States as well as globally (Asia, Australia, Canada, Germany, South America, Europe, and Senegal) in collaboration with Germaine Acogny and her all-male company, JANT-BI).

www.urbanbushwomen.org

The Late or Contemporary Period Part II (1970–Today–Extreme)

An era has emerged reflecting traces of the struggles of the 60s. It is a repetition of the social challenges of people of color and the practice of racial profiling, leading to senseless abuse and fatal attacks. The African-American community finds the need to reestablish respect that was thought to be resolved during past civil rights movements. With a déjà vu effect the protests of today have an uncanny resemblance to the past. The work of Nick Cave and the brilliant creation of the soundsuit was previously addressed in the text as an artistic protest inspired by the video recorded account of the beating of Rodney King. Cave delivered another soundsuit creation in response to the Trayvon Martin tragedy. Choreographic artist Iega Jeff, and Abdel Salaam, Artistic Director of the well renowned company Forces of Nature, have made powerful artistic statements of dissention and visual representations of injustice. Kyle Abraham has depicted through his contemporary works fatal attacks on African-American men, and the resulting protests of communities. These issues have changed themes in the African-American concert stage once again and have uncovered the recognition of works by new choreographers.

Kyle Abraham

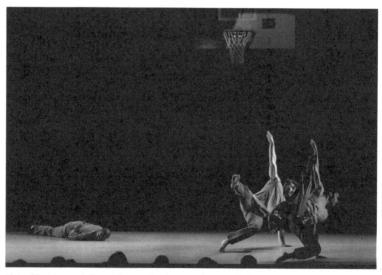

Kyle Abraham, left, performs in dress rehearsal "Pavement".

Lawrence K. Ho/Los Angeles Times/ Getty Images

A product of the hip-hop culture, Kyle Abraham was born in 1970s in Pittsburg, Pennsylvania. Abraham's upbringing included listening to classical music and observing works of visual artists. He started his dancing career later than most, but still managed to graduate from Purchase, a college with a rigorous dance program. Afterwards, he performed briefly with the Bill T. Jones/Arnie Zane Dance Company. A successful dancer and choreographer, Abraham chose to pursue his love for the art of choreography. In 2006, he founded his own company, Abraham In Motion (A.I.M.), an ethnically diverse group of

performers who skillfully executed his style of mixing hip-hop with modern contemporary styles. One of his works, The Radio Show, revealed a touching area of Abraham's life. The Radio show was about a radio show and the emotional anguish Abraham experienced during his father's illness. In the 1990s Abraham choreographed Pavement, a work about urban life. He gathered some of his inspiration from John Singleton's film, Boyz n the Hood. The work, Pavement, was performed on a stage that was structurally designed like a basketball court.

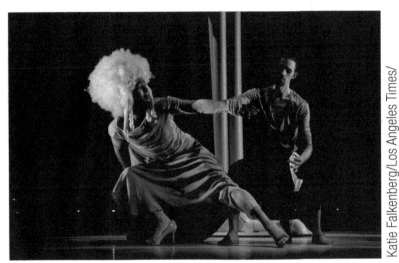

Kyle Abraham's "The Watershed".

Katie Falkenberg/Los Angeles Times/ Getty Images

Abraham has been honored as a Doris Duke Artist Award recipient, a USA Ford Fellow, and a Jacob's Pillow Dance Award recipient, among others.

"http://www.abrahaminmotion.org/about/" www.abrahaminmotion.org/about/

Was an article. Kyle Abraham AMERICAN DANCER AND CHOREOGRAPHER WRITTEN BY: kristan M. Hanson

The thematic reality of choreographic works was reflective of the world's technology. Movements were abstract and more or less devoid of traditional movement vocabulary. Technology facilitated the capture of inhumane scenarios that were shared publicly. Dance has gone deeper into extremes to depict the realities of life as well. Choreographers openly address their philosophical interpretations with the use of Late or Contemporary modern dance movement choices with an "in your face" vocabulary unveiling a discourse on the political socio-economic conditions using the freedom of the body. Costume choices have deviated from the traditional norm, and more frequently choreographers made use of nudity.

Creating a wide chasm or disconnection has yielded an intensely dense arena of movement interpretation. The Avant Garde initiative of the Late or Contemporary Period has been the catalyst of movement creation that seemed to unwittingly reject even the basic elements of traditional codified movement.

Two choreographers who have harnessed the everyday relevance of the Avant Garde are DaDa Masilo and Fana Tshabalala. These South African choreographic artists have a reputation for political and

abstract social works. They have utilized the extreme to deliver profound messages and expanded their thematic repertoire attracting the attention of African-American dance companies.

DaDa Masilo

Born in Johannesburg, South Africa, DaDa studied classical ballet, modern, and contemporary styles. Her formal training began at the Dance Factory. She graduated from the Johannesburg National School of the Arts, trained at Jazzart Dance Theatre of Cape Town, and was accepted at the Performing Arts Research and Training Studios in Brussels.

DaDa began to create work in 2006 after returning to South Africa. Stylistically, she merged all of her techniques, including African dance. Choreographically, her rendition of the ballet classics were stripped of traditional exposition. Her interpretation of *Giselle* challenged gender norms, while her *Swan Lake* deconstructed classical ballet movements and functionality of the conventional tutu. DaDa was acclaimed for her avant-garde approach to the interpretation of ballet classics.

Awards DaDa has received are the Standard Bank Young Artist Award in 2008 for Dance, the 2006 Most Promising Female Dancer in a Contemporary Style, and the Gauteng Arts and Culture MEC Award.

https://www.dansedanse.ca/en/dada-masilo

Timothy A. Clary/AFP/Getty Images

DaDa Masilo in "Masilo's Swan Lake"

Fana Tshabalala

Kevin Iega Jeff, founder and co-artistic director of Deeply Rooted, embraced the work entitled "Indumba" choreographed by Fana Tshabalala. The work broached the psychological impact of apartheid politics centering around the need for emotional and spiritual reconnection. Fana chose to focus on the parallels in the history of South Africa and America, reflecting on the candid internal effects of

each individual dancer. "Indumba" was a term in Zulu which represented a facility or hut designated to initiate healing under the counsel and enlightenment of elders and healers.

Fana's exasperation with the Truth and Reconciliation Council of South Africa to avert civil war in the after effects of the apartheid was the catalyst to produce a work that allowed participants to convert their personal anguish to positive energy through organic movement.

Fana's awards include the South African Standard Bank Young Artist Award 2013 and the South African National Art Festival Award.

Dec 6, 2017 | By Lynn Colburn Shapiro "Indumba" Launches Deeply Rooted Dance Theater's "Deeply Free" This Weekend

Jazz Dancer

©Pavel Shlykov/Shutterstock.com

Introduction

Various choreographers who earlier embraced the experimental precepts of the Late Contemporary avant-garde aesthetic proclaimed indifference to the viewers' response and refused to tailor their artistic works to entertain others, ironically, were invited and agreed to choreograph for Broadway, an industry all about pleasing an audience for a successful run. During this time the hard core concepts of the experimental movement had mellowed. African Americans used their modern dance talents to premiere award winning musicals.

Bill T. Jones choreographed *Fela!* and *Spring Awakening* on Broadway and received Tony Awards for both. Garth Fagan choreographed *The Lion King*, which also won a Tony Award for best choreography. Their work in the Late Period of modern dance produced innovative, unconventional choreographic approaches to the musical genre taking the artistic appeal of Broadway to another level.

A number of African Americans who had studied and performed in traditional modern dance ventured into different movements with ethnic or cultural influence.

In the 1960s and 1970s African Americans came into a fresh consciousness of themselves, their ancestral roots, and recognition of their worth in what was called "The Black Power Movement". They reconsidered their efforts to fit in with the American ideal. The Civil Rights Movement and movements of black pride were spreading in the African American community. During this time there was a holistic investigation of the power of a people-respectfully, intellectually, creatively, and culturally. James Brown released songs with bold and practical messages for the movement. Songs with lyrics such as "I don't want nobody to give me nothing, open up the door, I'll get it myself" and "Say it loud I'm black and I'm proud" echoed the consciousness of the period. African Americans were celebrating their hair in its natural state without the use of chemicals or straighteners, used to replicate the hair texture of European Americans. The Afro, whose name is associated with the style of the natural hair of the African American, represented a sociopolitical movement, not a fad. It was a statement of beauty, pride, and cultural acceptance. Courses similar to this survey delved into the history and legacy of the African American. Many universities developed curriculum for students to major in African American Studies. These courses had not existed previously.

Alex Haley wrote a book about his journey to uncover his African ancestry. The book *Roots: A Saga of An American Family* was a tremendous best seller, which encouraged people of all races to research their heritage. In 1979, *Roots: The Next Generation* was a television miniseries that broke viewing records the first time it was aired. In 2016, a different production company directed a version of *Roots*. The original Kunta Kinte, LeVar Burton, as the executive producer.

There was a new awareness of the African culture reflected in the attire. Dashikis became popular and there was more focus on wearing mud and kente cloth. In Harlem and other locations throughout the nation, African American community franchises focused on selling authentic African attire or African inspired clothing and jewelry.

There were two camps addressing this social movement that focused on civil rights and African American pride-one of nonviolence (the philosophy of those who followed the leadership of Martin Luther King Jr,) and the other, which had more of an urgency for change represented by the Black Panthers. Both chiseled through the fabric of racism and made monumental inroads.

African visitors to the United States were welcomed in the African American community, which coveted further education of their heritage. In the streets, young African Americans were learning authentic African Dance. Dance studios located in these neighborhoods hired African instructors to train students in their cultural dance forms and customs. Students at the end of an African dance class learned to pay homage to the live drummers by applause with the use of the floor as they kneeled and pounded the ground in gratitude and respect. This gesture was a traditional ritual of reverence for the drum and drummers, a demonstration of an appreciation of the arts, music and dance of Africa.

African American dancers who trained in other idioms (modern and ballet) started to introduce the aesthetic into their studies, classes and choreography. Consequently, researchers and artistic dance

creators and those searching for something new adopted the ethnic approach to movement. Dance pioneer, Katherine Dunham is considered the "Mother of Jazz Dance." Her research on Haitian dance and her personal movement, as influenced by the Haitian people, produced what is called body isolations (addressed in the chapter 3, African Dance). Those isolations would become the warm-up movements for jazz dance.

Ailey choreographed eclectic works combining African, modern, and ballet which culminated in a jazz flavor. Some European Americans also reached out to ethnic influences for choreographic inspiration. One such choreographer was Jack Cole, a European American considered the "Father of Jazz Dance." He was attracted to all ethnic forms, but enjoyed the rhythms and gestures of East Indian dance.

Jazz dance is a blend of African movement qualities, East Indian dance, Broadway, commercial, social/ballroom, and street dance.

All that we have studied to this point is the history of jazz dance. It has the rhythmic focus of syncopation found in African dance by Dunham, East Indian, street, and the elements of social dance that bled into ballroom.

Jazz involved many facets of movement, cultures, and movement qualities. As music changed, so did movement. Art does indeed reflect life, and the community spearheads the changes of the mood in the contemporary time.

1900s

In the 1900s, ragtime was a strong syncopated music expression. It was the accompaniment for the Cakewalk still performed on stage and in competitions. Scott Joplin, an African American composer referred to as the "King of Ragtime," created the music genre. Joplin melted the musicality of marching rhythms with classical and former African American spiritual songs. His most popular composition was *The Entertainer*. (Breckenridge, 2004).

Joplin composed an Opera entitled *Treemonisha*, which was not performed until the 1970s. Unfortunately, Joplin himself did not have an opportunity to see his opera come to fruition or witness the impact and relevance of the opera at a time when the African American population was seeking civil rights. *Treemonisha's* theme was focused on the need for responsible education in the African American community. Louis Johnson, sited in the Ballet section of this text, was the choreographer who successfully created the movement genius for the opera.

1920s

In the 1920s, the use of syncopation evolved into more complicated rhythmic and secular styles ushering in the era of the blues. Some researchers contend that the blues was a secular substitution for the spiritual. Many blues singers began singing in the African American churches. The style incorporated West African vocals with improvisation using call-and-response phrasing (Jackson, 1985).

The music and dance represented the times as Americans were feeling the effects of the Great Depression. Jazz music and gospel affected the musicality of the dance. The shout that had been identified on the plantation in Praise Houses continued in its contemporary stylization in many African American churches, with the steadfastness of the solo shout.

Jazz Dance, as a technique was finding its legs. Those who were in modern dance, or those who wanted fresh motivation surrendered to the improvisational essence of the music of artists like Louis Armstrong and Billie Holiday.

Another aspect of jazz dance was the Broadway musical, generational offspring of the minstrel shows. The 1920s was a theatrical opportunity/awakening for the African Americans' Broadway shows like *Shuffle Along*, one of the successful musicals using the compositions of Eubie Blake who demonstrated his ability to incorporate ragtime with other musical influences. Performers like Josephine Baker, Florence Mills, and Bill "Bojangles" Robinson added the rhythmic qualities of syncopated movements that incorporated the hoofing style of tap.

1930s and 1940s

Distinctive to the big bands was the rarity of allowing the audience to have visual contact with the musicians and their band conductors. The display itself was a dance, a performance, and an art form. Conductors like Cab Calloway, who would start a rendition with his band in a very composed manner which would gradually expand with the improvisational movements organic to the emotional crescendo dictated by the music, resulting in a medley of engulfing harmony of body and spirit between the passion of the music, instruments, and the audience. Mr. Calloway would end this execution of beauty with a totally disheveled hair style and frenzied demeanor. Not only did the band move, but the conductor was a dancer of sorts.

The big band or swing era of jazz dance established an acknowledgement of social dance and (as in the African tradition) dictated the energy and tempo to be followed.They welcomed, nurtured, and inspired tap dance due to the rhythmic quality and visual presentation of the band and band leaders (Breckenridge, 2004).

African American big bands played in popular venues like the Savoy, which opened its doors in 1926. Thousands rocked the building to the rhythms of Fess Williams and His Royal Flush Orchestra. Social dances like the Lindy hop were conceived with the energy and dynamic of the big bands. (Malone, 1996).

1950s

Cool jazz was one style of music used to accompany poetic verse of Beat poets. Cool jazz was given to an introspective style of music and dance allowing for freedom of emotion, moment by moment.

Similarly, dance reflected the beginnings of experimenting with social movements. Dances such as the Lindy in the European American community explored ways to partner and make easy transitions

with rhythmic knee swaying. In Harlem, the dancers of the Lindy were executing jaw dropping athletic partnering by sliding partners through the legs, over the backs and shoulders, and tossing one another above the head, falling in a split and being twirled back into a standing position which was always low to the ground. In the Lindy, many different levels were involved and there was constant invention. The masters of the Lindy hop were Frankie Manning and Norma Miller, both with Whitey's Lindy Hoppers.

Frankie Manning

Frankie Manning has been referred to as the unofficial Ambassador of the Lindy hop. Manning was a driving force that spread the popularity of The Lindy Hop into three continents.

Frankie started dance in his teens at the Alhambra Ballroom in Harlem. He then moved to the Renaissance Ballroom, and finally graduated to the Savoy Ballroom, known for exceptional dancers and bands. At the Savoy Ballroom, Frank Manning joined the 400 Club, an elite group that could come to the Savoy Ballroom during the daytime hours and practice alongside Savoy's performing bands.

Manning's style included dancing at an angle to the ground similar to a track runner instead of in an upright position. He created the first Lindy air step. Herbert White started a top professional Ballroom performing group named Whitey's Lindy Hoppers. Their first presentation showcased the choreography of Frankie Manning. After that performance, Manning began to partner dynamic dance movement patterns with swing music, patterns and subsequently, became the artistic director of Whitey's Lindy Hoppers. Archives of Early Lindy Hop. Savoystyle.com

http://www.savoystyle.com/frankie_manning.html

Norma Miller

Known as the "Queen of Swing," Norma Miller was the youngest of Whitey's Lindy Hoppers. First discovered as a talented Lindy Hopper at the age of 14, Norma often danced outside on the sidewalk. Whitey noticed her at a Savoy Ballroom dance contest. At the time, Norma was not with Whitey's Lindy Hoppers, but after she defeated him in contests he asked her to be a member of the company. Norma had a creative, comedic fun style of executing the Lindy. She was rhythmically impeccable and vivacious. Archives of Early Lindy Hop. Biographies of the Original Lindy Hoop. Savoystyle.com

http://www.savoystyle.com/norma_miller.html

1960s

After the 1950s, jazz music continued its purity but the new generation shifted popular music of the 1960s with the advent of Rock and Roll. African Americans contributed greatly to the social dances of this time. Dances like The Twist (popularized by Chubby Checker) and the musical genius of Chuck Berry and Little Richard incorporated no-holds-barred song and dance while playing an instrument, magically uniting the three talents as one man's performance. Rock and Roll rose in popularity along with television shows solely focused on the dancing of the era, like *Dick Clark's American Band Stand* and *Hullabaloo*. Attire of miniskirts and white go-go boots were rampant.

1970s

The 1970s brought a musical shift into the "disco" era. The nightclubs called "discos" introduced special rhythmic flow of music. The music and style of the disco was captured in the movie *Saturday Night Fever* starring John Travolta with choreography by Lester Wilson, an African American who choreographed movies in the 1970s through the 1990s representing the disco era dance genre. The dance had elements of African and Hispanic influences, especially with the evolution of "the Hustle," a hand dance not practiced much today. The dances were with partners. There was strong competition in the clubs between the African American "Hustle" and the Latin style "Salsa." The valuable institution of "The DJ" (one who would mix music seamlessly and visibly on turn tables) was introduced and the beginnings of Break Dancing emerged, with the African and street-fusion producing rap music and hip hop.

Dance Party

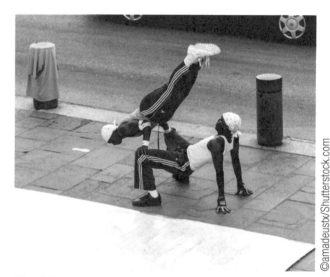

Street Performer

1980s to Present

The 1980s introduced a melting of many different styles in jazz dance, sometimes considered a jazz rock fusion. The dancing flowed with the changing genres of musical styles. The historical flow is much too intricate to investigate here. Elements of the musical movement were reflected in street dance. The two were married. This span of time for the African American who molded the hip-hop culture, was focused on personal creative exploration and confidence to challenge one another artistically, visually, and psychologically. The presence of House music, which created a freedom of music and dance sometimes referred to as freestyle, prompted dancers to outperform one another with new and daring rhythms, athleticism, and movements. Performances

were created to out manuever the competitor in the African tradition that had sustained itself through the years from Africa to slavery to Master Juba and John Diamond, as well as challenges of hoofers to the present day. Each era continues the qualities of African dance such as community strength, creating from common environments, surrounding and egging on challengers by the shouts and encouragement of viewers, and the embracing of the youth.

The quality of jazz dance as an art form is rhythmic and syncopated. The style tends to have more of a sensual aesthetic. The women's or men's attire can be loose or tight depending on the demands of the class. The movement stylization is eclectic, meaning that it can be a combination of many dance idioms.

Women's Attire for Class

1. Tights or fishnets and leotards of varied colors. No color restrictions.
2. Barefoot or jazz dance shoes of soft flexible material to accentuate the articulation of the feet.
3. Tennis shoes or character shoes depending on class style.
4. Baggy or tight-fitting dance pants.
5. Musical theater classes may require character shoes.
6. Hair may be short, medium, or long. No set look. Always preferred off the face.

Men's Attire for Class

1. Jazz pants or baggy dance pants.
2. Jazz shoes or danceable tennis shoes.
3. Tight-fitting or baggy top and pants.
4. No color restrictions.

Styles of Jazz Dance

Due to the eclectic nature of jazz dance, there are various styles:

1. African Jazz —use of isolations
2. Latino Jazz—Latin dance qualities
3. Modern Jazz—modern dance influence
4. Lyrical Jazz—flowing, balletic quality
5. Street Jazz—urban contemporary
6. Theatrical/Broadway—eclectic

©Lana K/Shutterstock.com

Jazz Dancer

©Julenochek/Shutterstock.com

Jazz Dancer

Pioneers of Jazz Dance

As discussed, many African Americans had to expand their training to compete in the dance world. One such personality is Katherine Dunham, who is considered the "Mother of Jazz Dance." Her research in Haitian, Caribbean, and African Dance established the concept of body isolation, one part of the body articulated separate from another. The use of these isolations (vital in the exercises of jazz dance) address the warmup of the multi-unit torso articulation. Certain areas of the body must be addressed differently from those of ballet or modern. Simply using those warm-up exercises would result in injury for jazz dance movement phrasing. Dunham's technique breaks down the body movement into four areas of isolation to ensure that the physical is prepared for the dynamic of the jazz dance idiom. The four areas of body isolation are head, shoulders, ribcage, and pelvis.

Another previously mentioned African American artist associated with the jazz dance form is Alvin Ailey. His company's broad-based repertoire included multiple dances that reflected contemporary music and dance of historical eras from African-based choreography, to a tribute to Katherine Dunham, and music of all eras—gospel *Revelations*, *Blues Suite*, (a pure jazz music work) *Cry*, (a mixture of contemporary songs of the period) to Rennie Harris' hip-hop choreography. The Alvin Ailey American Dance Theatre was dedicated to applaud the pride of the African Americans' artistic journey.

Additional Jazz Dance Artists

George W. Faison

George Faison had a choreographic gift for successfully fusing popular music and dance with seamless crafting. His professional company, The George Faison's Universal Dance Experience reflected his creative energetic high-spirited dynamic choreographic works (Giordano, 1996).

Faison's choreography mirrored the African American experience with an eclectic versatility that could be universally interpreted. Faison, born in Washington D.C., attended Dunbar High School. He trained at the Jones–Haywood School and attended Howard University as a dentistry major. After seeing a performance of the Alvin Ailey American Dance Theatre, Faison set his sight on New York and studied with Arthur Mitchell and others including Charles Moore. In 1967 his aspiration was realized when he was invited to join the Alvin Ailey American Dance Theatre. After his tenure with the company, he began to choreograph for the stage and founded the George Faison's Universal Dance Experience. George, coming out of the Ailey company, chose to choreograph eclectically like Ailey. He chose an African American aesthetic with elements of mostly jazz but also modern and ballet. Faison simultaneously choreographed

The Wiz Musical Logo

for his company and a Broadway show, *The Wiz*. In 1974 he put his full effort into *The Wiz*, which would win him a Drama Desk Award and a Tony Award in 1975, establishing him historically as the first African American to win a Tony Award for Best Choreography of a broadway musical. The award was well-deserved. His genius in the interpretation of character and movement was unmatched. Faison went on to coproduce and write the *Cosby Salutes Ailey*, the NBC TV special commemorating the 30th Anniversary of the Alvin Ailey American Dance Theatre. Faison won an Emmy Award for his choreography in the HBO special *The Josephine Baker Story* in 1991.

He gave two works to the Ailey company that he had previously choreographed on his own company, *Sweet Otis* and *Slaves*.

To date, he has put his efforts in the Faison Firehouse Theatre, which he cofounded with Tad Schnugg. Faison serves as artistic director. It is an innovative, performing arts-based outreach and youth theatre project. (Alvin Ailey American Dance Theatre Website).

https://www.alvinailey.org/alvin-ailey-american-dance-theater/george-faison

Lester Wilson

Lester Wilson was a major force in the introduction of break dancing films. His effort to raise the caliber of breakdancing to make it palatable to mainstream audiences was for the most part, successful in the film *Beat Street* . Wilson initiated a choreographic union of breakdancing and technical jazz dance.

Orion Pictures/RGA

His choreography in the movie *Saturday Night Fever* contributed to the artistic credibility of the social disco movement. His work on the variety show *Solid Gold* intertwined dance with popular music in a context that supported the singing artists, but did not belittle the work of the dancers. Wilson incorporated the performers into the totality of the musical theme.

Carlton Johnson

Many dance pioneers have not been properly acknowledged. Their earlier conquests need to be noted for the sacrifices and racial insults they had to endure to prevail in the career of their choice. Carlton Johnson is one of many whose presence and stellar work broke the typical stereotypes that permeated show business. The "business" of show business tied the hands of some directors and choreographers who wanted to allow African Americans and dancers of color into their choreographic opportunities but could not for political reasons.

Those performers who made inroads had to be 150% as good as their European American counterparts to be considered for a dancing job on stage, television, and film.

Carlton Johnson's exceptional approach to movement, exhibiting strong clean impeccable lines, gave him the opportunity to be the first and only African American on the *Carole Burnett Show*, which in the 1980s had a variety talent format. He also performed on *The Sammy Davis, Jr. Show* and *Diana Ross and the Supremes with the Temptations Special*. He assisted Louis Johnson in the movie *The Wiz* and choreographed the movie *The Blues Brothers*.

Michael Peters with Michael Jackson

When Michael Jackson left the Jackson 5 and pursued a separate career, he enjoyed performing street dance steps like the breakdancing movement "moon walk" performed for *The Motown 25 Special*. His approach to dance as a solo artist focused on street movements. He desired a certain movement quality outside of his own talent, which was a hybrid between Street and Jazz Dance. He obtained this connection working with Broadway choreographer Michael Peters. Peters developed a style to move to the sounds of the instruments in the records, throwing aside traditionally established

Michael Jackson

dance steps and rhythms. His philosophy was that the body should accentuate movement with the flow of the instruments, not against. In 1983, when Michael Peters choreographed "*Beat It*", his movements were was new and innovative. Jackson embraced Peters' movement style, using him again in *Thriller*, Peters' signature work and the first video MTV paid to air (Thorpe, 1989). Jackson marketed *Thriller* like a movie, which was a revolutionized format for a music video. The film gave Peters other offers and introduced him as a top-notch choreographer. He went on to show his talent in the hit Broadway musical *Dream Girls*, along with Michael Bennett, winning a Tony Award in 1984.

Another recognized accomplishment was his choreography in the movie version of *Sarafina,* based on the musical of the same name.

Joel Hall

Joel focused on the jazz dance idiom using jazz music and the jazz dance movement vocabulary. He often worked with blues music. Hall delved into the human condition, thematically investigating the sense of emotionalism. (Thorpe, 1989).

Hall was born in Chicago. He began his career with a concentration on modern dance. However, for several months he visited New York to study jazz with Nat Horne, Pepsi Bethel, Thelma Hill, and Michele Murray (former Ailey Dancer). Hall met Joseph Ehrenberg, an actor and Director of the Chicago City Theatre in 1974. The two pooled their talents and founded the Joel Hall Dancers as a division of the Chicago City Theatre and toured the East Coast with successful seasons at New York's prestigious Joyce Theater. Hall was the predominant choreographer for his company but solicited major works by Talley Beatty and Ruth Page, who were well-respected choreographers in the Chicago area.

Long limbed with great flexibility, Joel was a stunning performer. He was a standout in jazz-based works such as *Nightstalker*, with music by Duke Ellington. Hall also established the Joel Hall Dance Studios to train younger dancers to facilitate his company in the future. He created a company with an ethnically diverse aesthetic. *Uhuru* was his signature work, which addressed the plight of blacks in South Africa (Thorpe, 1989).

Frank Hatchett

Frank Hatchett had a unique style of jazz dance called VOP. VOP is a technical jazz dance term and style coined by Hatchett. Early in Frank's teaching career, the term evolved organically as he would encourage his students to add dynamic emphasis to a movement. It was a percussive dynamic, applied energetically for effect. The term used by Frank strengthened the accents of the body and was a catalyst for an attack of the movement. He had a gift for marrying rhythmic movement with music, merging elements of street dance with traditional jazz training. He was a master, coordinating the two to flow together effortlessly.

In 1990, the World Jazz Dance Congress (WJDC) was founded by Gus Giordano. Five legendary jazz dance masters were featured at the first WJDC. Of the five, Hatchett was the only African American instructor. His classes were always packed and students enjoyed his enthusiasm and hands-on approach.

After graduating from the University of Connecticut, Hatchett was given an opportunity to buy property in Springfield, Massachusetts which he converted into a dance studio. In 1967, he was offered a teaching position at the Dunbar Community Center in Springfield. The curriculum that he created evolved into a dance program and grew to be a major part of the institution named the Frank Hatchett Center for the Performing Arts. Frank expanded his career options when hired to choreograph professionally in New York. He taught his style of VOP at the National Dance Conventions of Dance Makers, Dance Olympus, Dance Educators, and Dance Masters. In the early 1980s, Frank settled in New York and taught at the Henry LeTang and JoJo's Dance Factory. In 1982, he teamed with Maurice Hines to start Hines and Hatchett. Hines left after a period of time and Frank called the studio the Broadway Dance Center, one of the largest and most frequented dance studios in New York, serving performers from all artistic arenas (Hatchett, 2000).

Debbie Allen and Sister Phylicia Rashad

©Everett Collection/Shutterstock.com

Debbie Allen

Deborah Kaye Allen was born in Houston, Texas. Her mother was an award-winning poet Vivian Ayers-Allen and her father, Arthur Allen, was a dentist. At the age of five, Debbie exhibited her love for the dance. Her parents

attempted to enroll her in the Houston Ballet School but she was rejected because of her body type. Frustrated with racial bias Allen stopped pursuing dance. She attended Howard University as a drama major. While there, she caught the eye of choreographer Mike Malone who was observing her energetic and dynamic dancing at a social event. He encouraged her to join his company, The D.C. Black Repertory Dance Company. The invitation reignited Debbie's love for dance. Allen credits Mike Malone for providing direction in her dance pursuits (Lane, 2015). After graduating college cum laude with a degree in drama, Debbie joined her sister Phylicia Rashad in New York. She became a member of the chorus line of *Purlie* and later won her first significant role in the successful Broadway musical *Raisin,* and subsequent roles in *Ain't Misbehavin* and *West Side Story*. She received critical acclaim and a Drama Desk Award for Outstanding Feature Actress in a musical as Anita in the Broadway revival of *West Side Story*.

Allen played a small role in the movie *Fame*, which paved the way for being cast as the dance instructor, Lydia in the television version of the movie by the same name. She choreographed all of the dance numbers and directed the episodes as well, receiving an Emmy for Outstanding Achievement in Choreography. She gained feature roles in *Good Times*, *The Love Boat*, *The Cosby show*, and the movie *Ragtime*. Allen received accolades as the director of the Cosby show spin-off, *It's a Different World*, and performed as the divorcee with two children in the sitcom *In the House*.

Most impressive was her position of co-executive producer with Steven Spielberg on the movie *Amistad*, a groundbreaking film depicting captured slaves, fighting the legal system and ultimately winning their freedom. Allen had the rights to the story for many years but felt the best director for the movie was Spielberg, who was familiar with the case, but was convinced by Allen to take on the project. She has directed and acted in *Grey's Anatomy*. Her directorial expertise has been exhibited in two popular mainstream shows, *Scandal* and *Empire*.

Allen's contribution to the arts at large was prolific. She has made many inroads for African Americans. Debbie and her husband, Norm Nixon opened the Debbie Allen Dance Academy for the youth with the well-respected instructor, Karen McDonald serving as dean. It should be acknowledged that Debbie Allen choreographed more Academy Award Shows than any other choreographer in its history. She has authored two children's books, *Dancing in the Wings* and *Brothers of the Knight*.

Jo Jo Smith

Jo Jo Smith (Joseph Benjamin Smith) was a renowned jazz dancer and choreographer. He is the son of Anna Grayson, a Dunham dancer who taught the great Nicholas Brothers and performed in many Broadway shows. He was a consultant of dance in the successful 1977 movie musical *Saturday Night Fever*. Smith, a powerfully dynamic teacher with a strong work ethic and thorough warm-up technique distinctly his own, mixed jazz with Latin and martial arts. He founded his own school in the 1960s, Jo Jo's Dance Factory. For jazz dancers, Jo Jo's Dance Factory located in New York City, was a lifeline for quality training in jazz dance technique (Lane, 2015).

Darrin Dewitt Henson

Henson is an award-winning choreographer who worked with singers such as Christina Aguilera, Jennifer Lopez, and Britney Spears. He has choreographed the tours of Prince, Usher, and Justin Timberlake. Darrin Henson is known for his workout video, *Darrin's Dance Grooves*, which sold 3 million copies. 'NSync's *Bye Bye Bye* is one of Henson's signature music videos granting him an MTV Video Award for Best Choreography. His pursuit of acting has been his focus to date. (Website).

His role and performance in *Stomp the Yard* warrants special recognition. The movie centered on the stepping demonstrations of fraternities. His combative character was heightened by his powerful dancing performance. Other film credits include *Soul Food, The Express, Life Support*, and *The Salon*. Darrin has written a motivational book entitled, *Ain't That The Truth* and *Intimate Thoughts,* a book of poetry for which he received an NAACP Image Award nomination. (Darrinhenson.com)

Darrin Dewitt Henson

http://darrinhenson.com/darrin-henson/

Fatima Robinson

Fatima Robinson, dancer, choreographer, and director landed her first success choreographing Michael Jackson's *Remember the Time* video. Robinson's gift of developing hip-hop into a commercial dance art form has helped the mainstream acceptance of the movement idiom.

Robinson trusts her instincts in her choreographic process. She often avoids hearing a song until she begins crafting the movements. Her movie credits for choreography include *Dream Girls*, *Romeo Must Die*, *Save the Last Dance*, and *Ali*. Robinson was a close friend to Aaliyah and was with her in the Bahamas while filming *Rock the Boat* which Robinson choreographed. The musical short *Wild Wild West*, starring Will Smith is another of her well-known choreographic works. In 2016 she choreographed the TV special *The Wiz*. And she has been recognized for her Gap commercials and named by *Entertainment Weekly* as one of the most creative people in entertainment.

Fatima Robinson

http://stylelikeu.com/profiles-2/closets/fatima-robinson/

Dave Scott

Dave Scott has choreographed for both film and television, including *So You Think You Can Dance* on FOX, Bravo's *Step It Up & Dance*, and *Step Up 3D for Dance Flick* with the Wayans Brothers. *Stomp the Yard* was another choreographic project successfully ranking number one at the box office. He received the 10th Annual Choreography Award for *You Got Served*, in 2004.

Scott is one of the master instructors on The PULSE convention tour sponsored by the Broadway Dance Center.

https://www.broadwaydancecenter.com/faculty/bios/scott_dave.shtml Website

Laurieann Gibson

Born in the year 1969, Laurieann "Harlee" Gibson trained at the renowned Ailey dance school. She then segued from concert dance to hip-hop. Blending hip-hop with her Horton training from Ailey has allowed Gibson to take hip-hop to a higher level. She secured the opportunity to choreograph the dance movie *Honey*, a story mirroring Gibson's life.

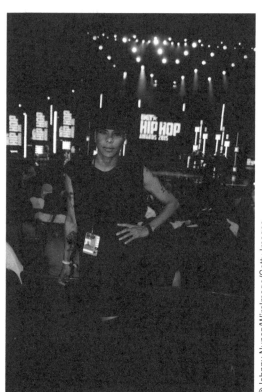

©Johnny Nunez/Wirelmage/Getty Images

Gibson has worked with acclaimed director Spike Lee and became part of mainstream through her role as choreographer for MTV's hit reality show *Making the Band* with P. Diddy. Within the seasons of *Making the Band*, the dance phrase coined by Gibson, *Boom Kack*, (based on her word imagery for accented movement) became part of the jazz dance vocabulary, much like VOP coined by Frank Hatchett. Gibson was also headlining The PULSE on Tour, with Dave Scott. Her choreography encompassed most of the videos for Lady GaGa, Katy Perry, Nicki Minaj, and Alicia Keys. Laurieann has been a replacement instructor in the TV show, *Dancing Moms* and has had a couple of her own shows. In 2018, Lifetime's *Laurieann Gibson: Beyond the Spotlight*, delves deeper into her professional world.

Laurieann Gibson

https://www.broadwaydancecenter.com/faculty/bios/gibson_laurieann.shtml
http://laurieanngibson.weebly.com/

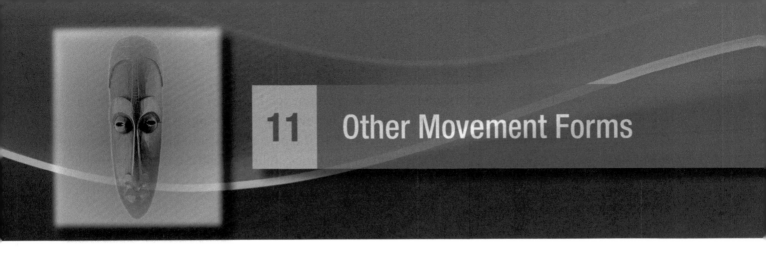

11 | Other Movement Forms

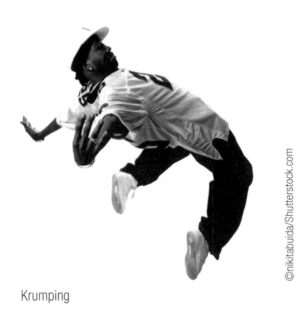

Krumping

©nikitabuida/Shutterstock.com

Introduction

All dance forms had their origins in the streets. Early stages of ballet were inspired by the movements of the peasants, refined as court dances by the elite before evolving into an art form. Dancers who did not fit physical, race, or age criterion took a stance and created modern dance. Jazz Dance originated from the unique phrasing of jazz music and the social street dances connected to it. Break dancers brought linoleum to the sidewalk to satisfy a passion for movement, inspired by musical variations created by DJs during breaks in the music. Hip-hop dance and culture was met with major resistance from its inception. It is the common folk, the deprived and disenfranchised in economically strapped communities that saw the restorative power in music and movement whether it was athletic movement, dance or play. Ordinary people have produced extraordinary developments in the artistic world. Lack fuels creativity.

African and African American Dance continues to give birth to the new and fresh. It shifts circles and glides into different forms of movement outlets. As it is embraced by other cultures, its richness is more profound and as times changed African American improvisational methods created deeper substance. Jazz music and hip hop was not originally embraced by the mainstream populace, but eventually gained acceptance. Once the community appeal was recognized, those who looked down

upon the movements began to subtly attempt to obtain commercial ownership similar to the transfer of power exhibited in the business of Minstrel shows. However, by the time hip-hop became popular, those who created and developed it refused to relinquish it. Rappers used their money to market themselves or establish brands, and African American communities embraced and claimed the originality of their street dance forms.

Breakdancing and Hip-Hop

Breakdancing history can be approached on many planes including one of peace between gangs. The power of dance to curtail gang wars was originally successful. Rivals worked out their differences without violence and turf wars were settled through movement competitions. Though short lived, the love and respect for breakdancing reduced senseless killings.

Hip-hop, an urban subculture expressing an attitude, authority, history, or theology, sought to expand collective consciousness, cultural recognition, and racial pride (Hodge, 2010). When hip-hop emerged, it was predicted to have a brief existence. But it has grown to a universal form that has spanned the entire world. More than any other dance form, hip-hop has been an ambassador for African American urban dance. All cultures that have been exposed to hip-hop have embraced it. Its communicative effects as a universal dance form has far surpassed any other dance genre. Ballet, modern, nor jazz has accomplished the universal appeal of hip hop or transcended its continued growth and interest of the youth.

Hip-hop has several foundational elements including DJing, Emceeing, Breaking, B-Boying, urban fashion, graffiti, Business Enterprise, and street knowledge. This merely scratches the surface of its complexity (Hodge, 2010).

Rennie Harris

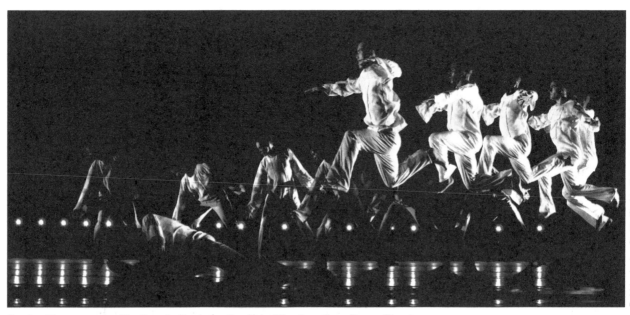

Exodus Choreographed by Rennie Harris for the Alvin Ailey American Dance Theatre.

Robbie Jack - Corbis/Corbis Entertainment/Getty Images

Dr. Lorenzo (Rennie) Harris (dancer, instructor, choreographer, and company founder) is the hip hop guru, having been a participant since its inception. Harris gained recognition for being a spokesperson for the importance of "street" origins in dance styles. Rennie Harris' Puremovement was a company founded to preserve and disseminate hip-hop culture through education in the form of lecture demonstrations, residencies, mentoring programs, and performances. With the roots of hip-hop being in the inner-city of the African American and Latino communities, Harris viewed it as a contemporary indigenous form that reached outside of economic boundaries. Rennie believed in the essence and spirit of hip-hop rather than exploited stereotypes.

Stepping

At the turn of the twentieth century, African American students who attended predominately European American colleges and universities in the North experienced isolation and needed to establish an outlet of socialization with other students of color. In response, seven black men at Cornell University formed the first historically black Greek-letter fraternity, Alpha Phi Alpha in 1906. Stepping was a valuable ingredient to Black Greek-letter fraternity and sorority life. It was the quintessential art form uniting rhythmic movements, old and new together. Stepping acknowledged and performed centuries of African slave dance movement vocabulary such as the Patting Juba and Ring Shouts (Malone, 1996).

To chronicle stepping, the words "demonstrate" and "demonstration" began to appear in campus newspapers in the 1960s. They were used interchangeably with stepping. The essence of stepping was civic pride, unity, community, faith, strength, respect, discipline, perseverance and commitment. Each sorority or fraternity had their own philosophy, attire, and focused movement (Fine, 2003).

African American sororities and fraternities center on community service, which is another aspect of the African cultural philosophy. The value placed on their mission required a mental disposition which entailed control of thought, action, purpose, freedom from resentment under persecution, and faith in oneself to decipher right when faced with wrong. (Malone, 1996).

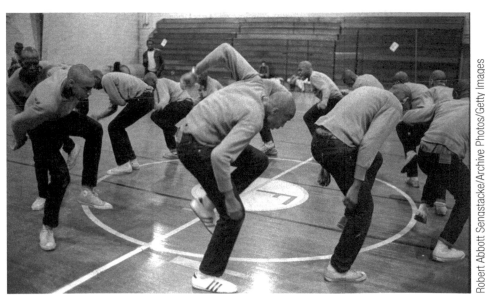

Fraternity Pledges Moving in a Circle Counterclockwise

Robert Abbott Sengstacke/Archive Photos/Getty Images

The Divine Nine

Many characteristics innate to African movement have influenced stepping such as call and response, pantomime, circular counterclockwise movements, percussive use of hands and feet, sounds and chanting, ritualistic attire, and low to the floor movement positioning (Brown, 2005).

When the first Black Greek-Letter Organization (BGLO) was founded, the African American student body was aware of their connection to Africa. The founders of the first eight BGLOs were scholar-activists, a little more than a generation from slavery. Two major goals motivated the establishment of BGLOs. First was the mission "for the good of the race." The second was establishing patterns that affirmed the connection between North American institutions and their African roots. (Malone, 1996).

The National Pan-Hellenic Council was made up of 9 historically Black Greek-Letter Organizations (BGLOs) referred to as "The Divine Nine".

Alpha Phi Alpha Fraternity(1906)- Cornell University
Alpha Kappa Alpha Sorority (1908)– Howard University
Kappa Alpha Psi Fraternity((1911) – Indiana University
Omega Psi Phi Fraternity (1911) – Howard University
Delta Sigma Theta Sorority (1913) – Howard University
Phi Beta Sigma Fraternity (1914) – Howard University
Zeta Phi Beta Sorority (1920) – Howard University
Sigma Gamma Rho Sorority (1922) - Butler University
Iota Phi Theta Fraternity (1964) – Morgan State
(Malone, 1996)

Marching Bands and Drum Lines

Versatile African American Marching Band

Drum Line

Most black college bands formed, including Alabama A&M (1890) and Florida A&M (1892), before the turn of the century. W.C. Handy, "Father of the Blues," assisted in the forming of The Alabama A&M group.

Dr. Foster was the most widely known and respected band director globally. He was the creator and innovator of the FAMU in 1946, which led to a 52-year career. At Florida A & M University (FAMU), he began redefining band pageantry with a showy flare employing high-stepping, accelerated tempos and syncopated dancing. Most band directors maintained a sedate military tradition with emphasis on correct carriage and measured marching precision. The drum majors at FAMU kept time for the band and were artists with a baton. FAMU Marching 100 captured the half-time spotlight when their musicians performed. They served as an example for other marching bands of all ethnic cultures. Angularity and asymmetry are pronounced in the Marching 100 repertoire inspired by African American dance. The band has an endless vocabulary of dances ranging from the Charleston of the 1920s, tootsie roll from the 1990s, and popular present-day urban dances. When traveling, the performers of the Marching 100 showcase themselves to assist in the recruitment of students.

African American marching bands had to be proficient musicians who could conduct the rhythmic intricacies of physically raw and demanding choreography, memorization of music, and management of precise geometric floor patterns (Malone, 1996).

Cheerleading

Originally, Cheerleading started in the States for men but in 1923, women dominated the cheerleading squads. Traditionally, the squads were limited to a certain body type, and were adept in the projection of winning chants, execution of gymnastic formations, and proficiency in tumbling feats.

Cheerleader

In North Carolina and Virginia during the late 1970s, African American ladies developed a style called "Stomp n Shake." These stylized cheerleaders had the traditional role for delivering motivational cheers and igniting enthusiasm which later entailed African American social dance and stepping aesthetics. Their demeanor was dominate and forceful. Tumbling and gymnastics still existed but there appeared an earthy approach along with more dance movements reflective of the times. "Stomp n Shake" cheerleaders' movements had an African sensibility with an in-your-face attitude. As the name implied, multi-unit torso movements was a common expression of the movement vocabulary (Powell, 2011).

https://thesocietypages.org/socimages/2011/07/21/race-and-the-changing-shape-of-cheerleading

Hip-Hop Majorettes

A group of predominately African American female groupings from the south have emerged to achieve popularity for their extremely athletic dance movements and stand battles. Their popularity has blossomed with the exposure of the Jackson Mississippi's Dancing Dolls, featured on the television show, *Bring It!* The Dancing Dolls, under the leadership of Dianna Williams, are referred to as hip-hop majorettes.

The dance organizations travel to compete with other groups of majorette tours. The vocabulary of motion focused on synchronized movements with hard driving choreography which incorporated many dance forms such as jazz, lyrical, hip–hop, freestyle, and African. Batons were not used unless the prop is specific for the choreographer. The competition aspect of the hip-hop majorettes involved a segment entitled "Stand Battle", a challenge between two teams tossing eight-count movements back and forth until a winner is announced by the table of judges. A stand is an eight-count movement phrase.

Costumes are dependent on the theme of the dances. All of the ladies' hair is long. The stand battles attire was usually tight-fitting and predominately ornamented with fringe and glitter (Powell, 2016). http://pancocojams.blogspot.com/search?q=Hip+Hop+Majorettes

Krumping and Clowning

Krump was an acronym for Kingdom Radically Uplifted Mighty Praise. A surprise to most, Krumping was a spiritual form of communication with religious roots and very expressive highly energetic, aggressive, athletic movements. The pioneers of the form were Tight Eyez (aka Ceasare Willis) and Lil C. Krumping was divided in three levels; Krump, Buckness, and Ampness. Other movements included Chest Pops, Armswings, Stomps, and Syncs.

Originally fast and aggressive, Krumping was intended originally like break-dancing to serve as an outlet to release anger and present a nonviolent alternative to confrontations in the streets. Krumping was influenced by diverse arenas of inspiration. African dance was the strongest.

Krump Dancer

©nikitabuida/Shutterstock.com

Tommy the Clown Battle Zones offered an African influenced competition format structure as dancers vie for championship belts. Most clown dancers organized into groups or tribes and painted their faces to represent their affiliations.

The two camps, Krumping and Clowning saw themselves as different. Clowning was the predecessor of Krumping and less aggressive. Both were executed in total freestyle expression and rarely choreographed, which lent itself to organic emotions that color the intensity and motivation of the movement. The dance competitions were presented in sessions or battles in theatrical venues. Clear distinctions could be seen in David LaChapelle's film *Rize,* featured at the 2004 Sundance Film Festival (Guerra, 2005).

http://www.urbandictionary.com/define.php?term=krumping

Double Dutch

Frederic Stevens/Getty Images Sport/Getty Images

Double Dutch

Jump rope activity can be traced back to 1600 AD when the Egyptians used vines for jumping. After World War II, young African American girls participated in jump rope using a clothesline on the street in front of their homes where they could play in a safe environment under supervision. Boys rarely participated in jump rope originally.

Double Dutch utilizes two ropes and rhythmic footwork, a dance in itself. Participants must be proficient and dependent on the timing of their team mates. The intricacies of Double Dutch have grown to include faster speeds and riskier acrobatic feats. In national and international competitions, jumpers accomplish ball bouncing or picking up items as rope turners travel forward, back, right or left. A few standard tricks are pop-ups, around the world, and mambo.

http://www.aaregistry.org/historic_events/view/double-dutch-fun-and-great-exercise

Liturgical and Praise Dance

Liturgical dance or Praise dance is a type of staging using codified gestures and technical dance movements performed in special church celebrations and holiday services. Its history dates back to biblical scriptural text. The term "liturgical" can be used interchangeably with "praise dance". From the beginning, dance was an ultimate form of giving homage to the Creator. The religious roots for dance can be found in the Holy Bible. Biblical scriptures reveal the dance activity of many major personalities on numerous occasions. In Psalm 149, Israel is invoked to worship, "Let them praise His name with dancing;" (Psalm 149:3 Amplified Bible). In II Samuel 6:16 (Amplified Bible), when the Ark of the Lord came into the City of David, King David was "leaping and dancing before the Lord". In Exodus 15 :20-21, Miriam, the sister of Aaron, was followed by all the women "with timbrels and dancing" after Israel witnessed the miracle of God parting and restoring the Red Sea destroying Pharaoh and his army. [As cited in Chapter 2 of this text, the difference between the Egyptians and Hebrews were their religious zeal not color difference. This approach to history was depicted in Dream Works' 1999 film, *The Prince of Egypt*].

https://www.britannica.com/topic/liturgical-dance

miw.org.uk/worship-mission/liturgical-dance

www.liturgical-praiseworshipdance.com/p/the-history-of-liturgical-dance.html

David Dancing Alone, 2001 (oil on canvas), Mcbee, Richard (b.1947) (Contemporary Artist) / Private Collection / Bridgeman Images

David Dancing

Dance, an integral part of the African lifestyle, began as a form of worship for the slaves on the continent of Africa. The love and necessity for dance was instinctively brought to America under the duress of slavery. On the plantation some slaves converted to Christianity, and adaptations were made to accommodate inherent elements of religion. In Africa certain deities were allowed to inhabit the worshipper through voluntary surrender; consequently, the concept was not foreign to the enslaved Africans who

freely accepted the practice of being filled with the Holy Spirit. Enslaved Africans also practiced traditional movement formations such as the circle in the ring shout and its counterclockwise movement.

As with the characteristics of African dance and its marriage to music, worship was also connected to the quality of instrumentation used in praise demonstrations. The music of worship was a more complex form of the ring shout accompaniment discussed in Chapter 5. It had complicated polyrhythmic tones and a larger group of singers. With time the choir was birthed, establishing a conduit for stylized musical interpretation. The African-American church evolved, multiplying the need for music ministries.

In the 1930's, dance was not allowed in the church outside of the single shout due to its connection to sensual secular social dances found in early jook joints and speakeasies. However, today most charismatic, Pentecostal, interdenominational or nondenominal churches employ praise dance ministries. Due to its rapidly emerging popularity in many churches today, dance attire is readily available in all colors and designs that are not offensive to the congregation, internet viewers or the performers themselves.

Renowned choreographer Alvin Ailey (spoken of in the modern dance chapter), used symbolism and an element of church worship in his signature work, Revelations. Revelations was based on and performed to negro spirituals. Liturgical props such as billows, shredded materials for flags, streamers, banners and majestic umbrellas were used in the work.

The intention of liturgical dance was to invoke the praises of the congregation. Consequently, Praise Dance ministries were demonstrated in an eclectic wave of dances. It may be any genre such as ballet, modern, jazz, tap, African, Afro-Caribbean, cultural, hip-hop, pantomime and krump dancing. Members of the congregation not on a praise team usually exercised the solo shout when moved by the Spirit. To appeal and connect with the younger generation, the African-American church has purposely offered an opportunity for the demonstration of worship through hip-hop movement, krump and pantomime (sometimes referred to as gospel mime).

Krumping as noted earlier stands for Kingdom Rapidly Uplifted, Mighty Praise. Hip-hop and krumping borrowed from the emotional freedom expressed in forms of African dance. When the surrender to organic responses of the body with the intensity of varying levels of consciousness are spontaneously released, the means of expression is borrowed from the culture.

Churches have integrated Holy hip-hop and step teams into their praise ministries to give the youth an avenue of worship expression. Opening the door to new conduits of worship has encouraged contemporary congregations to grow and establish a reconnection to African roots.

As worship, pantomime may illustrate a narrative or embellish the words of a gospel song or liturgical hymn. Gospel mime performers with faces painted white in a circular design leave a silhouette of physical features for visual clarity. The audience's eye is attracted to the abstract impression with attention given solely to the posture of the body and nuances of exaggerated facial caricatures. Mime as a secular artistic movement form has existed many years but was formally established in the African-American church as an art form in the late 1980s by brothers Karl and Keith (K &K Mime)

http://www.liturgical-praiseworshipdance.com/p/the-history-of-liturgical-dance.html

The Washington Post/Getty Images

Praise Dance

Hiplet

An evolving movement style has surprised the dance world by taking a dance form strictly codified and classically executed with the single unit use of torso movement and deconstructing it to make use of multi-unit torso articulation. Morphing from the strict technical demands of the single-unit ballet idiom to a multi-unit version of the dance form presents a problem for the ballet purist who is resistant to accept the form of movement called hiplet. Birthed in early 2009 when the term was coined, hiplet, is a hybrid of ballet on pointe and hip-hop. Homer Bryant was inspired to develop this form of movement after attending a rap concert in Canada. Hiplet was seen on Instagram in 2016 introducing it to mainstream America, resulting in wide spread attention. Needless to say, it received thousands of views; thereby opening the door to further exposure on television and variety talk shows.

Homer Hans Bryant studied under the legendary Arthur Mitchell who founded the internationally acclaimed Dance Theatre of Harlem, of which Bryant was a member. Mitchell refuted all myths, stereotypes, and misconceptions regarding African-Americans' ability to perform in the genre known as ballet, as discussed in Chapter 8.

Homer Hans Bryant founded the Chicago Multi-Cultural Dance Center (CMDC) in 1981. CMDC is the only ballet school in the world that trains dancers in hiplet technique. The technique has become a worldwide phenomenon and instructors globally want to teach hiplet. Bryant's goal is to train and build a dance company specializing in hiplet and set up a system of instruction awarding certification for those who want to teach.

Hiplet requires agility and strength in the ankles and knees. The fusion of classical pointe and hip-hop with the addition of urban dance styles was created to make a once inaccessible dance form palatable for the masses and especially the youth. The accompaniment used is not restricted to classical pieces but include socially familiar music styles.

Hipletballerinas.com

Hiplet

Tofo Tofo

The Tofo Tofo dance group consists of three young Mozambican men. The crew has been celebrated globally for their intricate precision in performing the African dance, Pantsula. Tofo Tofo performs to a musical genre called Kwaito, very similar to house music. Footage of the crew's dancing was seen on You Tube by Beyonce. The style, which could not be given its authentic quality by Beyoncé's trained dancers made it necessary to locate the dancers originally seen in the You Tube video. The popular music video "Run the World" was the masterpiece realized by collective individuals including the appearance of Tofo Tofo.

Beyonce Tofo Tofo dancers visit Kenya

"https://www.capitalfm.co.ke/lifestyle/author/laura-walubengo12413/"LAURA WALUBENGO· OCTOBER 7TH, 2011

Pantsula

In the1980s, pantsula evolved from the violent streets of the Apartheid period and grew to a popular form of expression. The dance originated in Soweto when townships were introduced to the global contemporary music influenced by America's hip-hop. Pantsula culture was commonly associated with gangs and youth with aggressive tendencies. These attitudes spilled over into their movements. Similar associations were given to the beginning of street dancing forms such as breaking and hip-hop in America. Pantsula dance has moved out of the townships and its popularity has graduated into the mainstream commercial arena.

Pantsula utilizes rhythmic improvisational movements reflective of life in the township community. It is similar to flat-footed hoofing with a hip-hop aesthetic but emphasizes a gliding element in the

movement. Pantsula is reported to be of Zulu origins and is said to mean strike (with a whip), symbolic of its energetic snappy and dynamic nuances. Often, it is performed using the accompaniment of not only instrumental music but props such as buckets, brooms, sticks or cans. Its movement evolution stems from street competitions.

Pantsula is psychologically a dance of freedom from the stresses of township life. Its participants use the dance as an escape and source of strengthening power in tandem. The low economic and thug image associations were negated with the acceptance and fame of Tofo Tofo in the production of Beyoncé's internationally acclaimed music video. Performed in crews of men and women, the attire worn in the midst of the execution of pantsula is distinctive. Dickies brand work pants are worn along with American made Converse All-Star shoes. The original participants of the dance were fascinated with and inspired by American jazz records reflective of the 50s and 60s style of American clothing.

PANTSULA 4 LYF: POPULAR DANCE AND FASHION IN JOHANNESBURG
JANUARY 29-SEPTEMBER 3, 2017

https://www.fowler.ucla.edu/exhibitions/pantsula/

Sunday Times/Gallo Images/Getty Images

Pantsula

Recognition of Africa in contemporary social dance

Effects of Black Panther

The blockbuster 2018 movie phenomenon Black Panther, a Marvel epic, has morphed into a catalyst for African and African-American cultural pride. The essence of the beauty of Africa was poured into a marvelous pot of African aesthetic and royalty on film.

The movie's impact has created for the younger generation an interest in the knowledge of African art, dance, and theatre. The youth have gained a healthy respect and hunger for the African culture and have incorporated that enthusiasm into the dance. The movie itself is rich in movement from special effects to the dance and African martial arts. You Tube is rich with the movements of groups participating in the Black Panther dance challenge. The challenge is executed by different groups performing a hybrid of African and hip-hop qualities to similar sounding rhythmic African music. As a rule, challenge participants wear some form of African-American attire influenced by the African aesthetic.

Groups of all kinds have joined in this challenge, including Elementary programs such as the Ron Clark Academy, which has taken hold of the concept of African pride by inviting lecturers and linguists to teach African languages and African dance, proving the movement to be a unifying artistic art form positively affecting the community. Again, highlighting the qualities, characteristics, and importance of community unity that were articulated in the third chapter of this text.

The symbolic crossing of the arms movement prevalent and used multiple times in the movie, commonly called "The Wakanda Forever Salute" has become a popular movement in many areas of mainstream African and African-American culture. The movement is a symbolic representation of "Black Excellence". Tennis player, Sachia Vickery celebrated the biggest win of her career with the salute. Gael Monfils also used the movement after his victorious match with Matthew Ebden. Basketball, rugby, football and other sports have demonstrated the symbolic movement globally, promoting the unification of people of the African diaspora.

"https://quartzy.qz.com/author/amohdinqz/" Aamna Mohdin
March 13, 2018

Display for Black Panther

References

Chapter 2 - Ancient Egyptian Dance

Browder, Anthony T. 1992. *Nile Valley Contributions to Civilization.* Washington D.C.: Institute of Karmic Guidance (IKG).

Diop, Anta Cheikh. 1967. *The African Origin of Civilization Myth or Reality.* Edited and translated by Mercer Cook. Chicago, IL: Lawrence Hill Books.

Draper, Robert. 2008. "Black Pharaohs." *National Geographic*, Vol. 213, No. 2, 2008, 38–39.

Erman, Adolf. 1971. *Life in Ancient Egypt.* Translated by H.M. Tirard. New York: Dover Publications Inc.

Lexova, Milada. 2000. *Ancient Egyptian Dance.* Translation by K. Haltmar. New York: Dover Publications, Inc.

Spencer, Patricia. 2003. "Dance in Ancient Egypt". *Near Eastern Archaeology,* Vol. 66, No. 3, 2003. Published by: The American Schools of Oriental Research. Stable. http://www.jstor.org/stable/3210914. Accessed on November 23, 2014.

Chapter 3 - African Dance

Oldest bones

Boyes, Steve. 2013. "Getting To Know Africa: 50 Interesting Facts . . ." *National Geographic*. http://voices.nationalgeog...-to-know-africa-50-facts/. Accessed on October 31, 2013.

Brown, Ronald K. n.d. Information from "Evidence" website. www.evidencedance.com.

Munro, Cait. 2015. "Nick Cave Made a Soundsuit Inspired by Trayvon Martin", *artnet news* Artnet Worldwide Corp (article). https://news.artnet.com/exhibitions/nick-cave-trayvon-martin-tribute-310854. Accessed June 24, 2015.

Muntu Dance Theatre. n.d. http://www.muntu.com/

Perpener III, John O. 2001. *African-American Concert Dance the Renaissance and Beyond.* Chicago, IL: University of Illinois Press, p. 107.

Shreeve, Jamie. 2009. "Oldest Skeleton of Human Ancestor Found". *National Geographic Magazine*, 2009. http://news.nationalgeographic.com/news/2009/10/091001-oldest-human-skeleton-ardi-missing-link-chimps-ardipithecus-ramidus.html

Thompson, Robert Farris. 1974. *African Art in Motion (Icon and Act in the Collection of Katherine Coryton White).* California: University of California Press, pp. 6, 7.

Welsh, Kariamu. 2010. *African Dance* (2nd edition). New York: Chelsea House.

Chapter 4 - Transatlantic Slave Trade

Carter, Cynthia Jacobs Dr. 2003. *Africana Woman Her Story Through Time,* Washington D.C.: National Geographic Society.

Emery, Lynne Fauley. 1988. *Black Dance from 1619 to Today* (2nd revised edition). New Jersey: A Dance Horizons Book, Princeton Book Company.

Glass, Barbara S. 2007. *African American Dance an Illustrated History.* North Carolina: McFrland & Company Inc Publishers. Hazzard-Gordon, Katrina. 1990. *Jookin' The rise of Social Dance Formations in African-American Culture.* Philadelphia, PA: Temple Press.

Hine, Darlene Clark, William C. Hine, Stanley Harrold. 2006. *The African-American Oddyssey* (3rd edition). New Jersey: Pearson Education, pp. 29, 30, 32.

Thorpe, Edward. 1989. *Black Dance.* New York: The Overlook Press.

Chapter 5 - Dance on the Plantation

Carter, Cynthia Jacobs Dr. 2003. *Africana Woman Her Story Through Time,* Washington D.C.: National Geographic Society.

DeFrantz, Thomas F., editors. 2002. *Dancing Many Drums.* Wisconsin: University of Wisconsin Press.

Emery, Lynne Fauley. 1988. *Black Dance from 1619 to Today* (2nd revised edition). New Jersey: A Dance Horizons Book, Princeton Book Company.

Evans, Tony. 1995. *Let's Get to Know Each Other, What White and Black Christians Need To Know About Each Other.* Tennesse: Thomas Nelson Publishers. Glass, Barbara S. 2007. *African American Dance an Illustrated History.* North Carolina: McFarland & Company Inc Publishers.

Hassan-EL, Kashif Malik. 1993. *The Willie Lynch Letter and The Making of a Slave* (Historical Documentary). Chicago, IL: Lushena Books.

Hazzard-Gordon, Katrina. 1990. *Jookin' The rise of Social Dance Formations in African-American Culture.* Philadelphia, PA: Temple Press.

Kebede, Ashenafi. 1995. *Roots of Black Music.* New Jersey: Africa World Press Inc. Rosenbaum, Art. 1988. *Shout Because You're Free.* Georgia: University of Georgia Press.

Thorpe, Edward. 1999. *Black Dance.* New York: The Overlook Press.

Chapter 6 - Minstrelsy

Driver, Ian. 2000. *A Century of Dance (A hundred years of musical movement, from waltz to hip hop).* London: Octopus Publishing Group Limited.

Emery, Lynne Fauley. 1988. *Black Dance from 1619 to Today* (2nd revised edition). New Jersey: A Dance Horizons Book, Princeton Book Company.

Glass, Barbara S. 2007. *African American Dance an Illustrated History.* North Carolina: McFarland & Company Inc Publishers.

Hill, Constance Valis. 2010. *Tap Dancing America (A Cultural History)* New York: Oxford University Press.

Lane, Stewart F. 2015. *Black Broadway (African Americans on the Great White Way)*. New York: Square One Publications.

Long, Richard A. 1989. *The Black Tradition in American Dance*. New York: Rizzoli.

Thorpe, Edward. 1989. *Black Dance*. New York: The Overlook Press.

Chapter 7 - Tap

Driver, Ian. 2000. A *Century of Dance (A hundred years of musical movement, from waltz to hip hop)*. London: Octopus Publishing Group Limited.

Emery, Lynne Fauley. 1988. *Black Dance from 1619 to Today* (2nd revised edition). New Jersey: A Dance Horizons Book, Princeton Book Company.

Glass, Barbara S. 2007. *African American Dance an Illustrated History*. North Carolina: McFarland & Company Inc Publishers.

Glover, Savion and Bruce Weber. 2000. *(My Life In Tap) Savion!* New York: William Morrow and Company.

Hill, Constance Valis. 2010. *Tap Dancing America (A Cultural History)*. New York: Oxford University Press.

Lane, Stewart F. 2015. *Black Broadway (African Americans on the Great White Way)*. New York: Square One Publications.

Malone, Jacqui. 1996. *Steppin' on the Blues (The Visible Rhythms of African American Dance)*. Urbana and Chicago: University of Illinois Press.

Thorpe, Edward. 1989. *Black Dance*. New York: The Overlook Press.

"Today in Black History: Small's Paradise". 2011. http://keepingupwiththejones-markjones.blogspot.com/2011/02/today-in-black-history-smalls-paradise.html

Chapter 8 - Ballet

Bishop, Amy. 2016. "Up close with Houston's Lauren Anderson" dance, Houston public media, a service of the University of Houston.

https://www.houstonpublicmedia.org/articles/news/2016/01/18/123362/up-close-with-houston-ballets-lauren-anderson/

Dance Theatre of Harlem website. Founders/Directors http://www.dancetheatreofharlem.org/directors

DePrince. 2014. *Taking Flight (From War Orphan to Star Ballerina)*. New York: Ember

Dunning, Jennifer. 1994. Obituaries "Billy Wilson, 59, Director and Choreographer". *New York Times*. Accessed on August 16, 1994.

http://www.nytimes.com/1994/08/16/obituaries/billy-wilson-59-director-and-choreographer.html

Emery, Lynne Fauley. 1988. *Black Dance from 1619 to Today* (2nd revised edition). New Jersey: A Dance Horizons Book, Princeton Book Company.

Houston Public Media. A service of the University of Houston.

King, Alonzo. http://www.blackpast.org/aah/king-alonzo-c-1952

Kraus, Richard, Sarah Chapman-Hilsendager, and Brenda Dixon. 1999. *History of the Dance in Art and Education* (3rd edition). New Jersey: Prentice Hall.

Long, Richard A. 1989. *The Black Tradition in American Dance.* New York: Rizzoli.

Shinhoster Lamb, Yvonne. 2006. "Director and Teacher Mike Malone; Nurtured D.C. Black Theatre Scene." *Washington Post.* Accessed on December 6, 2006.

http://www.washingtonpost.com/wp-dyn/content/article/2006/12/05/AR2006120501511.html

Sofras, Pamela Anderson. 2006. *Dance Composition Basics (Capturing the Choreographer's craft.* North Carolina: Human Kinetics.

Steele, Shauna L. and Kristen Farmer. 2014. *Experiencing Dance.(A Creative Approach to Dance Appreciation.* Dubuque, IA: Kendall and Hunt Publishing.

Wilkinson, Raven. 1935. Ballet pioneer (African American Registry). www.aa**registry**.org/historic_events /view/**raven-wilkinson-ballet-pioneer**

www.**complexionsdance**.org

http://www.complexionsdance.org/dwight-rhoden

http://www.complexionsdance.org/desmond-richardson

Misty Copeland Website. http://mistycopeland.com/about/

Chapter 9 - Modern Dance

Blunden, Jeraldyne. Dayton Contemporary Dance company. http://www.dcdc.org/founder

Brown, Camille A. http://www.camilleabrown.org/camille-a-brown/

Brown, Joan Myers. http://www.philadanco.org/about/brown.php

Cleo Parker Robinson website. https://cleoparkerdance.org/

DeFrantz, Thomas F. 2002. *Dancing Many Drums.* Wisconsin: University of Wisconsin Press.

Desmond, Jane C, editor. 1997. *Meaning Motion.* Durham: Duke University Press.

Dunning, Jennifer. 1966. "Ulysses Dove, Creator of Dark, Driving Dances, Dies at 49". *New York Times.* Accessed June 12, 1996. https://www.google.com/search?client=safari&rls=en&q=Dunning,+Jennifer.+ 1966.+"Ulysses+Dove,+Creator+of+Dark,+Driving+Dances,+Dies+at+49".&ie=UTF-8&oe=UTF-8

Eichenbaum, Rose. 2004. *Masters of Movement.* Washington D.C.: Smithsonian Books.

Emery, Lynne Fauley. 1988. *Black Dance from 1619 to Today* (2nd revised edition). New Jersey: A Dance Horizons Book, Princeton Book Company.

International Association of Blacks in Dance. http://www.iabdassociation.org/highlights-and-milestones

Jeff, Kevin Iega. Gardner Arts Network, Presenters Corner. www.gardnerartsnetwork.com/choreographer /kevin-iega-jeff

Joffrey Ballet Chicago. Joffrey.org. http://joffrey.org/people/christopher-l-huggins

Jones, Bill T. https://www.britannica.com/biography/Bill-T-Jones

Kraus, Richard, Sarah Chapman-Hilsendager, and Brenda Dixon. 1999. *History of the Dance in Art and Education* (3rd edition). New Jersey: Prentice Hall.

Long, Richard A. 1989. *The Black Tradition in American Dance.* New York: Rizzoli.

Lula Washington Dance Theatre. http://www.lulawashington.org/foundation/about-lula-washington/

Miller, BeBe. http://bebemillercompany.org/about/bebe-miller/

Thompson, Denise Saunders. http://www.iabdassociation.org/denise-thompson

Thorpe, Edward. 1989. *Black Dance.* New York: The Overlook Press.

Urban Bush Women. www.urbanbushwomen.org

Williams, Ann. http://www.iabdassociation.org/ann-williams

https://www.alvinailey.org/alvin-ailey-american-dance-theater/robert-battle

Chapter 10 - Jazz Dance

Breckenridge, Stan L. 2004. *African American Music for Everyone.* Iowa: Kendall/Hunt Publishing Co.

Jackson, Irene, editor. 1985. *More Than Dancing.Essays on Afro-American Music and Musicians.* Connecticut: Greenwood Press.

Malone, Jacqui. 1996. *Steppin' on the Blues(The Visible Rhythms of African American Dance).* Urbana and Chicago: University of Illinois Press.

Lane, Stewart F. 2015. *Black Broadway (African Americans on the Great White Way).* New York: Square One Publications.

George Faison

Giordano, Gus, author and editor. 1996. *Anthology of American Jazz Dance* (2nd edition). Chicago, IL: Orion Publishing House.

Alvin Ailey American Dance Theatre Website. https://www.alvinailey.org/alvin-ailey-american-dance-theater/george-faison

Blk or Blk dance = Black Dance

Thorpe, Edward. 1989. *Black Dance.* New York: The Overlook Press.

Hatchett, Frank and Myers Gitlin, Nancy 2000. *Frank Hatchett's Jazz Dance,* Illinois: Human Kenetics.

Henson, Darrin. http://darrinhenson.com/darrin-henson/

Robinson, Fatima. http://www.fatimarobinson.com/

http://stylelikeu.com/profiles-2/closets/fatima-robinson/

Scott, Dave. https://www.broadwaydancecenter.com/faculty/bios/scott_dave.shtml

Laurieann Gibson. http://laurieanngibson.weebly.com/

http://www.savoystyle.com/norma_miller.html

https://www.broadwaydancecenter.com/faculty/bios/gibson_laurieann.shtml

Chapter 11 - Other Movement Forms

Brown, Tamara L. 2005. Edited by Tamara L. Brown, Gregory S. Parks, and Clarenda M. Phillips, *African American Fraternities and Sororities: The Legacy and the Vision*. Kentucky: University Press of Kentucky.

"Double Dutch, Fun and Great Exercise". *African American Registry*. http://www.aaregistry.org/historic_events /view/double-dutch-fun-and-great-exercise

Guerra, Gabo. 2005. "Krumping" *The Urban Dictionary*. http://www.urbandictionary.com/define.php?term=krumping. Accessed on July 26, 2005.

Hodge, Daniel White. 2010. *The Soul of Hip Hop Rims, Timbs and a Cultural Theology*. Chicago, IL: Intervarsity Press. p. 38

Fine, Elizabeth C. 2003. *Soulstepping: African American Step Shows*. Chicago, IL: Board of Trustees of University of Illinois.

Malone, Jacqui. 1996. *Steppin' on the Blues(The Visible Rhythms of African American Dance)*. Chicago, IL: University of Illinois Press.

Powell, Azizi, Guest Blogger. 2011. "Race and the Changing Shape of Cheerleading". *Society Pages.org*. https://thesocietypages.org/socimages/2011/07/21/race-and-the-changing-shape-of-cheerleading/. Accessed: July 21, 2011

Powell, Azizi, editor. 2016. Stand Battles & The Changing Meaning of "Majorettes" in African American Culture. *Pancocojams*. http://pancocojams.blogspot.com/search?q=Hip+Hop+Majorettes. Latest Revision on July 27, 2016.

Urban dictionary by Gabo Guerra July 26, 2005. http://www.urbandictionary.com/define.php?term=krumping

Index